S E M I N A R

P R O C E E D I N G S

The Preservice Challenge:

Discipline-Based Art Education and

Recent Reports on Higher Education

August 8–15, 1987

Snowbird, Utah

A national invitational seminar

Sponsored by The Getty Center for Education in the Arts

©1988 The J. Paul Getty Trust

The Getty Center for Education in the Arts
1875 Century Park East, Suite 2300
Los Angeles, CA 90067

Seminar proceedings prepared by
Keens Company, New York, New York
 William Keens, President
 Bruce Peyton, Project Director
 Adam Bellow, Project Associate

Kurt Hauser, Designer, J. Paul Getty Trust
Publications

Library of Congress cataloging-in-publication data.

The Preservice challenge.

 Includes bibliographies.
 1. Art teachers—Training of—United States—Congresses.
2. Art—Study and teaching—United States—Congresses.
I. Getty Center for Education In the Arts.
NX284.3.P74 1988 707'.1173 88-13164
ISBN 0-89236-144-1

Table of Contents

Foreword

THE GETTY CENTER FOR EDUCATION IN THE ARTS is strongly committed to professional staff development as a means for strengthening art education in American schools. One of our special concerns is preservice education, the long-term professional preparation of teachers who are qualified to offer instruction in art.

The establishment of art education programs that reflect content from four foundational art disciplines has been advocated for the past five years by the art education profession, many state education departments, and a host of education reform reports. We call this approach "discipline-based art education" because it draws its content from four art disciplines: art production, art history, art criticism, and aesthetics. Because this approach is being accepted as a new paradigm for teaching children how to create, understand, and respond to art, it is incumbent on teacher education institutions preparing future art specialists and classroom teachers to enable them to teach art in this more comprehensive and substantive way.

We proposed to encourage the development of discipline-based art education in teacher training programs in universities by inviting fifteen institutions from around the country to send faculty teams to Snowbird, Utah, in August 1987, for a week-long conference on art education teacher preparation. Each team was comprised not only of art educators, but also of representatives from the various art disciplines of studio production, art criticism, art history, and aesthetics. We

believe that the needs of preservice art educators, as well as the congruence of interests among their colleagues in university art and education departments, made it particularly suitable that they should all have the opportunity to work together in a convivial setting while focused on topics of mutual interest.

These proceedings offer a complete and detailed view of the presentations, discussions, and other activities that took place at the Snowbird seminar. It is our hope that this material will encourage other universities to consider how they might strengthen teacher preparation programs in preservice art education to prepare teachers more thoroughly for their responsibilities in teaching art. As one reads the various summaries and texts, it is clear that the issues raised by discipline-based art educators and by preservice art educators are complex, but ones that the sixty participants at Snowbird were eager to discuss. We hope these proceedings will extend the dialogue begun at Snowbird into the larger arena of art education.

Leilani Lattin Duke
Director
Getty Center for Education in the Arts

Introduction

Art teachers and specialists hold the power to shape their students' ability to understand and value art. Prospective art teachers and specialists therefore need more than a strong background in studio art if they are to provide the balanced instruction that will foster these abilities. They need the additional foundation coursework in the other three disciplines that contribute to discipline-based art education (DBAE): art history, art criticism, and aesthetics. Teachers also need appropriate teaching skills for translating art content from these four disciplines into instruction. This multifaceted approach to art content has been supported by many groups concerned with the quality of art education, including the College Board, the National Art Education Association, and numerous state education agencies. Historically, however, most preservice art education programs have concentrated on art production (studio) courses to the neglect of the other three disciplines.

To respond to the need for strengthening preservice teacher education programs in art in relation to DBAE, a seven-day preservice seminar for interdisciplinary teams from fifteen universities was held in Snowbird, Utah, from August 8-15, 1987. The purposes of the seminar were: (1) to discuss major issues relating to change in preservice art education programs, and (2) to formulate plans for revising preservice coursework or programs. Each of the interdisciplinary teams was comprised of two art educators and two representatives from studio, art history, art criticism, and aesthetics.

The present climate of major changes in preservice education provides an auspicious time for the seminar to have taken place. Recent national reports about educational reform have sparked a broader public awareness of teacher education issues. These reports have come from various agencies over the past three years. For example, the Holmes Group—a committee of educators from leading research universities—makes recommendations for strengthening the teaching profession through abolishing the undergraduate education degree, strengthening liberal arts undergraduate programs, and establishing a three-step career ladder. The Carnegie Forum on Education and the Economy calls for a National Board for Professional Teaching Standards. *Time for Results: The Governors' 1991 Report on Education* presents recommendations based on the findings of their seven task forces. Among others who have issued reports on reform in teacher education are: the Department of Education, the Education Commission of the States, the Carnegie Foundation for the Advancement of Teaching, the American Association of Colleges for Teacher Education, the American Federation of Teachers, and the College Board. Simultaneously, art educators are faced with the challenge of preparing teachers who can reexamine and broaden the content of art instruction taught in schools. It is exciting to anticipate what may

THE SEMINAR WAS THE RESULT OF THREE YEARS OF STUDY . . . REGARDING THE PROBLEMS FACED BY PRESERVICE ART EDUCATORS.

eventually result from the interdisciplinary university teams who met together to make plans for educating a new generation of art teachers.

The seminar was the result of three years of study by the Getty Center for Education in the Arts regarding problems faced by preservice art educators. As it conducted these studies, the Center frequently heard the concern voiced that the press of routine university responsibilities often prevents discussion of substantive issues about program and content, both among faculty within the university and among universities themselves. Educators also have communicated the need for time away from everyday problems in order to gain a longer-term perspective, as well as to formulate plans for revitalizing the preparation of art teachers.

Both of these concerns guided the planning of the seminar, called "The Preservice Challenge." It was hoped that the spectacular setting at Snowbird, Utah, combined with the seminar's vigorous and stimulating program, would inspire the discussion necessary to generate inventive and effective plans for strengthening preservice art education in the current climate of reform and increasing interest in discipline-based art education.

Nancy P. MacGregor, Associate Professor of Art Education at Ohio State University, chaired the Seminar Committee that worked with the seminar director in planning the event. The two other committee members were Stanley Madeja,

Dean of the College of Visual and Performing Arts at Northern Illinois University, and Mary Ann Stankiewicz, Associate Professor at California State University, Long Beach, and formerly from the Department of Art at the University of Maine. The planning team met several times over the period of a year to develop the diverse agenda that would help accomplish the ambitious goals of the seminar in bringing faculty from the art disciplines together with art educators not as consultants but as peers.

The planning team also assumed responsibility for the selection of the universities that participated. Chief among the criteria were (l) the strength of the preservice art education program at the institution, coupled with the extent to which the program was already involved with discipline-based art education, and (2) geographic diversity among the universities. The universities chose their own interdisciplinary teams of four persons to attend the seminar. The teams consisted of two art educators—one new to the field and one more established—and two faculty members from two of the four art disciplines. The universities that participated included:

Brigham Young University
California State University, Long Beach
California State University, Sacramento
Florida State University
Indiana University
Kutztown University
Northern Illinois University

Ohio State University
Texas Tech University
University of Arizona
University of Kansas
University of Minnesota
University of Nebraska, Lincoln, and Omaha
University of Oregon
Virginia Commonwealth University

(The University of Nebraska at Lincoln and the University of Nebraska at Omaha participated as one team.) They represent a range of universities: some that have embraced the Holmes Group initiative (among ninety universities who have agreed to implement the recommendations of the Holmes Group report issued in 1986), and others that have not; some noted for research and graduate programs as well as preparing future teachers, others for their preservice programs alone; some well-established in their DBAE efforts, others at a more incipient stage. This diversity proved fruitful in discussions throughout the seminar.

The first four days of the seminar were devoted to both keynote addresses and panel presentations on issues that have a major impact on preservice programs. These sessions provided occasions for considering and discussing a range of vital issues before participants met as individual university teams to generate plans to strengthen their own programs. Reflecting the complexity of the topics, many of the sessions were followed by question-and-answer or small-group discussions.

During the latter part of the week (Thursday and Friday) individual university teams convened to review their current programs and coursework and to develop plans for strengthening either single courses or programs to reflect discipline-based art education. On one afternoon the teams met together in small groups to critique each other's plans. A morning period was set aside to permit teams to revise plans, and to prepare for the culminating session Friday afternoon, when the plans were shared in plenary session.

The diversity and detail of the plans developed by the university teams testified to the hard work accomplished in team meetings. Plans for revising existing course content were perhaps the most prevalent. Several comprehensive plans were also advanced for virtually the complete revision of programs, including changing course content and requirements for preservice art education majors. New courses were also proposed, such as a thematic approach to a cross-discipline course in art; an introduction to imagery; the interrelationship among the four art disciplines; and a foundations course that exemplifies DBAE, for all art majors. A visiting scholar program was planned, to be developed into a videotape library. Designs for increasing awareness of DBAE among art and art history faculties were put forth. Two features were especially prominent in the various university team presentations: (1) plans for team teaching among faculty from art education and the four disciplines, and (2) plans for including

a greater balance of content (from the four art disciplines) in courses taught by the art discipline faculty members present at Snowbird.

Among the rewarding yet impromptu events occurring at the seminar were meetings arranged by participating faculty from the four art disciplines. As the seminar progressed through the week, it became apparent to the discipline representatives that they would benefit from meeting together to discuss the importance and utility of DBAE for their own discipline.

The seminar schedule was designed to enhance the intense work sessions by allowing ample time for informal discussion and for exploration of the magnificent surrounding mountain terrain. Morning sessions of presentations and discussions were followed with a two-and-one-half hour break for lunch, reflection, and relaxation, followed by afternoon sessions for discussion groups.

Specific times were set aside in the schedule for the more casual interactions that were so important to the success of the seminar. On Wednesday afternoon, in the middle of the week's schedule, after a rigorous morning's work, participants had the afternoon free to do as they liked. A sunset bonfire dinner was held in a mountain meadow perched above the valley, reached by ski lift. Evening receptions were planned for the four occasions when no group dinner was scheduled.

Requests for proposals for contracts to strengthen preservice programs were distributed to university teams midweek. Participating teams were encouraged to submit competitive proposals during the fall for modest funding to help accomplish plans outlined at the seminar.

In order to share the benefits of the presentations and discussions with a broader professional audience, the Getty Center for Education in the Arts recorded and documented fully the Snowbird Seminar. This information has been edited and organized in these published proceedings, which are arranged in two major parts, "Proceedings" and "Complete Texts." The former includes summaries of: keynote addresses and panels (grouped together for panel presentations); questions and answers that followed the addresses; and small-group discussions. The latter includes the full texts of all 22 presentations from the Snowbird Seminar. Between these two major parts are two sections that may be of interest to the reader. "Post-Snowbird Activity" summarizes the Request for Proposals and the preservice contracts that were awarded to universities. The contracts were for enhancing discipline-based art education in teacher preparation programs. This section is followed by the list of universities and participants.

I hope these proceedings will inform and encourage others engaged in the ongoing struggle of improving preservice art education.

Successful seminars are always the result of many persons. I especially want to thank my seminar committee—Nancy

MacGregor, Stanley Madeja, and Mary Ann Stankiewicz—for their sagacity and hard work both before and during the seminar. I am also grateful to Valsin Marmillion and Daylanne Johnson of Hunt Marmillion and Associates for their unfailing help with the seminar arrangements. Additionally, I want to express my delighted appreciation of the participants, whose enthusiasm and astuteness were an inspiration to me throughout the event.

Marilynn J. Price
Seminar Director
January 1988

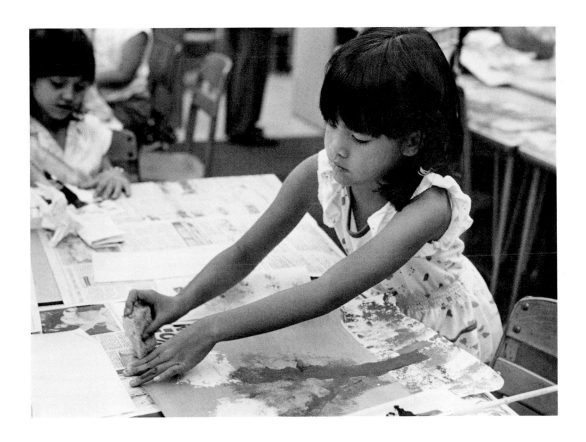

Program of Events*

*Not all events listed here are covered in the proceedings.

1:00–3:30	Lunch, Reflection, Relaxation
3:30–5:30	INDIVIDUAL UNIVERSITY TEAM MEETINGS
	Begin Plans to Strengthen Programs and Course Work
5:30	Bonfire Dinner

Wednesday, August 12

8:00–11:15 a.m.	PLENARY SESSION

Address: *History of the University Curriculum*

Lewis B. Mayhew, Stanford University

Panel Presentation: *Problems and Issues in Teacher Credentialing*

Thomas Ferreira, California State University, Long Beach

Stephen Kaagan, Vermont Department of Education

Richard C. Kunkel, National Council for the Accreditation of Teacher Education

Clyde McGeary, Pennsylvania Department of Education

Mary Ann Stankiewicz, University of Maine, Moderator

11:15–11:45	Break
11:45–1:00 p.m.	INDIVIDUAL UNIVERSITY TEAM MEETINGS

Which Credentialing Factors Influence Successful Implementation of Preservice Programs at Your University?

1:00 on	Free for Activities

Thursday, August 13

9:00–10:00 a.m.	PLENARY SESSION

Questions and Answers About Requests for Proposals for Modest Grants

Stephen M. Dobbs, Getty Center for Education in the Arts

10:00–10:15	Break
10:15–4:00 p.m.	INDIVIDUAL UNIVERSITY TEAMS
	Complete Development of Plans to Strengthen Programs and Course Work
4:30–6:30	SMALL-GROUP DISCUSSION
	Critique Plans
6:30	Wine and Cheese

Friday, August 14

9:00 a.m.–1:00 p.m.	SMALL-GROUP DISCUSSION
	Revise Plans and Prepare for Afternoon Presentations
1:30–3:30	PLENARY SESSION
	Small Groups Report on Plans
3:30–4:00	Break
4:00–5:30	PLENARY SESSION
	Small Groups Complete Reports
7:00	Reception and Dinner

Saturday, August 15

9:00–11:00 a.m.	PLENARY SESSION

The Interrelationship Between Preservice and Inservice Education for Art Teachers and Specialists

Speaker:

Frances S. Bolin, Columbia University

Respondents:

Michael D. Day, Brigham Young University

Linda Peterson, Provo, Utah, School District

Jerry Tollifson, Ohio Department of Education

Proceedings

The Importance of the Arts in Undergraduate Education

SPEAKER

Benjamin Ladner
National Faculty of Humanities, Arts,
and Sciences

A Summary of
Benjamin Ladner's Address

"The primary task of art educators is to educate the citizenry about the whole range of human experience," said Benjamin Ladner, contending that the arts are not merely "basic" to education; they are essential to the resolution of the human condition. In this light he offered three major proposals, which he said "could dramatically alter what and how we teach in the university generally and in the arts in particular."

First, he urged educators not to accept education in the arts as one more specialized field in a disconnected array of university disciplines. The model of human intellection now prevailing in universities must be exposed and transformed by the arts; inquiry itself must be reconceived. Contrary to our inherited ideal of knowing, which has reduced knowledge to disembodied, abstract ideas, we must realize that "ideas have the power to mean what they do, not because we look *at* them but because we can see *from* or *through* them to something else."

His second proposal used his first as a base. Taking the primary role of the arts in the university to be that of an instrument of inquiry, he suggested that the arts must provide "a paradigmatic form of inquiry on the basis of which other disciplines function and cohere."

Third, he said, the arts must reestablish their crucial link to culture. He quoted Hannah Arendt, who said that "we mean by culture the mode of intercourse of man with the things of the world." Understood in this way, culture is essentially dependent upon the arts and upon the taste and judgment of those who preserve the arts.

And yet, undergraduates are led by their universities to perceive courses in the arts as peripheral, as options. Parallel with the trivializing of art, human feeling has been preempted in academia by the science of psychology, and art has been reduced to the psychology of self-expression. Undergraduates "almost never feel that by studying art they will be making important choices about the kind of world in which they will live."

Ladner described art forms as "modes of intercourse by means of which we lay claim to that which we already possess." His proposals, he said, are not intended to make a case for the equal status of the arts with other subject areas in the university. He sees them, instead, as "the heart of the university curriculum and of life insofar as the raison d'etre of the university is inquiry, discovery, and the shaping of insight and meaning into expressive, comprehensible forms."

A final task that must be undertaken if the arts are to move to the center of the university curriculum and to the center of shared cultural experience, Ladner concluded, is that "artists and educators,

relying upon art forms as the source and direction of their own meaning, must self-consciously and deliberately reinvent preservice and inservice education. The arts must give us more than valuable cultural objects and effective forms of inquiry. They must give us teachers." Teaching the arts is an urgent professional and cultural necessity. It can be accomplished only by engaging students in a process of inquiry through the arts that draws them irresistibly into a more profound relation to the world and enables them thereby to feel the lure of sharing their understanding, even as they continue to deepen it.

The case for the arts in the undergraduate curriculum is at the same time a case for teachers who are passionately engaged in the process of integrating their own lives with objects, words, ideas and meaningful forms that ennoble their own lives and the human community. "It is this relentless engagement—intense, bewildering, risky, ambiguous—that is the sina qua non of teaching and inquiry."

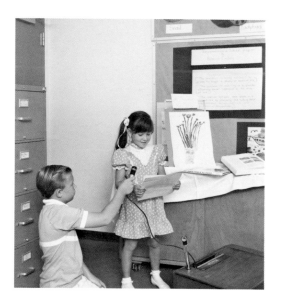

Implications of Discipline-Based Art Education For Preservice Art Education

PANELISTS

Kathleen Cohen
 San Jose State University
Edmund Burke Feldman
 University of Georgia
Anita Silvers
 San Francisco State University

MODERATOR

Marilynn J. Price
 Seminar Director

A Summary of Kathleen Cohen's Address

Today, prospective teachers are being asked not only to learn studio competency, art history, art criticism, and aesthetics, but to go beyond the Western tradition and deal also with the art and culture of the whole world. Because the amount of material that can be added to the preservice curriculum is limited, Kathleen Cohen urged educators to *infiltrate* and *integrate*. Educators need to devise strategies for infiltrating literature and social studies classes so that students will be "saturated with art" and art will seem like a natural activity.

Although academics know that connected learning is more effective than separated bits of information, they are trained and rewarded as specialists within narrow ranges of expertise. How, then, are they to guide prospective teachers into making connections between ideas, between disciplines, and between cultures? Rather than try to give all the answers, Cohen suggested, educators might better teach students to ask the right questions—

and these can be learned from colleagues in other disciplines. From her own experience, she has found that, in the appropriate circumstances, teachers learn best from each other.

She described educators today as faced with a tremendous challenge: how to prepare students to teach art from a much broader perspective than that from which the educators themselves were taught. To deal with the challenge, educators must be willing to take risks and to experiment with the ways in which they teach.

Having given several examples from her own experience, Cohen urged each of the educators participating in the conference to find a way to infiltrate at least one new course. In doing so, they could give students the experience of creating integrated lessons and experiencing the unified core not only of art history but also of the art expression that lies at the heart of civilized life itself.

A Summary of
Edmund Burke Feldman's Address

The typical graduate of a college or university art education program is prepared to teach studio art and little else, Edmund Feldman said. But if art is to play a significant role in the lives of both art professionals and lay people, then to the studio artists and art historians conducting preservice programs must be added philosophers, aestheticians, and art critics. Such an expansion would require at least a five-year program.

In recommending how an expanded art teacher education program should be constituted, Feldman focused on four central questions. First, should new courses be added to the curriculum? The answer is yes, he feels, and among the most essential of new courses would be the philosophy of art—which he defined as instruction in the "functions, purposes, and values of art in human societies."

Second, what is the desirable sequence of DBAE studies? He recommended moving (outside of studio courses) from art criticism to art history to aesthetics to the philosophy of art. Before studying aesthetics or philosophy of art, the student must have considerable experience with individual artworks *in depth*, which is gained through art criticism, and with the various forms of visual art, which is gained through the study of art history.

Third, how is the new material to be delivered? In general Feldman favors "courses" as the best way to transmit the DBAE subject matter. He approves of team teaching as long as *someone* takes responsibility for organizing and integrating each team member's contributions.

Finally, who will teach? Feldman cautioned against dilettantism masquerading as liberal education and urged a search for critics, historians, and aestheticians who are serious students of the differences among the arts.

He further observed that the work of art is already a "highly integrated phenomenon." It embodies personal, social, religious, economic, and historical events. Teachers should talk less about art in the abstract and more about particular buildings, pictures, and statues. The study of methods is no substitute for the study of art, and integration requires something to integrate *with*. Therefore, educators must put a reasonably comprehensive fund of artistic images into their students' minds.

How can one get painters, potters, and printmakers to collaborate with art historians and aestheticians on presenting the material that students are to integrate? Feldman had no advice. It will be no small feat, he admitted, even calling it an art—an art that might well be added to the four DBAE disciplines.

A Summary of Anita Silvers's Address

For many reasons, the shift of twentieth-century educators from teaching common content to developing individual potential proved fertile for art education, Anita Silvers said. But perhaps because of the critical links of art to its own history, art studies did not retreat from subject-matter content to the extent that other disciplines did. Thus, art studies continue to provide a well-developed pathway to an understanding of other cultures and other times. While students cannot directly encounter events or people from the past, by seeing the same art that their ancestors saw, and being informed by the same narrative and theoretical frameworks, students can look directly at the perceived ideals, visual paradigms, and key images of people and societies in both the present and past.

The art world has a unique kind of history that is "methodologically different from the history of events." It is a world delineated by institutions constructed out of characteristic practices and informed by commonly acknowledged narrative histories and evaluative theories, and mastery of the subject-matter content of art requires the student to participate in the art world's institutions. A corollary of this is that mastering the disciplines of art making, art historical narration, art criticism, and aesthetics is essential for participating in the art world. One cannot understand which teaching strategies promote learning about a work, style, or period without understanding the work, style, or period itself.

Just as methods and content are intertwined in art study, so the mastery of appreciative skills is inseparable from a knowledge of art. With this kind of integration as a starting point, a curriculum could be developed in which challenging cases (1) lead to acquiring a knowledge of art; (2) use skills in interpretation and evaluation; and (3) lead to reflection on the aesthetic concepts and methodologies invoked during these processes. "Such a course could suit both the general education and teacher education curricula, particularly if it were designed and taught collaboratively," said Silvers.

Unable to abandon the concrete, art studies are anchored in immediate perception and for this reason are well suited to children's cognitive abilities. For children as well as adults, the process of unlocking key images can retrieve or recreate crucial cultural principles and can lead to the understanding of abstractions that have informed cultures of the past. In this way, art educators can respond to the reform movement's call for education that recovers and revitalizes tradition and culture.

• • •

Questions and Answers

Q: Dr. Feldman, did you say that most universities' philosophy of art is taught only at the graduate level?

A: [Feldman] In most art education programs, it is found at the graduate level. What is more important is whether it is required for certification.

> ONE CANNOT UNDERSTAND WHICH TEACHING STRATEGIES PROMOTE LEARNING ABOUT A WORK . . . WITHOUT UNDERSTANDING THE WORK.

Q: About your distinction between philosophy of art and aesthetics: you seemed to rely on a "psychology of art" in a Deweyan sense being assimilated to aesthetic theory. Surely that isn't the focal point of what aesthetics has been about for the last decades.

A: [Feldman] I don't believe there's currently a consensus among aestheticians on that.

A: [Silvers] One reason for not distinguishing between philosophy of art and aesthetics is that you include critical judgment within the philosophy of art, but you include the reasons for those conclusions in aesthetics because those reasons involve an appeal to expression, interpretation, and so forth. Maybe there's no true distinction between aesthetics and the philosophy of art.

Q: Most children receive most of their instruction from general classroom teachers. How can the climate for honoring and valuing the arts in general studies be improved?

A: [Cohen] As I mentioned, we must consider infiltrating all these other classes. Get into social science requirements and show them some creative activity. This will appeal to elementary teachers without specialist training. It takes working with people on your campus, serving on committees that can help make decisions.

A: [Silvers] The general education requirement is where the flexibility exists. The course I described is slightly tongue-in-cheek, but it's the kind of thing I do in a heavily enrolled general education course at my university.

A: [Feldman] If you want to introduce aesthetic theory into the training of art teachers, you will have to sell it to them, make it relevant rather than superficial and trendy.

Potential Impact of Recent National Reports On Preservice Art Education

PANELISTS

Martha E. Church
 Hood College

John W. Eadie
 Michigan State University

Susan Adler Kaplan
 High School English Teacher and
 Coordinator, Writing Project, Providence,
 Rhode Island, Public Schools

Victor Rentel
 Ohio State University

MODERATOR

Nancy P. MacGregor
 Ohio State University

A Summary of
Martha E. Church's Address

The key to all the reports, Martha Church said, is that they focus not so much on the number and variety of course offerings as on the development of students' *skills* in writing, speaking, listening, analysis, and inquiry; on understanding numerical data, work, and values; and on gaining some historical perspective. The researchers at the National Institute for Education (NIE) spoke of turning teachers into "coaches" who learn *with* students, rather than talking *at* them. Their report does not advocate process over content but seeks to maintain a delicate balance, as does the Association of American Colleges (AAC) report.

The AAC committee also tackled another unexamined aspect of the curriculum—the overloaded major—and recommended that once students have been exposed to the distinctive modes of inquiry and structure of a particular discipline, there is no need to keep elaborating "horizontally." This point of view has not been popular in academe, but when latitude is sought for introducing new things, pruning is essential.

Church feels that the various curriculum reports have been widely read and are being absorbed. A range of faculty development programs across the country are helping teachers focus on their students' thinking, writing, and analytical skills. Collaborative projects between research universities and liberal arts colleges and between universities and local school systems are being proposed. And many curricular experiments involving interdisciplinary dialogue and interaction among different educational levels are being funded. Teacher preparation is also being taken more seriously now, reflecting a new appreciation of the critical importance of elementary teachers.

Impediments to reform include the fact that in many urban areas, teachers will have difficulty putting into practice what they learn in preservice training. And there is concern that performance assessment at a given level or during a given school year not be limited to testing. But the reports are making it clear that the most important aim of reform is to create classroom environments that are favorable to good practice in both teaching and learning.

DBAE's integrated approach gives it "a better than even chance" of survival in a reconstructed liberal arts program.

A Summary of John W. Eadie's Address

John Eadie noted that the Holmes Report proposes three changes in existing curricula: (1) that all teachers complete a major in the liberal arts and sciences, (2) that undergraduate degrees in education be abolished, and (3) that teacher education be restructured as a graduate degree program. At the same time, it calls for major changes in undergraduate curricula: (1) curriculum should be reshaped so that future teachers can study with instructors who model fine teaching, and (2) undergraduate requirements should allow students to gain a total view of their disciplines, rather than "a series of disjointed, prematurely specialized fragments." Nothing in this conflicts with DBAE's objective of integrating the disciplines of art education, he said, and while the report does not focus on preservice training in this field, many of the questions it raises parallel those raised in recent discussions of DBAE.

Eadie warned that because the debate about DBAE has now shifted from a focus on objectives to a focus on implementation, proponents have entered a new and "unpredictable" political arena. Art departments might be considered natural allies, but to date they have expressed indifference to DBAE. A recent survey indicates, for example, that despite repeated attempts to alter graduation requirements, studio art remains the preeminent component in preservice training, with the other three disciplines playing a secondary role at best. It may be that university departments, observing the indifference of school districts to expanded visual arts programs, respond with like indifference in designing their curricula. In any case, the most serious obstacle to advancement toward DBAE's goals is the lack of *political backing* in the universities.

Competition for resources is increasing. In the present national environment, deans must be persuaded that the courses required for DBAE are intellectually defensible, serve the needs of art education teachers more effectively, and provide attractive opportunities for *all* their students. And clearly, one must "win the hearts and minds" of colleagues in the arts before the university at large can be expected to support a more integrated program.

DBAE's integrated approach gives it "a better than even chance of survival" in a reconstructed liberal arts program, Eadie feels. At some colleges, resources may already exist for reconstruction, while at others a thorough reassessment of objectives may be needed. In either case, successful implementation of DBAE curricula depends in large part on the backing of the college deans and those faculty members to whom they are accountable.

A Summary of
Susan Adler Kaplan's Address

The 1986 Carnegie Forum report, *A Nation Prepared*, was the subject of Susan Kaplan's address, with particular emphasis on the report's eight recommendations. Together, these represent a call for revolutionary changes aimed at turning teaching into "a true profession," said Kaplan.

The recommendations were as follows: (1) creation of a national board for professional teaching standards with power to certify teachers, (2) restructuring schools to give teachers greater freedom of decision and increased accountability, (3) creation of a group of "lead teachers" to provide active leadership in redesigning schools and upholding high standards, (4) requiring a B.A. in arts and sciences as a prerequisite for teacher training, (5) developing a new curriculum for a teaching M.A. that will stress internships and in-school residencies, (6) mobilizing national resources to prepare minority youngsters for teaching careers, (7) relating teacher incentives to schoolwide student performance and enhancing teacher productivity with appropriate technology, services, and staff, (8) making teachers' salaries and career opportunities competitive with those in other professions.

A Nation Prepared holds that if American civilization is to survive, schools must raise average achievement to levels formerly thought possible only for the privileged. The mass-education system must strive to make *quality* compatible with *equal opportunity*.

The Carnegie report has drawn a wide range of responses from supporters, participants, and critics. Nevertheless, with the incorporation of the National Board for Teaching Standards, in May 1987, the first phase of implementation has been accomplished. With this cornerstone in place, the second phase can proceed from raising standards to initiating structural change in schools. These changes will affect both trainers of new teachers and educators beginning to implement DBAE.

In recognition of a shifting world economy, the recommendations are based on the need to produce graduates with a high level of technical accomplishment. "We need to become a nation of people who think for a living," Kaplan said. We need young people who are articulate, imaginative, and confident, able to solve problems and make decisions; and the central message of the Carnegie report is that the excellence we look for in our students must be fostered in our teachers first.

In the areas of quality assessment and certification, increased dialogue between schools and teacher-training programs, and improved preservice and inservice training, the report expresses goals shared by the proponents of DBAE. "The spirit of collaboration, collegiality, and colloquy that this second wave of reform has awakened must remain as powerful as it is today," if the movement is to succeed, Kaplan concluded.

DBAE HAS NOT PROGRESSED BEYOND A GENERAL DESCRIPTION OF THE DISCIPLINARY FOUNDATIONS FOR ART EDUCATION.

A Summary of Victor Rentel's Address

Victor Rentel focused on the Holmes agenda as carried out at three of the ninety-three Holmes consortium's schools: Ohio State University, Michigan State University, and the University of Nebraska at Lincoln. At these and other Midwestern Holmes Group institutions, he said, the dominant issue has been the Holmes reform agenda itself and the threat to teacher education it represents by advocating abolition of the undergraduate education degree. Most plan to develop pilot Holmes programs in elementary or secondary education, but they intend cautiously to assess risks and benefits before proceeding further.

At the University of Nebraska at Lincoln, Rentel said, the B.A. education program will not be discontinued. Instead, an experimental fifth-year internship will be added, along with a five-year elementary education program and a transition program for working professionals. Similarly, while Michigan State University will shift professional training to the graduate level, the university will retain an undergraduate education minor as well as offerings in the general studies curriculum that are expected to contribute to the civic education of all students.

The Ohio State program parallels that of Michigan State University in terms of the types of programs planned and expected outcomes. The differences lie in the nature of faculty and governance committee involvement. Ohio's formal governance mechanism, unlike Michigan State's, reviewed and approved all actions concerning Holmes Group membership; and unlike any midwestern university, Ohio's president was invited to participate in the deliberations. Also unique to Ohio is its plan for a districtwide joint training organization with the Columbus Education Association and Columbus School District, which will mesh preservice education with induction, continuing education, and professional preparation.

Turning to the implications for DBAE, Rentel noted two trends in teacher education reform that will certainly affect this effort: a movement toward enhanced teacher assessment and certification procedures and the imminent expansion of the knowledge base for teaching. He observed that DBAE has not progressed beyond a general description of the disciplinary foundations for art education. Its historical sources of pedagogical knowledge are child development and traditional curriculum analysis, and it has not proceeded to study either the nature of pedagogical knowledge in the visual arts or the reasoning process that teachers use to make knowledge accessible. He warned that the future importance of national board certification requires that this void be addressed.

• • •

Questions and Answers

Q: What percentage of future high school graduates will actually be in jobs that have a thinking rather than material mode of production? The factor that's being left out is the change to a service

economy. Massachusetts has a problem because there aren't enough people to work in fast-food restaurants; these and other jobs may not require the kind of thinking you describe.

A: [Kaplan] I can't answer that with a finite statistic, but what concerns us is developing all students' thinking skills. First we have to make schools places where students want to stay. We have to make the students literate. Given the developing economy, the future will involve more decisionmaking jobs than at present.

Q: How does the task force reconcile the ideals of teacher autonomy with the obvious creation of more bureaucracy?

A: [Kaplan] The aim is not to create a new bureaucracy, but to involve teachers in decisionmaking by creating an atmosphere of collaboration, trust, and communication that does not presently exist.

A: [Rentel] As historians look back on the period from the 1940s through the 1970s, they may observe that schooling in America developed an assembly-line mentality. Teachers became functionaries who carried out preplanned curricula and operated much as assembly-line workers do, with curriculum supervisors occupying middle-management positions designed to enforce instructional homogeneity. Now there is a realization that teaching does involve a great deal of intellectual activity. Those middle-management

supervisors will be retiring soon, and we're going to start replacing that assembly-line mentality with a very different one. Those managers are better paid than teachers, by and large, so there's a substantial chunk of money sitting in schools at a middle-management level that, if it can be redirected to teaching, can offer an incentive for talented people to consider teaching again as a career.

A: [Kaplan] Teachers may also gain a sense of *empowerment*, a true sense of being professionals.

A: [Church] Most liberal arts colleges do reward good teaching, but often at the expense of keeping teachers active in their professions. There are some hopeful signs where collaboration is emerging—Cornell is one, where freshman math courses were typically pushed off onto teaching assistants. Transformation in the rewards system is changing attitudes. Some of the teaching assistants are becoming excited by the prospect of teaching in a liberal arts college; senior faculty are saying, "Maybe it's to our advantage to teach freshmen." MIT is saying, "Maybe we have to give the curriculum a more humane side and not put out human slide rules." The reports focusing on undergraduate education have not gone unread. At meetings of the American Council on Education, presidents and deans are embarrassed by the criticism regarding quality of teaching, particularly in research institutions. Mr. Bennett

lays it on us every other day how bad we're doing, saying that we're greedy, and I think that kind of criticism is beginning to get through. Faculty development at large universities indicates they do value teaching. It's not going to change overnight, but I think you can see hopeful signs that teaching will be more highly valued at research universities, while a little research to keep up with your profession will be more encouraged at liberal arts colleges.

A: [Eadie] Faculty have a right to complain concerning the reward system, for administrators have been generally indifferent to quite legitimate complaints. But one of the most difficult problems anyone has is the assessment of teaching, particularly in higher education, where everyone is granted peer status. There is resistance from the faculty to any such suggestions. We are going to have to design some means of reaching an agreement on what good teaching is and on the methods of assessment.

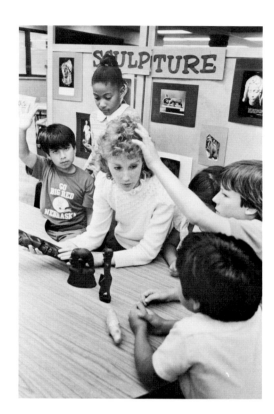

Significance of Recent National Reports
For Preservice Discipline-Based Art Education

SPEAKER

Maurice J. Sevigny
 University of Texas at Austin

A Summary of
Maurice J. Sevigny's Address

The challenge of the current wave of reports is to translate reform theory into goals for educating teachers, said Maurice Sevigny. DBAE needs a variety of "instructional legs" to get its theoretical premises into classrooms. He is convinced that a substantive new curriculum cannot be implemented simply by increasing the preservice requirements in the four disciplines of art. Preservice and inservice teachers must be offered choices, rather than control, if they are to act as models for their students.

Further, teacher educators can no longer ignore the socialization process for beginning teachers, so many of whom quickly abandon what they have been taught when they find such methods do not work in less-than-ideal situations or that the methods are too theoretical for what they confront in the schools. More often than not, efforts to improve higher education programs and efforts to improve school curriculum proceed with little mutual awareness.

Current recommendations for reform center on three major issues: (1) the desire to improve the professional image of teachers, (2) the need to increase liberal arts training, and (3) the need to reduce and restructure the sequence and content of professional education courses. Unfortunately, the reports tend to focus on short-comings and provide, at best, only a skeletal framework for program redesign.

The Holmes Group offers one of the most comprehensive diagnoses of the drawbacks of current approaches, but the proposed new strategy, in assuming that institutions outside the group would focus only on entry-level teaching roles, may limit different types of institutions to specific missions. Further, the plan to extend program requirements for art teachers will make art education less attractive as a profession unless increased costs are offset by added benefits.

Sevigny pointed to a strategy developed for the American Association of Colleges for Teacher Education's Task Force, which he feels could be adapted to teaching DBAE skills. This approach uses "protocol materials," actual recorded classroom situations and episodes or simulated reproduction of teaching events that have occurred in an educational context, based on the premise that the most efficient means to develop teaching skills is to provide drill and practice for the application of teaching theory to actual situations.

Since 1971, Sevigny has adopted and extended Asahel Woodruff's four-step sequence, which suggests that teacher educators: (1) identify a set of student goals, (2) determine from behavioral research the conditions essential for changing student behavior toward these goals, (3) determine which skills teachers must have in order to set up and maintain those conditions, and

(4) determine how those skills can be developed in teachers.

Many reform reports are demanding increased accountability, through the testing of teaching competency and effectiveness, said Sevigny. As one report reminds its readers, the real test of any educational reform movement is the extent to which the changes make it easier to accomplish the basic responsibilities of a discipline of study.

The real "preservice challenge," he concluded, is to determine what reform is *attainable* for art education. Most of the desired changes, he advised, will be at times experimental and partial; they will vary from place to place and never be as neat or as logical as the initiators of DBAE might wish. "Nonetheless, let us be refreshed by the current splash toward change that could inspire us to build the vehicles to carry our students to new educational crests."

• • •

Questions and Answers

Q: I think that whether new knowledge can be related to the personal background and daily lives of students depends on the subject matter. With certain subject matter you want to tell students, "This has nothing to do with your personal life or your background or anything else about you up to this point. You should love it in and of itself because of what it is." We want to shake them out of that individual chauvinism that insists that unless a subject has

something to do with them personally, it isn't worthwhile.

A: [Sevigny] I also examined industrial psychology to see what makes people want to perform tasks. The research shows that one shortcoming has been our failure to establish either relevance or accountability for what we're teaching. Many teachers think that if they share their objectives, the students may attain them too early. I think this is a problem. Students need to know why we are doing certain things, particularly when they expect, from tradition and history, that they're going to be doing studio process only. They may get impatient when time is taken from studio for new materials. We, as teachers, need to establish relevancy and not just assume that because we're authorities that our students are going to listen to what we have to say.

Q: But it's important to teach things other than those that affect your own life. Why do you teach Locke's Theory of Complex Ideas? It's part of an intellectual subject matter that is worthwhile in its own right.

A: [Sevigny] You have misread this recommendation if you think it is saying that every single word that comes out of a teacher's mouth must be justified as relevant to students' personal lives. The writers I've alluded to are speaking in larger terms, of what one does when one initiates a course and then, periodically, when

one revises in units within that course. The aim is that students understand a particular event as part of a larger picture, a larger goal for the course overall.

The Uniqueness and Overlap Among Art Production, Art History, Art Criticism, and Aesthetics

PANELISTS

Margaret Battin
 University of Utah

David Ebitz
 J. Paul Getty Museum

Joseph Goldyne
 Artist, San Francisco

Franz Schulze
 Lake Forest College

MODERATOR

Stanley Madeja
 Northern Illinois University

A Summary of Margaret Battin's Address

Margaret Battin's discussion focused on the relationship among the four DBAE disciplines. She stressed that although they appear to overlap, they are distinctly separate approaches; and although they are often considered to be equal, aesthetics is in fact a "parasitic" discipline with respect to other three areas of study.

Battin noted that on the surface it would seem that artists, art historians, art critics, and aestheticians often disagree. However, there is no inherent disagreement among the four disciplines, because each one's approach to art is so different from the others: art history relies on facts; criticism is based on the making of value judgments; art-making is the practical application of certain techniques to achieve an effect; and aesthetics points out the strengths and weaknesses of the foundations on which the other three disciplines rest. Each is thus unique, and each makes a particular contribution to the study of art.

According to Battin, even though the four disciplines themselves do not overlap, no individual in one discipline can exclude himself from the others. And it is in these "areas of overlap" where provocative discourse occurs among people with varied and properly trained backgrounds. However, it must be understood that the disciplines are actually "radically different" from one another.

In her conclusion Battin observed that if the four disciplines are so completely different that they can't even disagree with each other, then the assumption that they should be treated as equal elements of a discipline-based program of art education is weakened. She described aesthetics as "metatheoretical": it is not an independent area of study; it relies on what the artist, art historian, and art critic say about art. Indeed, aesthetics is always taught in conjunction with other disciplines. It cannot be a separate course of study, and it cannot be deleted from the curriculum. It should be considered a way of "scrutinizing, testing, challenging" what the other three say and do in art. And although it may be easier for adults to acknowledge the inclusion of aesthetics among the disciplines in DBAE, the actual reason that it is included is for the intellectual development of children.

A Summary of David Ebitz's Address
David Ebitz's remarks addressed the
idea that increasing specialization has
compartmentalized the manner in which
knowledge of art history is acquired.
Although this specialization has lent
prestige to the study of art history and
has perhaps made it more demanding
intellectually, Ebitz admitted that his
generation of art historians has had little or
no experience in art-making or in the more
subjective areas of aesthetics and criticism.

Specialization has created a gulf
between intellectual knowledge and direct
emotional experience. The art historian has
become too dependent on the text as the
primary source for understanding and
knowledge of art; current modes of
learning stress the "content of knowledge"
rather than the "practice of inquiry."
Understanding of the iconography of works
of art is achieved through an examination
of reproductions, and the social, political,
economic, and religious contexts of a work
of art are learned through the analysis of
existing texts. Ebitz suggested that what is
needed is a new way of studying art
history, in which different "frames of
reference" would be used; art would be
examined not only through reproduction
and existing texts, but through a direct
relationship with the object itself. This
mode of inquiry would enhance not only
the study of art history but of the other
three disciplines as well.

Ebitz then discussed the division of
art historians into three groups of
"subspecialists": (l) the connoisseur, who
focuses on the art object and is interested
in the circumstances of its creation and its
formal characteristics; (2) the biographer
and social historian, who focus on the artist
and the context of production; and (3)
those who examine changing perceptions
of the artist and art object through such
frames of reference as structural analysis,
semiotics, phenomenology, and political
and feminist theory. This specialization
within the study of art history has
weakened the discipline as a whole. Very
few art historians today have the training to
embrace more than one approach to their
field, so it is no surprise that they lack the
ability to understand the full range and
complexity of the other three disciplines.

Recently, the discipline of art history
seems to be undergoing a period of self-
examination and may be entering a period
of renewal. Art historians have addressed
historical methodology in books and
articles. And anthropologists, Marxists, and
feminists suggest that our perception of art
and art history has been limited by a
Western, male-dominated point of view.
Ebitz expressed his hope that art history's
self-examination will improve its relation-
ship with the other three disciplines as well
as help develop models for teaching by art
educators in classrooms and museums. He
reiterated the tremendous need for com-
munication among all the disciplines in art
and stressed his belief that if art history is
to be concerned with art of the past, it must
become involved with the practice,
criticism, and understanding of art. Finally,
Ebitz said that he felt the process of inquiry

would be the most effective method of teaching art history, because it would involve students as active participants in the learning process itself.

A Summary of
Joseph Goldyne's Address

An artist himself, Joseph Goldyne centered his remarks around the role of the artist in DBAE and stressed the necessity for a curriculum in which the interests and strengths of the artist are emphasized. Such a curriculum would lean toward connoisseurship, which in turn would depend on the disciplines included in DBAE.

Goldyne urged that practitioners of all four disciplines recognize the interdependence among them. Although art historians, critics, and theorists rely on intellectual knowledge while artists tend to respond emotionally to what is visually exciting and what can be created with their hands, the lines separating the disciplines cannot be so clearly drawn. For example, artists' aesthetic and critical attitudes, as well as their knowledge of art history, will influence their own work. Likewise, Goldyne believes that the best art historians must also be connoisseurs.

As for DBAE, a curriculum that included connoisseurship would not only convey the combined knowledge of all the disciplines, but would allow students to become personally acquainted with a work of art. The connoisseur, often considered to be academically weak and intellectually shallow, nevertheless is able to maintain a more direct relationship with a work of art, and the knowledge he gains through that relationship will be of significance to the other disciplines.

Goldyne stressed the importance of children's participation in DBAE, as well as their involvement with art through such activities as museum visits and art-making. He advised that an artist's interests are best represented in a curriculum that stresses connoisseurship. To that end, he suggested that (1) teaching should rely on originals, at museums, from local artists, or from talented students, (2) teachers should refer to examples not just from texts but from other sources that reveal the beauty of art, (3) children should meet artists and learn that art is a profession like others, and (4) teachers should stress art-making as well as art history.

Finally, Goldyne stressed that DBAE's effectiveness will depend on the teachers and the curriculum. Without effective teachers and a sound curriculum, DBAE will produce students unprepared for dealing with art.

A Summary of Franz Schulze's Address

Franz Schulze commented on the position of the educator with respect to artists, critics, and art historians and stressed that the educator must establish his own criteria in considering the merits of art or artists.

He noted that viewpoints and opinions in the arts are constantly changing and shifting. Artists change as their careers are divided into periods, critics take up different critical stances, art historians at various times may alter their criteria and favor different artists or styles.

His point was that there are no absolutes in an era of uncertainty. Absolutes that in other times were established givens have been lost to a "relativistic understanding" of the world. The heady pronouncements of previous artistic movements seem childishly simplistic to us now.

Schulze noted that the critic, like the artist, has played a significant role in the movement of art from certainty to "laissez-faire pluralism." Just as critics' opinions are informed by artists and their work, they also can have an influence on those artists. And art historians may deride an artist's work at a particular time and praise that same work later.

Schulze believes that in the midst of changing currents in art, it is the educator's responsibility to develop his own independent viewpoint and opinions. Art is fluid, and what is embraced now may be spurned later. Schulze suggested that the educator learn not simply to accept and act on another's judgment, evaluation, or criticism

and to insist on clarity if the other's pronouncements are given in prose that is wordy or incomprehensible.

Finally, he suggested that if a teacher prefers absolutes, he should produce his own. But he must be careful to consider the opinions, viewpoints, and ideas of those who disagree with his pronouncements. To this end, he must be knowledgeable and professional in all that he says and does.

• • •

Questions and Answers

Q: One thing that did not come out of your papers was the traditional role of developing the arts skills—drawing or making a pot or doing what traditionally artists have done and what has been taught in colleges, universities, and schools.

A: [Goldyne] Of course, I believe that skills are essential, but I know that artists are by nature introverts in a certain way about what they're doing when they do it. So I haven't come to any feeling about what part skills should have in DBAE. I was relegating the teaching of skills to a specific art-oriented school. I was stressing general education, connoisseurship—which I think DBAE, properly integrated, would accomplish.

A: [Ebitz] What the other three disciplines offer to studio art is options. Rather than have a required course in art history and art criticism for studio students, I think a better model would be to provide options, to educate undergraduates earlier that there are

other artists in this world that have tackled problems like the one they are working on—technical problems or problems of subject matter or narrative. You can show students in the classroom that these other artists exist, tell them how to find the artists, take them to museums to alleviate the feeling of discomfort of going into museums. You'll open up much more than they can possibly have if they tackle the problems of studio production solely from the point of view of studio production.

That is also a relevant issue to criticism. Many critiques go on in studio classes, but there are several effective ways of criticizing of which studio faculty might not be aware. Aesthetics offers a larger frame of reference for studio production, to consider the questions of the status and nature of art generally. Even kids by the time they're in high school—and certainly college students—must be wondering what they're engaged in. The aesthetician in college and the high school teacher are ready to tackle some of these larger issues.

A: [Schulze] As we endeavor to create this ideal creature—the cultivated, aesthetically sensitive human being—we should realize that it can be done through many different roads. To become a connoisseur or an art historian, it is not necessary to have drawn or painted. Some students profit from drawing; some gain nothing and

don't necessarily become better or worse art historians as a consequence. It depends very much on the particular situation, the teacher involved, and the individual student.

A: [Battin] The other disciplines serve very nicely as "fodder" for aesthetics. When I say that aesthetics is a parasitic discipline, I don't mean that negatively; I see aesthetics as a kind of constructive parasite that sets up a symbiosis in which everyone in the arrangement is enhanced.

Regarding the different aptitudes that individual students have, I think we understand this better with respect to other disciplines, particularly art production, than with respect to aesthetics. You mentioned the kid who draws a lot in school. Every scrap of paper he's exposed to has little wonderful things on it. We recognize that this kid has some special kind of concern and interest, and as we inspect the drawing during his development, we begin to notice what we call talent or special skill. Now, if we look around at kids generally, we also notice that some develop critical talents better than others. In an unkind characterization, they are the ones who find something wrong with everything they confront. They carp, they criticize, they pick things apart. We begin to see that as their natural cast of mind. We also notice that some people are more adept at historical kinds of enterprises. For them a sense of continuity, a long view,

a capacity to absorb a very broad range of material is somehow native. Is there some kind of special capacity or talent that is characteristic of people who are destined to work in aesthetics? The answer is yes, but because we don't understand aesthetics very well, we often overlook this.

What is that capacity? I think it is best identified as a capacity for probing and poking, for pushing at something even when it seems that there is already a good answer. Unlike criticism, it's not a matter of asserting that something is amiss or something else is particularly excellent. It is a way of asking that apparently answerless question that can be so annoying to parents and teachers. We have to recognize that different people have different capacities for this. For some, it is nearly impossible. Some people's minds are simply more orderly and more attuned to a kind of right-answer scenario than this enterprise tolerates.

Q: Peggy, it is difficult to figure out how representatives from the four disciplines cannot but disagree. For instance, the fact-value distinction probably isn't the best way to distinguish between historians and critics. There is something more that historians and critics do: they interpret. Interpretive statements are sloppy. They're not factual claims per se, and value assumptions play an important

role in them. Can you suggest a way to deal with that?

A: [Battin] I have given an extremely purist picture. I don't think anyone actually operates this way. I am a little nervous, though, when the historian gives an interpretation. If I'm interested in what has led up to a certain period, it may be that I am always limited to a view that is the product of a great deal of interpretation; but it seems to me that what I aim for is a view that is as innocent of the incursions of interpretation as I can get it to be. This may be theoretically possible while impossible in practice, but I don't think we want to give up the notion too readily.

A: [Schulze] I don't think we do either. But we must admit that we are always looking through a glass darkly. You're saying that we should strive for objectivity, and I say, yes, we should—but keep in mind how exceedingly difficult that is to achieve. The question is how do we determine what is an important phenomenon?

A: [Goldyne] You cannot impose on young people the kind of strict, formal processes that we are talking about here. I've concluded that history is gossip in perpetuity. You remember things about Vasari not because he was the first art historian but because of the neat little tidbits that he told you about what so-and-so was doing. The great writers are the people that can inspire one in that way. I personally think younger people need an interpretative

rather than a purist approach.

Comment [from the floor]: I don't think the ideal of separation of fact and value is even desirable. There's a danger of confusing means with ends if you reduce art history to a collection of facts. Art history is more a creative attempt to find meaning in art of the past through a particular mode of inquiry.

A: [Ebitz] In a general sense, the purpose of art history, like criticism and studio, is to participate, and I assume the same is true for aesthetic inquiry. Engagement is the extraordinary thing, and that's what we want to happen in our college classrooms.

Q: Franz, you characterized what we're seeking as an "informed pluralism." You talked about three levels of taxonomy: first, enjoying; second, requesting proof; and third, reflecting on one's own bias and interest. One can achieve the first level without instruction, and we mean to go further than that. The third level is more complicated and may be more of an end state. Would you elaborate on the middle level of requiring proof?

A: [Schulze] I suppose the answer rests on that third level. If you don't know what you're talking about, if you don't know the art world at all, and someone comes along with fancy words, you are not in an enlightened position to demand proof. You see this in big-city art worlds, where people are striving to

become collectors; they ache to become part of the art world. They sit at the feet of people who toss big words around, and they eat those words up. To demand proof you have to have some kind of knowledge, but you can begin at least by saying, "Look, I didn't understand what you said. Say it again, please, in words I can understand."

A: [Goldyne] One can't help drawing on one's own experience. I do that continually. But not everyone is going to have the skills of an artist or the articulation of a historian or an aesthetician. Still, the more a teacher knows about these things, the more he can orient his teaching to his strengths. Just as medicine has come back to the general practitioner, so DBAE depends on the informed teacher— someone has to look at the big picture. Einstein's quote is true for all of these disciplines: "If I've accomplished anything, it's because I've stood on the shoulders of giants." There's a lot of art today that is derived from the past. Some of it will be judged derivative; some of it will be thought of as having sprung from the shoulders of giants. The same is true in art history, aesthetics, and criticism. So I would argue for a generalist teacher who is as excellently prepared as possible in whatever his or her strengths happen to be.

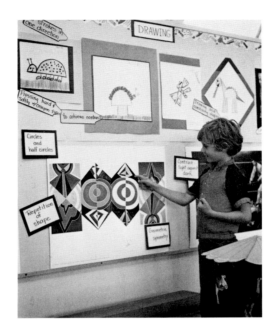

History of the University Curriculum

SPEAKER

Lewis B. Mayhew
Stanford University

A Summary of
Lewis B. Mayhew's Address

Perhaps the single most significant development in curriculum history, said Lewis Mayhew, was the medieval conception of the university as a place in which a life of study is pursued through interactions between student and professor, student and student, and professor and professor. The concept was refined through the development of a formal curriculum, taught by a trained, organized faculty, with institutional self-governance allowing the freedom to grow and change as times changed.

The colonial American college was a transplant of the English college, itself a permutation of the medieval university, but with governance by a lay board of trustees. The laymen ran colonial colleges in much the same way as they ran Calvinist churches, and by the end of the Revolutionary War a strictly prescribed curriculum was discouraging large numbers of students, who saw scant value in what was being taught. In response, the collegiate experience gradually embraced new elements that would eventually lead to an entirely new curriculum. These included student libraries, the organization of professors into departments, the bootlegging of more pragmatic subjects in evening lectures, and experimentation with new teaching styles. Between 1870 and 1910, changes took place that gave root to American higher education as we know it today. These included the replacement of the prescribed curriculum by the free elective system; the introduction of education and other applied programs as courses of study at new land-grant colleges; and the creation of new institutions and the expansion of old ones to offer education in whichever subjects students or professors wanted. This period also saw the introduction of the Ph.D., which has remained the most respected academic degree in the country, if not in the world.

In addition, regional associations, formed to facilitate cooperation between colleges and high schools, quickly developed minimum standards of quality for the institutions, and thus voluntary accreditation was created in pretty much the form it takes today. Similarly, standardized admissions tests were developed to determine a high school student's ability to do college work. Finally, it was during this period that self-governance was restored to institutions of higher learning, through the assertion by academic departments of the controlling voice over curriculum and faculty selection.

After 1910, the next great period of innovation and expansion was after World War II, aided by the Veterans Bill, the high postwar birth rates, a sustained period of affluence, the stimulus to higher education that came from war-related research, and the ability of higher education to respond to new needs. The most successful inno-

vation was the increased use of off-campus experiences such as cooperative work-study, overseas campuses, and internships.

In the 1970s, nontraditional education emerged, which made extensive use of part-time faculty, emphasized self-study programs and convenient physical accommodations, and tended to assign academic credit for nonacademic life experiences. By the end of the decade the popularity of this approach was in decline, but nontraditional students are likely the reason that the enrollment declines expected for the 1980s did not materialize, Mayhew said.

Two more recent curricular develop-ments of particular relevance to DBAE are the "evolution" of a group of curricular theorists who believe that their theories can bring order to the undergraduate curriculum, and the many critiques of undergraduate curricula that have appeared over the past six or seven years. The problem with these reports, said Mayhew, is that the ideals that they promote cannot possibly be achieved in the contemporary college or university.

Still, it is his belief that curricular discussion is valuable because it allows people to air their views on topics they consider to be of utmost importance. Out of these prolonged discussions, change gradually emerges and becomes real.

• • •

Questions and Answers
Q: What is the role of the fine arts in the future evolution of the university curriculum?

A: [Mayhew] In the undergraduate curriculum and in the admission process, the arts, as you know, have not fared very well. Most of the standard admission tests, if they do anything with respect to the arts, are probably limited to art history. Aesthetics never comes up. Gradually, I think the arts have been accepted into the under-graduate curriculum, and I'm beginning to see an interest around the country in ensuring that students do have an opportunity for some reasonably intensive aesthetic experience in some form of the arts. I'm not sure how far that's going to go, but the opportunities now are considerably better than they were in the 1960s.

Q: Do you have tactical advice to ensure that progress is made?
A: [Mayhew] The techniques and skills of academic politics represent, I think, the best hope. Forming alliances, operating as close to the centers of financial and appointing power as possible—these things are essential. You can't assume that rationality is going to make your case, but politics will. I created a department of educational admin-istration where nobody thought we could, and it has lasted for fifteen years; but the basic techniques were those of a shanty Irish politician.

Q: Now that we're in a technical mode that makes it possible to spread the library concept (in a broader sense), is there any advice you might offer?

THE OPPORTUNITIES NOW ARE CONSIDERABLY BETTER THAN THEY WERE IN THE 1960s.

A: [Mayhew] There have been many recommendations to bring the library into a more central position in the whole curricular complex. There was a movement some years ago, the library college, that envisioned people occupying library physical space for both pedagogical and reference purposes. Some of the techniques for making library resources more easily available, such as networking, are steps in the right direction, but probably, even in small institutions, the emergence of the library as a central educational effort is an idea whose time isn't here yet.

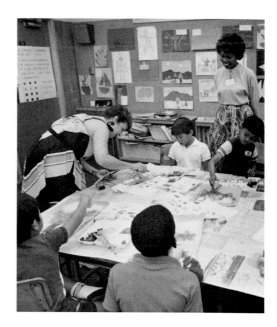

Cluster colleges (about which there seems to have been a lot of nonsense written) had the idea that through having their own classrooms and faculties, through learning and living together, the curriculum could come to life. Most of these efforts didn't live up to expectations. It's an interesting idea, and those few students who take to a kind of womblike intellectual atmosphere seem to love it. But it's not everyone's cup of tea. I seem to end up as a die-hard conservative who believes that we haven't yet found a better way to educate than to have a group of people in some sort of an organization interacting in some sort of scheduled, regular way with somebody who knows something about the subject.

Problems and Issues in Teacher Credentialing

PANELISTS

Thomas Ferreira
 California State University, Long Beach
Stephen Kaagan
 Vermont Department of Education
Richard C. Kunkel
 National Council of Accreditation of
 Teacher Education
Clyde McGeary
 Division of Arts and Sciences,
 Pennsylvania Department of Education
MODERATOR

Mary Ann Stankiewicz
 University of Maine

A Summary of
Thomas Ferreira's Address

Thomas Ferreira, who spoke on several of the more "pragmatic" issues concerning the implementation of DBAE, focused on questions or problems involved in accreditation.

He noted that educational reform takes time because of the conservatism of higher education and the number of agencies and constituencies that have to be involved. Although it seems that these groups hinder progress, they also ensure fiscal responsibility, uphold academic standards, and demand adherence to legal mandates.

One of these agencies is the National Association of Schools of Art and Design (NASAD), the only accrediting agency in art and design recognized by the Council on Postsecondary Accreditation and the United States Department of Education. It is NASAD, said Ferreira, that anyone

thinking of curricular reform needs to be aware of, as the agency considers the "quality and *quantity*" of studio instruction in degree-granting programs in art and art education.

He noted that schools that neither have nor seek NASAD accreditation should be aware of what the agency offers for two reasons. First, as the only accrediting agency for art and design, it has more power than the member institutions, federal agencies, foundations, and some state agencies. Second, NASAD's insistence on quality and *quantity* of studio instruction in art degree programs reflects the uniform opinion and interests of many studio faculty.

Ferreira next discussed the standards for undergraduate degrees in art education that are given in the *NASAD Handbook*. He cited various pages and paragraphs that indicate emphasis on studio instruction, which better prepares art teachers. But he also noted that competence in the disciplines of art history, aesthetics, and criticism is also necessary and even desired in some cases. The handbook also lists the personal qualities a prospective teacher should have, teaching competencies, and guidelines for art education programs, all of which reflect the standards of other art education groups.

He then considered the implications of standards for accrediting. The emphasis on studio art or performance art in a student's program of study is largely at the insistence of a group of studio artists and performing artists among university faculty. Thus, any effort to implement DBAE should be

approved by studio faculty. The second implication, said Ferreira, concerns overlapping of or conflict over demands or standards established by other accrediting groups.

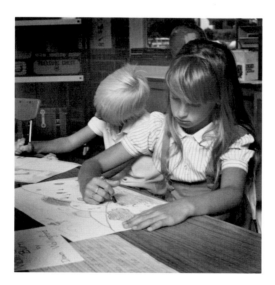

A Summary of Stephen Kaagan's Address

Stephen Kaagan spoke on the politics of credentialing and "commitments inherent in a fiduciary responsibility" to children. According to Kaagan, three assumptions related to the idea of commitment are (1) that art education is essential to the development of a child, (2) that it should be recognized that "one in four of today's preschoolers is poor [and] one in nine is living in a household with income at less than half the poverty level," and (3) that cognitive and effective development for children and adolescents should be required in training programs and schools.

Kaagan said that educators supporting DBAE can be a "core" of support at their respective universities to help work with those responsible for the areas mentioned in his assumptions. He noted the potential of DBAE insofar as it forces schools to confront their weaknesses in curriculum and pedagogy. Also, DBAE can prove valuable for "nonmainstream" students, the ones he mentioned in his second assumption.

Kaagan then directed his attention toward the political nature of credentialing. He noted three aspects in credentialing that are "up for grabs" and thus advantageous to DBAE. First of all, most credentialing systems depend on "a matrix, a categorization" of various people who get different licenses. Every state, he noted, operates under a "matrix" and establishes categories for licensure or certification. This matrix is not so firmly established, as indicated by

the intervention of Holmes, Carnegie, and other groups.

The second aspect that is on tenuous ground involves the university's responsibility for credentialing. Kaagan also thinks there are questions about preservice education—whether or not universities play a prominent role in training and preparing teachers. He believes the university should be more involved in reform in elementary and secondary education. A third precarious aspect is assessment, which Kaagan explained as referring to the establishment and application of criteria against which a teacher's qualifications are measured.

In his conclusion, Kaagan directed his comments to proponents of DBAE. A matrix should be determined for the training of an art specialist across the board in K-12. What is also needed are credentialed art teachers who are familiar with child and adolescent development. Noting the work of the Holmes Group, Kaagan said that postbaccalaureate work should be part of the preparation of the teacher, and national certification should be given to such a teacher. Because multiple-choice tests are inadequate for art, DBAE must become active in the development of new forms of assessment growing out of the Carnegie work. DBAE can be a reality, said Kaagan, if other and different kinds of assessment are used.

A Summary of
Richard C. Kunkel's Address

Richard Kunkel defined four processes often confused with each other: accreditation, certification, licensure, and program approval. Accreditation refers to national recognition of a teacher education program that meets certain standards. Certification involves the professional recognition of a person who satisfies the qualifications established by a nongovernmental agency or association. Licensure is the granting of permission to work by a state government agency to a teacher who has met certain state qualifications. Program approval refers to a state's recognition of a teacher education program if it meets the state's standards.

Kunkel then discussed the role of accreditation in credentialing, including comments on national accreditation from an art education point of view. He explained that NCATE, the National Council for Accreditation of Teacher Education, is a specialized accrediting agency that accredits universities and colleges that prepare teachers for the schools. Recognized by the Council on Postsecondary Accreditation (COPA) and the Department of Education, NCATE accredits 552 schools in addition to undergraduate and graduate programs of study. NCATE also serves as an accrediting agency for school personnel.

NCATE is divided into four constituencies: teacher educators, teachers, state and local policy developers, and national organizations of professional specialty groups.

DBAE MUST BECOME ACTIVE IN THE DEVELOPMENT OF NEW FORMS OF ASSESSMENT.

Educators interested in DBAE belong in the last group; however, art and music are not among the subjects included.

The content specialty organizations within NCATE, Kunkel said, have certain responsibilities in the granting of national accreditation. Once their standards for teacher preparation are accepted, four actions must be taken: (1) each institution must prepare a folio for NCATE that shows how its program is comparable with national standards, (2) the folio must be examined by the national specialty organization, (3) the institution may respond to the organization's comments by changing or defending its position, and (4) the Board of Examiners of NCATE then visits the institution.

Content specialists must also fulfill administrative roles with NCATE. They must serve on governance boards; they must help select as well as serve as members of the Board of Examiners; they should work within their specialty groups to develop national standards.

In conclusion, Kunkel said that in the last three years NCATE has revised standards that include extensive training for and development of site visitors. The maintenance of programs of study is a shared responsibility.

A Summary of Clyde McGeary's Address

Clyde McGeary began by refuting an aspect of Victor Rentel's address. Rentel had said that state departments of education would give little support to establishing national certification standards or changing teacher certification. McGeary insisted that although the relationship between the process of teacher certification and the standards set by individual states is complex, states are more helpful than Rentel suggested. And until significant changes occur to alleviate the problems, all one can do is study and understand the system as it presently exists.

To that end, McGeary suggested that people involved in preservice programs should become familiar with the manual of the National Association of State Directors of Teacher Education and Certification (NASDTEC). The standards and procedures outlined in this publication, which explains licensing and certification in each state, are consistent with NCATE programs. Licensing or certification of teachers according to governmental standards, said McGeary, benefits the public.

Problems arise when interstate licensing and certification is sought. This "reciprocity" is a serious matter, said McGeary, implying that teachers moving to another state should make sure their training and certification are recognized there.

McGeary referred to an emergency certification that permits a teacher without the necessary requirements for full certification—but with the necessary skills and knowledge—to teach, generally on a

temporary basis. There are also intern programs, through which individuals who change careers can become certified. Preservice people can benefit from this program, too; it allows them to teach while they study.

With regard to certification, state departments of education note four concerns: (1) teacher mobility, (2) the quality of intrastate as well as interstate preservice programs, (3) community needs (along with those of minority students and foreign-speaking students) ignored by preservice programs, and (4) teachers assigned to teach outside their area of certification.

McGeary discussed Pennsylvania's certification standards, including: (1) requirements for studying in the four disciplines,(2) "balanced offerings" of subjects such as arts and humanities, heritage, and human development, (3) studies of growth of learners, (4) pre-student teaching experiences, (5) the study of professional and ethical expectations, and (6) experience in classroom management, curriculum, and safety and health hazards.

The preservice standards in Pennsylvania are consistent with DBAE, McGeary said. And this has led to efforts in various areas, including, among others, developing a comprehensive plan for art education; symposia on DBAE and preservice and inservice; working with music educators on a program similar to DBAE; and DBAE workshops and Professional Art Educators Association

(PAEA) conferences.

Finally, McGeary stressed that efforts to improve the quality of preservice education in DBAE must demonstrate an appreciation of the complexity of the issues involved.

• • •

Questions and Answers

Q: This morning, Professor Mayhew emphasized the importance of politics in actualizing curriculum reforms in higher education, and each of you has alluded to the political dimension of teacher credentialing. How do you suggest improving our political skills in negotiating certification when we face conflicting recommendations and requirements?

A: [Kunkel] The answer to that is, do you want a giant effort of coalition building or do you want a giant effort of separatism and elitism? Some of you are identified with the Holmes Group, which has an elitist view of the topic. The whole field of professional education is broader than that. There are very good, small private schools that don't take on the research agenda of the Holmes Group. You have to take a posture on whether it's better to build coalitions with the whole or to gather together with people of like mind and like institutions.

A: [Ferreira] We have to make very clear to ourselves what we believe in, and then ask how best to implement this. We all have a kind of arrogance that comes when we know we're right. We should

BECAUSE WE LIVE
IN A DEMOCRATIC
ENVIRONMENT,
EFFECTIVENESS HAS TO
DO WITH COALITIONS
AND ALLIANCES.

recognize that frequently it's counter-productive to exhibit that arrogance.

Some people have indicated that not only is this conference the first time they have had real discussions with people from other institutions, but even on their own campuses they have occupied a separate world. When that happens, we develop stereotypes of each other, with a greater likelihood for antagonistic relationships. One doesn't have to agree with the National Association of Schools of Art and Design. But because, as a studio-oriented person (like the majority of the faculty), I lean toward those beliefs, an art educator at my institution can't ignore my position. Any changes that he or she wants to implement have to be concerned with realities like this.

A: [Kaagan] Rich is absolutely right that the issue is coalitions and alliances and with whom you want to cast your fate. Because we live in a democratic environment, effectiveness has to do with coalitions and alliances.

A: [McGeary] Our first role is to clean up our act at home. This symposium is one of the first times that some college staffs have met together to discuss these issues. That's got to improve. In order to build a basis from which you can move politically, the dumb thing to do, in my opinion, is to strike out as an individual or to strike out in ignorance.

From a practical, nitty-gritty point of view, the sources that one can tap for financial and program support at a state level are incredible. If one demonstrates

concern for the problems that program managers at the state level are struggling with, these administrators are eager to cooperate and to help provide resources.

Q: Richard, even though the National Art Education Association is not a member of your organization, would their teacher preparation standards be included as a part of your criteria?

A: [Kunkel] Right now they are in a "compliance criterion," which is a category smaller than the standard. There's a compliance criterion that all programs offered have to meet in order to indicate that they're conscious of what standards exist. But there's no system for gathering data, showing them to you, having you critique them, and carrying them in. I believe that the states are going to move to assessment, and program review will move increasingly to a national level.

Q: Mr. Kunkel, do you believe that substantial progress could be made without Holmes and others with large alliances?

A: [Kunkel] I'm glad you called me on that. You've got to be careful with blanket expressions like "go with Holmes" because it might mean you believe in a fifth-year program; it might mean you believe in multipurpose institutions with research missions; or it might mean you think the Holmes Group ought to be an accrediting body. Much of the leadership in Holmes is

the leadership in NCATE. I don't see Holmes replacing our business. What I see is that, if they really believe in their standards, their leadership will deliver those standards into our system.

Q: There's been a concern expressed that the proponents of DBAE might try to cut the amount of studio requirements. Tom and Clyde, could you address the role of studio in DBAE and the credentialing, licensing, or accreditation agencies?

A: [Ferreira] Most of us in higher education solve the problem of something new students should know by making a new course. Then, we have various accrediting associations that are saying, "You've got to include this, you've got to include that." The trouble is, we are running out of the ability to add new courses. I suggest we look at existing courses to see if DBAE material can't be incorporated into existing courses over time, rather than through a new course. For example, if students don't seem strong enough in drawing, there might be a way to spread drawing over the entire curriculum. Maybe it could even be done by cutting out some of the drawing and putting it into other programs. Curriculum is more than a bowlful of individual courses.

A: [McGeary] Too many courses seem to find their way into the catalogue or program without full thought given to the general competence that you're after in the student. That needs to be studied long and hard. It was one of my first surprises as a studio student to realize

that painting wasn't so much applying paint as it was thinking about issues. There's no question in my mind that DBAE is on a collision course with those people who believe in simply making more pots or cranking out things we call paintings or prints or jewelry. But there is a finite resource, and it must be considered much more straightforwardly than it has been in order to decide just what a student is to get.

Q: Two speakers advised seeking program funds that are identified as special needs. What are the relative advantages to short-term efforts like this in relation to long-term efforts to build the secure place art needs in the curriculum?

A: [Kaagan] I wasn't suggesting anything short-term at all; nor do I think my remarks had to do exclusively with special needs. One cannot work in this field without being concerned about the composition of the students whom one is teaching. There is no question that art as a language has to be first concerned with the totality of the group with which it is working. It cannot, therefore, disregard important aspects of that group, including those who have particular problems.

A: [McGeary] Let me give you a brief lesson in what Mayhew referred to as "shanty politics." Regarding the use of funds, I don't have any qualms about using what some of you might call "peanuts money" in a particular program. I'll take the brunt of the

blame and answer questions down the line when somebody puts me on the spot and says, "Why did you spend money that was really designated for environmental education for art education?" In the meantime, I'm going to go ahead with what I'm doing to advance my programs, because if I don't, nothing will happen.

Q: What was the outcome to the practical problem of the California State University system requesting that you be accredited by NASAD and yet limiting you to seventy-seven departmental hours?

A: [Ferreira] Each time we've undergone a review, we have kept meticulous records on our students to prove to NASAD that they meet or exceed the NASAD standards. We've presented NASAD with transcripts randomly selected to prove that the transcripts were not specifically selected for review.

Q: Are students taking more than the minimum baccalaureate hours?

A: [Ferreira] Yes, and one can look at this problem in two ways. First, there are certainly many people who are critical of accrediting organizations; most academic vice presidents would probably like to do away with them because they interfere with their prerogatives. Second, there are those who believe that NASAD standards are essentially valid. At least there's a constant alarm buzzer going off that

keeps our system management from cutting back further or from interfering very much with our programs. So, yes, we're caught between a rock and a hard place, but I would not want to see the rock removed.

Q: I'm concerned about people from the top down saying we need to add all these things that will increase the investment of prospective teachers without increasing their compensation on the job. Do you have anything to say about that issue?

A: [Kunkel] One of the strongest criticisms of the fifth year is economics. But the other side argues that it's chicken and eggs: if the public felt better about the people who are teaching in the schools, the minimum starting salary would be raised. But that's theoretical and didn't help my daughter pay for her fifth year of college.

A: [Kaagan] Regardless of whether the issue is the fifth year or something else, every actor on the scene has to think consciously about what he wants to engage in. What do you want to do that is going to make things better? My vision of the future is that NCATE will yield to a dramatically altered accrediting institution that will be affected by a variety of forces. My sense is that we ought to participate in the shaping of that. How one does so—whether it's a fifth year or some other handle—is a strategic decision, but the fundamental issues are all there on the table.

The Interrelationship Between Preservice and Inservice Education For Art Teachers and Specialists

SPEAKER

Frances S. Bolin
 Teachers College, Columbia University
 [Dr. Bolin was unable to attend the seminar because of flooding in the Chicago airport, but a summary of her address was given by Denis C. Phillips]

RESPONDENTS

Michael D. Day
 Brigham Young University

Linda Peterson
 Provo, Utah, School District

Jerry Tollifson
 Ohio Department of Education

MODERATOR

Denis C. Phillips
 Stanford University

A Summary of Frances S. Bolin's Address

The interrelationship between preservice and inservice involves teacher growth and development, according to Frances Bolin. Teacher education should be viewed as a continuum with three primary "strands" in preservice and inservice training. The first of these is autobiography, which involves encouraging educators to examine and articulate those personal experiences that affect their teaching. Autobiography can aid in clarifying principles of teaching as well as in gaining personal meaning while teaching. Regarding this area, Bolin feels that in implementing DBAE, teachers should be allowed to participate in making curriculum decisions. Studies have shown that teachers with no investment in designing the curriculum will not implement it fully.

The second strand is what Bolin called "studying the complex and dynamic context" of schools. Despite similarities, each school is unique in that it is formed by the interacting personalities of individuals, the vested interests of those in authority, and various rules or standards. Beginning teachers, in order to be effective, must be able to discern what can be learned from a given school environment while observing others' overt behavior, speech, and "implicit meanings." And inservice teachers will often overlook how much the school or classroom environment contributes to the ways in which they teach; they will often blame themselves for whatever problems exist in the classroom, when in fact they may not have been given a realistic class load, the appropriate materials, or enough supervisory support.

Bolin's third strand, scholarship, calls for an experimental approach to teaching. Citing John Dewey, Bolin has noted that for preservice teachers the development of a laboratory experience, which creates an experimental approach that is not routine, is preferable to "apprenticeship" in teaching. And inservice teachers should consider themselves students of their subject, pedagogy, and human growth, and should also continue their research and writing.

Moving from preservice to inservice is difficult, according to Bolin, but would be less so if teacher education were "reconceptualized" in terms of the continuum.

The process of learning to teach is complex, and it requires "experience, support, and time." All involved must see that preservice is not an end to learning but rather the beginning. Preservice and inservice should be part of the same continuum, with autobiography, study of context, and continuous scholarship as basic underlying strands in both. These three strands should provide a framework for acquisition of knowledge, analysis and reflection, reconstruction and application, and experimentation.

A Summary of Michael D. Day's Address

Michael Day directed most of his response toward the realities as well as necessities of inservice education. In his introductory remarks, he defined preservice and inservice in order to draw distinctions between the two. Preservice, he said, relates to a student's education and field experiences before graduation. Inservice refers to employment as a teacher.

Preservice experiences, he pointed out, include instruction in the disciplines of the arts, courses in pedagogy, and student teaching. Inservice experiences include released-time faculty inservice meetings and seminars and workshops. Citing Bolin's paper, in which she pointed out that "there are no generic schools or generic classrooms," Day commented on what graduates can expect when they begin teaching, making seven points about inservice:

1 Graduating art teachers can expect to be involved in a variety of responsibilities and duties. There is no way to fully prepare teachers in preservice for what lies ahead.

2 Preservice must consider the inservice reality. Because students can't be trained to handle all situations that occur, they need to be taught how to respond to them. They also need to be taught to try out ideas and to organize instructional units.

3 For the beginning teacher, inservice education is particularly essential.

4 Art teachers want inservice in the discipline-based approach and advanced work with the disciplines, especially in art criticism and aesthetics.

5 Art educators and representatives of each of the four disciplines are needed to provide inservice education.

6 Experienced art teachers familiar with the discipline-based approach are needed because they can be invaluable as mentors for preservice student teachers.

7 A graduate degree in art education can be considered a form of inservice. What is achieved in getting an M.A., in terms of progress, rivals student teaching in preservice.

A Summary of Linda Peterson's Address

DBAE won't be accepted unless administrators and school boards recognize that such an art program can raise the level of sophistication among students, said Linda Peterson. To that end, teachers need a curriculum they can handle easily. School districts must sponsor professional development programs to help implement DBAE.

Referring to the Provo School District, she noted that its Career Ladder Program had been responsible for reform and inservice. Reform was brought about by initiating a variety of educational programs and seminars and a districtwide inservice program, which at the beginning meant more money for the teacher. Now, though, inservice has led to more professionalism in teaching. It is on this Career Ladder Program, said Peterson, that DBAE in the secondary schools in Provo depends, since the program funds curriculum leaders and teacher specialists.

She pointed out that the success of inservice in Provo relies on ten principles in regard to DBAE: (1) to be open to and understand what is involved in change, (2) to create a need for change, (3) to structure goals for art instruction, (4) to provide quality art training, (5) to practice art strategies to insure they work, (6) to use different approaches to solving problems, (7) to encourage teachers to teach teachers, (8) to allow time for strategies or techniques to work, (9) to maintain contact in order to reinforce and support each other, and (10) to give incentives to those involved in the program.

Art inservice, said Peterson, is valuable because it helps make teachers more intellectually aware and more professional; it also helps them develop a sense of unity and closeness among themselves.

Again referring to the Provo School District, Peterson felt that the worst problem with inservice is resistance to change, to the introduction and application of new ideas. Nevertheless, inservice, she concluded, offers teachers an opportunity to learn, to be inquisitive, and to develop.

A Summary of Jerry Tollifson's Address
Jerry Tollifson based his remarks on the idea that DBAE is the "common turf" on which preservice and inservice relate.

In anticipation of resistance to DBAE, Tollifson suggested that supervisors at the state and district levels could make school districts more open-minded through various inservice programs "fertiliz[ing] the soil," so that preservice DBAE could "take root and grow." This metaphor, said Tollifson, indicates the proper interrelationships between preservice and inservice to advance DBAE.

Where Bolin felt that preservice and inservice should be "autobiographical," stressing the development of the self, Tollifson pointed out the strength of DBAE in this area, because it believes that works of art, as subject matter for study, are "humanistic inquiries" and embodiments of a variety of ideas, philosophies, and concepts of reality. In this way, subjects of art for study also become a learning of our own selves. The study of art, then, is "common ground" for preservice and inservice. Tollifson urged art educators to make it the central concern of preservice and inservice art education.

Tollifson made eight suggestions concerning inservice, based on regional seminars conducted by the Ohio State Department of Education:

1 Each school district would send a team to the seminar, consisting of elementary and secondary art teachers and an administrator.

2 The groups would become familiar with DBAE and learn how to implement it.

3 They would learn how to use various resources for teaching DBAE.

4 They would be encouraged to use museums as a resource for teaching.

5 University-level teachers would participate in the seminars, thus providing connections between inservice and preservice.

6 After the seminars, teachers would use exemplary curricula to teach at their respective schools. They would also design their own.

7 After the seminars, the different groups would plan how to introduce DBAE to all the grades in their own districts.

8 One year later, the groups would meet again.

Through these seminars, said Tollifson, the participants would become more familiar with DBAE and thus more inclined to accept the ideas introduced by the new DBAE-trained teachers.

If these suggestions are acceptable, he concluded, then one should take three steps: first, schools should have a way to anticipate any resistance to DBAE and prepare new teachers to deal with that resistance; second, preservice education should focus on studying works of art for the personal meaning they may impart;

and third, art teachers should work closely with state art supervisors and district supervisors. In this way, DBAE can gain the importance in education that it merits.

• • •

Questions and Answers

Q: I get the strong impression that young art teachers going out into the schools are like Glad-Wrap enthusiasts who end up at a Tupperware Party. They don't find themselves in a terribly happy environment. Why do you think this movement has a better chance than past curriculum reforms, nearly all of which foundered on the problem of inservice, the problem of changing the teachers who are already out there?

A: [Day] One of the differences is that the discipline-based approach has been going on within the field for twenty-five years. Many people in this audience were doing this kind of thing twenty years ago in their own classrooms. There is also considerable support in the field in general, which has built up over the years. State curriculum guides like the Ohio guide, and the positions of the National Art Education Association and the College Board indicate a great deal of receptivity. There may be difficulties in implementing all of this, but I think there's a tremendous amount of support. In preservice, the basic job is to develop teachers who can go out into the environment that exists; in

THE DISCIPLINE-BASED APPROACH HAS BEEN GOING ON WITHIN THE FIELD FOR TWENTY-FIVE YEARS.

inservice, we have the challenging job of developing people who are already out there and don't know how to proceed with DBAE. I don't envision everybody having to do it one particular way. With the kind of pluralism that we have in the United States, there's room for many approaches.

A: [Peterson] The ultimate success and continuation of DBAE will depend on what students learn and how they perform. If we're successful, the students will be the ones who encourage us to keep going.

A: [Tollifson] Actually, I'm optimistic about the success of DBAE in schools over the next several years. One of the reasons is because of Getty's lending credibility and visibility to the endeavor. Before, we were like visionaries in the wild, without support from others in the field.

I would have been disappointed with the slow pace of change over the last several years if it weren't for something I recall Mae West, the great philosopher, once said: "Boys, if you want to do anything well, you should do it slowly." By giving greater substance to the field of art education, we gain credibility from school administrators and from board members. When they learn about what's being tried here, in many cases they will be more supportive than the art teachers and art supervisors.

A: [Phillips] One of my colleagues studied the way teachers taught a hundred years ago, and found almost no difference from the way people teach these days. Teaching as a profession seems to be incredibly resistant to any sort of change, and that makes me a bit worried. Several studies some years ago measured student teachers on a progressive-conservative continuum. At the end of most teacher-training programs, most students were toward the progressive end, but within a year of being out in the schools, they swung over to the conservative end in their pedagogical thinking, largely because of the influence of the environment. Unless there is substantial attention given to inservice, this revolution is not going to be successful.

Q: Another element in this dynamic change is students, whom we often forget to consider. We tend to assume the same thing about children that we do about preservice students, that they come to us without experience, ready to be filled with information. Our success depends on the extent to which we do careful research at the university and school levels about the range of experiences that need to be considered regarding what sort of information to deliver to children. Maybe Linda would have a response to this.

A: [Peterson] In dealing with preservice and inservice, we need to account for

the uniqueness in people. Every classroom, student, and teacher is different. The composition of my classes changes from one period to the next, and, as a teacher, I must be creative in finding how to implement what I want to teach.

A: [Day] If your question is, "What can they learn," my answer is, "I don't think we know." But I think we've underestimated what students are able to learn even at very early ages. I had a conversation with a group of high school students from a Milwaukee program where the kids had the opportunity to work at the museum. I started informally writing down the names of the artists that they mentioned in their conversations after I got them talking about the artists they knew and liked. I got fifteen or twenty names, including contemporary American artists as well as the ones everybody knows from the Renaissance. What impressed me was that when we have this kind of program, where the content is there, kids can learn a tremendous amount.

Q: I'd like to address Jerry Tollifson. Middle management has diminished in the last twenty years. A number of school districts have eliminated the art supervisor; several states have eliminated the art supervisor; we have no representation in the Department of Education. Do you see any way we might reverse that trend?

A: [Tollifson] I don't know how we address

that without some financial help. For school districts, that's the bottom line, so to speak, in almost every decision. My hunch is that we'll probably make a better argument with superintendents and board members if we make the argument that DBAE is making, which is that we're into something quite fantastic that's new and requires informed leadership at the state and local levels.

Comment [from the floor]: We were without an art supervisor for a number of years in Oregon. Probably the most effective thing that happened to get a supervisor back was the development of an advocacy body of several organizations that supported art in the schools. That kind of energy, along with some of the administrators in school districts, recovered our former position. Now that we've got the state position back, we're trying to work more at individual district levels.

Comment [from the floor]: Parents haven't been mentioned as supporters at the local level. In the Sacramento area, when the three components that are missing from the studio-only model were introduced, we had tremendous parent support. Support from the bottom up was really important.

Q: As an art historian, I'd like to ask what you see as the role of the discipline specialist in the scheme of things?

A: [Day] I see a role in inservice for all the people within the disciplines, especially those who have been oriented to the

WHAT [IS] THE ROLE OF THE DISCIPLINE SPECIALIST IN THE SCHEME OF THINGS?

discipline-based approach. In general, in my department (and I think in most departments), we as art educators rely on people in the discipline areas to train our students well in those areas. We hope that with your understanding of what we're trying to accomplish—and without any imposition on what you're ordinarily doing—you can accomodate even better the interest that we all have in helping students be effective when they go out to teach.

A: [Tollifson] Perhaps this could be accomplished through team teaching the interrelationship of the four discipines, based on a model for a college setting.

Comment [from the floor]: It would be helpful for discipline specialists to address the problem of what important ideas about their disciplines are appropriate for earlier years and to write the books that will disseminate those ideas.

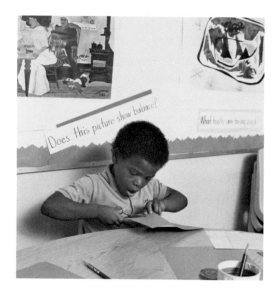

"If You Had No Constraints, How Would You Design the Ideal Preservice Program for Art Teachers and Specialists?"

Group One

PARTICIPANTS

Stephen Addis

Tom Anderson

Carmen Armstrong

Mary Burkett

Faya Causey

Michael Chipperfield

Myroslava Ciszkewycz

Gilbert Clark

Kathleen Cohen

Bruce Cole

John Paul Darriau

Michael D. Day

Rogena M. Degge

Jerry Draper

Ann El-Omami

Wayne Enstice

Michael H. Ferris

Kerry Freedman

Stanley Madeja

The group had several questions that it addressed. The first was whether a new program (l) should change the percentage of time students spend in each of the four disciplines, or (2) should integrate them by using experts from the field, or (3) should intensify the studio experience. Increasing studio experience was favored by some, who argued that meaning comes out of form, and that art history, art criticism, and aesthetics grow from the making of art. Concern was expressed that art education graduates receive more than a dilettante's exposure to studio. One suggestion was that they have a basic core of emphasis beyond survey courses, such as two or three painting courses. Discoveries made in these courses should be transferable to other art fields. A new studio paradigm was suggested, perhaps a new course in what society is all about.

Traditionally, it was noted, art education has emphasized either self-expression or technique, neither of which was seen as ideal. What goes on in schools should be reconnected to what goes on in the art community. Once students understand the elements of art and "the universal form of language," self-expression will be turned into meaning. A remark was made that DBAE cannot ignore creative self-expression if it is to cover the full scope of art education.

Some participants held the position that art history should be the starting place for preservice students because studio professors often neglect historical tie-ins and data that could enrich studio experience. Furthermore, production does not make up the whole root of art, and individual expression is not critical to understanding artworks. Rather than the "nifty puzzle" approach of six hours here and ten hours there, students should have various routes from which to choose, arranged in a flexible, multiple model.

One participant stated that the intent of discipline-based art education is for art education students to take both studio and history courses seriously. Each of them has unique contributions to make. In fact, students would benefit from studying with professionals from all four disciplines.

A second question was whether training should be different for artists and art teachers. The model for the last eighty years has been artists as teachers, but a more acceptable model might be teachers as artists, that is, teachers who know how to produce art, rather than artists who may or may not know how to teach.

Questions that were raised about pedagogy in an ideal preservice program included:

1 What should children learn about the four disciplines? What should a high school graduate know about art? Children are expected to know multiplication tables at a certain age; can parallel expectations be defined for art;

2 How should each of the disciplines be taught;

3 What is intelligence in art and how can it be transmitted;

4 How can the ideal program (and should it include a fifth year of study) incorporate early practical experience in the classroom to give preservice students a feeling of reality?

In envisioning the ideal preservice program, one suggestion was to start fresh, working with "singular chunks of time" rather than separate classes; to change the ratio of teachers to students to change the whole structure. There could be things that should be given up in order to grow, particularly in terms of the current overload of content in art programs.

Group Two

PARTICIPANTS

Edmund Burke Feldman	Sherron Hill
Thomas Ferreira	Howard Hitchcock
Robert Fichter	Eldon Katter
W. Dwaine Greer,	William Kolomyjec
Keith Gunderson	Beverly Krieger
Mark Hamilton	Louis Lankford
Gene Harrison	Jesse Lovano-Kerr
Donald Herberholz	Marilynn J. Price
	Frances Thurber

To begin, the observation was made that there is an assumption that the major task of the secondary art specialist is to teach studio courses to a small number of talented students. Recently, however, a number of states have instituted an arts requirement for high school graduation, meaning that secondary art programs could become more balanced, rather than be centered exclusively on studio experience. Art educators should train art specialists who are prepared to teach such a general course because, as the base of a large pyramid, it would give them many more students. The goal of the course would be knowledgeable students who can use their secondary art education as a foundation for specializing in a chosen art field.

The ideal preservice program might present a balanced program among the four disciplines. Rather than spending a majority of hours in studio training, students might choose to specialize in one of the other three areas. Because there is a

finite number of course hours students can take, and because teaching any of the four disciplines requires in-depth study, specializing in one area seems prudent.

The program might include a course in how to read images. Students live in a visual culture, but most university courses (as well as university administrators) rely chiefly on words for communication. Lack of understanding images presents problems for instituting DBAE.

Questions arose as to whether there is anything special about teaching aesthetics. There is a potential gap between the views of the philosophy and art education departments regarding the nature of aesthetics. An undergraduate course addressing what aesthetics is all about might be one solution, though concern was voiced about the sufficiency of only one course in aesthetics.

In this visionary program, art educators would work together in teams, inviting experts from different fields to speak at seminars. The seminars would bring the disciplines together to discuss methods of inquiry and teaching.

Suggestions were made that "methods" courses be avoided because of their reputation for insipid content. Some participants believed that this kind of course "would have to crumble" before the ideal preservice program can become a reality.

One problem discussed was that of different departments standing apart, not wanting to become involved with art education. One suggested solution to the problem was to sponsor the discussion of issues among the three disciplines and art education in journals. Another was for art educators to reach out to studio artists and art historians within their own universities, asking them if their own children are getting adequate art education in schools. A deciding factor in breaking down barriers was seen to be who hires the faculty. If the dean pressures newly hired art faculty to include the four disciplines, things can change more rapidly.

A short discussion on what it takes to change the system followed. Participants agreed that although meetings that include both faculty and administrators were "tiresome and toilsome," they are indeed necessary. Recommendation was made that faculty be blunt and ask for what they need. For example, if they need graduate assistants to provide time to develop DBAE coursework and programs, they should ask for them.

The ideal program, it was suggested in conclusion, would not neglect the preparation of teachers. It would provide prospective art teachers not only with practical teaching experience at the elementary and secondary levels, but with an idea of the research methodology of the field as well.

Group Three

PARTICIPANTS

Jane Maitland-Gholson Terry Morrow
Thomas Majeski Kenneth
S. Lee Mann O'Connell
Kenneth Marantz Daniel J. Reeves
Robert Marshall Howard Risatti
Sheila McNally Martin Rosenberg
Kurt von Meier Jean C. Rush
Jerry D. Meyer Mary Ann
Marvin Moon Stankiewicz

A first goal for an ideal preservice program was seen as preparing teachers who can talk about images. (A brief discussion about the meaning of the word "image" led to no specific definition, but participants agreed that students need the ability to express themselves verbally about visual imagery.) This means a shift in the focus of art education from manipulating art media to considering images and manipulating imagery. Seen as a quantum leap in undergraduate education, this shift may, it was speculated, result in generalist art teachers who are better prepared than specialist art teachers.

The proposition was put forth that an ideal DBAE preservice program would enrich rather than reduce required courses. The ensuing discussion centered on the extent to which teachers should be educated in breadth to the detriment of depth. Concerns were expressed that art education is now criticized (usually by studio faculty) for having little opportunity to specialize, compared to the B.F.A. in

painting, for instance. The requirements of art production, art criticism, aesthetics, and art history may result in such a thin curriculum that students who want to be artists as well as teachers may not go into teaching. The question was raised as to whether to sacrifice or strengthen studio.

Serious study of the four disciplines seemed to some participants to require four different baccalaureate degrees to avoid questions of competence and mastery of information. One suggestion was to think about the way one's discipline is taught and how it relates to others. Art history is a way to think about art, it is not a collection of styles and periods. For example, an intensive summer review of art history for art teachers should be conceptually rich rather than factually dense. Concern was expressed as to whether undergraduate education for art teachers should be the same as or different from that for studio artists, art historians, art critics, and aestheticians. It was observed that a crucial difference does exist. Little art historians, and so forth, cannot be produced because each of the disciplines looks at the world in a certain way. One notion offered was that perhaps the concept or process of understanding the world could be used to unify the disciplines; their visions do overlap at times.

Response to the question of how students could be taught to think "art historically" was to have them study individual works and to teach them how

to ask the right questions. A list of appropriate questions might even form the basis for a curriculum.

Several practical issues were raised. First, to provide students with a sense of the richness of art, they must have direct exposure to good art. How can the "mindless and pointless" troops through museums be avoided? The alternatives offered were (1) reaching out into the community and using one's own surroundings, and (2) having students themselves design tours through a museum for their peers.

Second, what survival skills are needed for dealing with the reality of the school day, such as (1) the lack of funds for supplies, (2) being one's own research assistant, and (3) the need for classroom management?

Third, what would be the ideal environment for teaching DBAE? What physical plant, buildings, rooms would be needed?

A fourth issue was, How can the ideal program be evaluated? How can educators evaluate whether their graduates can think? They can observe their art education students and former students in class-rooms. To discern if teachers know about images, one can look at their pupils' images. Suggestion was made that even before art education majors receive their degree, they should be evaluated in actual working situations according to rigorous minimum standards.

Discussion followed about the need for ongoing inservice education. Cited as

productive examples of inservice endeavors were: summer art programs that allow teachers to return to the campus for regeneration for a new school year; professors attending former students' art exhibits; and alumni being invited back to campus to speak to classes. Valuable as these efforts can be, required inservice follow-up was not seen as practical, given the geographic distribution of students once they graduate.

Group Four

PARTICIPANTS

Nancy P. MacGregor	Peter Traugott
Joseph A. Seipel	Kurt von Meier
Maurice Sevigny	Marie Winkler
Anita Silvers	Joyce Wright
Marvin Spomer	Terry Zeller
Marilyn Stewart	Enid Zimmerman

The discussion began with Anita Silvers's description of the philosophy course she teaches at San Francisco State University. Her goal is to give students—studio majors, for the most part—enough background to make their own aesthetic theory. This requires them to know how artists and theorists in the past made their theories as they made their art. Students learn to link older works to new works, and in this way to become reflective.

Teaching students to be reflective about art and to tie the philosophy of art to their own work was considered important by this group. Too often aesthetics courses make students feel lost, for they don't know how the subject fits into their own work or lives.

Concern was expressed about the "smattering" of work that art education students may receive in the four disciplines. For example, a number of participants said they would rather have sculpture taught by a painter than by a "dilettante" sculptor, because the painter would have focused intensely in at least one art form. Intense involvement was seen as more important than learning to do a

little of everything. Empathy with one's students is only possible by having such an intense experience in one area.

Artists' attributes that are crucial for art teachers to acquire include artists' skills, knowledge, and attitudes, knowing where artists get the ideas that motivate their work, and the ability to verbalize about their work. Solving professor-generated problems was cited as one of the tendencies in studio courses that may merit reconsideration. Real innovators ask questions and create new problems from which come whole new bodies of work. It is for students beyond the second semester that critique of students' ongoing work (rather than assigned problems) is more prevalent. Perhaps small groups of students could work with each other instead of the professor always working with individual students.

The observation was made that, faced with a general student audience, a future teacher needs a broad repertoire. A distinction therefore should be made between when student training is skill-based and when it is general education. However, persuading studio faculty to develop art courses that would form a bridge to general studies might prove difficult. There are times when the curriculum must blend art history into studio courses, with studio courses paying more attention to the history of their particular medium, for instance.

A discussion of studio critiques raised the question of whether students learn about their own and their professors'

works or whether they simply believe what is said, learning to "play the game of criticism." If students have a broad knowledge base, they can interpret what the teacher says and make their own criticism of their work. In fact, the term "criticism" might be reserved for going further and questioning the goal of the program assigned for coursework.

A series of pedagogical questions emerged from the session: How can methods courses be made more relevant? How can art educators train teachers to make connections, to make links between interdisciplinary knowledge, theory, and practices? How can preservice students be taught to make others more receptive to new ideas? How can they be taught to motivate themselves to teach?

"What Are the Concerns That Arise from the Presentations on the National Reports?"

Group One

PARTICIPANTS

Faya Causey, Thomas Ferreira, Howard Hitchcock (California State University, Long Beach)

Donald W. Herberholz, Kurt von Meier, Marie Winkler, Joyce Wright (California State University, Sacramento)

Rogena M. Degge, Jane Maitland-Gholson, Kenneth O'Connell (University of Oregon)

Susan Adler Kaplan, Maurice Sevigny (plenary session presenters)

Nancy P. MacGregor (seminar committee chair)

Participants expressed concern that the Holmes Group agenda may lead to a stratification of future art education graduates, with graduates of Holmes institutions in higher-level positions. The Holmes Group plan calls for simultaneous implementation at all levels of the career ladder, which should ensure that fourth-year graduates receive proper supervision. Supervision would be by fifth-year graduates but not necessarily products of Holmes institutions. Even so, some participants expressed fear that four-year graduates from some programs might begin teaching with no pedagogy but with full certification. Note was made of a similar plan recently practiced in New Jersey, which has had mixed results.

Two advantages of the Holmes Group initiative were mentioned. First, it emphasizes a strong liberal arts undergraduate degree. This could mean that liberal arts as well as art education students could benefit from general education courses in aesthetics and art criticism, which would relieve art education programs from having to support such courses alone. Second, the reform effort would allow four-year graduates the opportunity to get jobs and work while they are taking their fifth year of pedagogy.

Discussion of possible changes in M.A., Ph.D., and fifth-year programs included potentially different entrance requirements, lower foreign language requirements, and shorter doctoral programs. There was some question as to which department would supervise pedagogical areas of art education and who would teach the courses. In California, where there already is a five-year program, in one university undergraduates study in the art department but take their fifth year in the school of education. In another university, the art department supervises its own fifth-year art education students.

Participants agreed that the tests developed by the Stanford Teacher Assessment program (part of the Carnegie reform effort) reflect what teachers need to know and do and could be useful teaching tools themselves. There was further consensus that any teacher assessment should reflect the relationships among the different disciplines, just as DBAE attempts to do.

Asked whether Carnegie's intent was to extend certification to all elementary fields, including art, Susan Kaplan answered,

"absolutely." All areas would be tested, on a voluntary basis. The tests would be models for future certification and inservice testing—again, on a voluntary basis. Eventually, a library of tests would be available as models for various disciplines.

It was remarked that if the result of certification is that only certified teachers are sought after, the professional level of all teachers could be raised. Kaplan agreed that this was "precisely what we hoped would happen," that if teachers who voluntarily submit to the process returned to the classroom in isolation, nothing would be gained.

Group Two

PARTICIPANTS

Tom Anderson, Jerry Draper, Robert Fichter, Jesse Lovano-Kerr (Florida State University)

Mary Burkett, Eldon Katter, Marilyn Stewart, Peter Traugott (Kutztown University)

Michael H. Ferris, Daniel J. Reeves, Howard Risatti, Joseph S. Seipel (Virginia Commonwealth University)

John W. Eadie, Susan Adler Kaplan (plenary session presenters)

Stanley Madeja (seminar committee)

———————————

Several issues were raised about the reform efforts. For one thing, a member of a Holmes institution questioned whether non-Holmes graduates will have difficulty getting entry-level jobs. The group's opinion was that this probably will not become a problem. Another concern was about the political aspect of the reform agenda, noting that the graduate institutions who have adopted them were mainly looking to increase enrollment.

A third concern had to do with economic aspects of reform. Susan Kaplan mentioned that the Carnegie report's proposal to abolish the undergraduate education degree causes problems particularly for black colleges, where many four-year students currently graduate with education degrees. In other institutions, rising tuitions threaten to exclude minority students, particularly from fifth-year programs. Furthermore, for school districts,

remedial internships and line positions might lead to art teachers without art degrees. Small school districts might be at a disadvantage, finding themselves with fragmented resources at the school level. However, John Eadie remarked later, it is ironic that the Holmes Report is better liked by teachers in public schools than by teachers in the schools of education.

Kaplan was asked what evidence she had to support the belief that fifth-year programs produce better teachers than four-year programs. She replied that the Carnegie's notion was to fill undergraduate years with arts and sciences instruction rather than with education courses and clinical experience. Participants, while affirming that a rounded liberal arts education before professional training seems like a good idea, asserted that there ought to be a balance of subjects throughout the whole curriculum.

No one knew of an existing model for evaluating the five-year plan against standard four-year programs. Eadie said it was a problem that should certainly be put to the Holmes Group, adding that the report itself contains no research data. Only recommendations are included, in hopes of reaching the widest possible audience. (One participant noted that most educational reforms seem not to be tested before implementation.) Eadie went on to say that the Holmes Report does not answer all the questions that it raises, "much less the ones we have asked." Issued as Phase I of the agenda, the report will be followed with modifications and refinements.

Group Three

PARTICIPANTS

Stephen Addis, Ann El-Omami, Eugene Harrison, S. Lee Mann (University of Kansas)

Margaret DiBlasio, Kerry Freedman, Keith Gunderson, Sheila McNally (University of Minnesota)

Marvin Spomer (University of Nebraska at Lincoln)

Thomas Majeski, Martin Rosenberg, Frances Thurber (University of Nebraska at Omaha)

Maurice Sevigny (plenary session presenter)

Mary Ann Stankiewicz (seminar committee)

Asked to elaborate on his view that curricular reform may not be adequate to "stimulate the extraordinary," Maurice Sevigny said that successfully adopting DBAE would require extreme dedication from teachers wearing four or five hats in the classroom. Teachers must lobby for resources to assist them (which are more available now than previously). He further suggested collecting case studies of protocol.

A question was raised whether lack of communication is responsible for not knowing about existing models for collaborative efforts between art and education programs. It would be a waste of time for other schools of education to reinvent such models for themselves. Sevigny replied that he was unaware of

research on this topic and again advised teachers to work with what they have and lobby for what they need.

Internship programs were seen to require proper staffing in schools, with people able both to teach in their discipline and to give instruction in teaching methods. What is needed is either a "generic background of instruction" serving fifteen different disciplines, or fifteen discipline instructors in each school.

The Holmes Report was considered to have advantages for teachers who might otherwise burn out after ten years. Beyond the fact that teachers would have the foundation of a liberal arts degree on which to build a different career, the Holmes Report provides career alternatives for teachers that would keep them in the profession at higher levels. The real question of differential staffing was whether—because of the practical factors involved—there would ever be a mentor art teacher unless art were a subject in general education.

Participants agreed that most role models are simply based on good teachers one has known. One university reported that at its institution, graduate teaching assistants are paired with mentor faculty as a teaching team, an arrangement from which the graduate assistant gains invaluable experience.

As an art historian, one participant commented that he feels that consideration of what art teachers need to know about art history provides the opportunity to reflect on its essence, modes of thought, and intellectual processes. These reflections have bearing on what the different disciplines can offer education at large, as opposed to future specialists.

Suggestion was made that those who work in the arts in educational institutions other than schools and universities receive DBAE training. Museums are a neutral ground where various departments can collaborate, if contact can be brokered by museum staff.

The reply to the question of which studio course might be cut, assuming DBAE requires cutting anywhere, was that studio hours should be maintained or increased. Even if cutting were necessary, there are state requirements that must be met. The real question is not cutting courses, but deciding what students need to know to teach effectively and how to integrate the program.

Group Four

PARTICIPANTS

Gilbert Clark, Bruce Cole, Jean Paul
 Darriau, Enid Zimmerman (Indiana
 University)
Carmen Armstrong, William Kolomyjec,
 Jerry D. Meyer, Terry Zeller (Northern
 Illinois University)
Michael Chipperfield, Myroslava H.
 Ciszkewycz, Louis Lankford, Kenneth
 Marantz (Ohio State University)
John E. Eadie, Susan Adler Kaplan, Victor
 Rentel (plenary session presenters)
Marilynn J. Price (seminar director)

———————————————

Victor Rentel responded to a number of
questions in this session. First, how would
the long-term plan be affected by the fact
that only 10 percent of teacher-training
schools are presently involved in the
Holmes Group? Rentel noted that (1) the
presidents of those institutions must make
a firm commitment to the process, (2) state
department regulations must be reduced,
and (3) local superintendents and union
leaders must be approached on grounds of
common interest in order to gain their
assistance. Because those persons who are
unlikely to perform well can be weeded out
early, districts will save millions on teacher
salaries, while unions will be able to
redirect money to top-level teachers.
However, rural districts with smaller pay
scales "aren't about to enter into this deal.
They're going for the cheapest teacher they
can get."

Second, how would clinical faculty be

selected? Rentel described that a panel of
teachers and administrators would select
from the district those eligible to become
clinical faculty, who would undergo
doctoral training in a program not yet
created. We must work out a concrete
developmental plan for clinical faculty and
pay a portion of the salary, along with
brokering contractual changes with the
union and school district. State support
would be required for this, which also
means getting better at politics.

Third, isn't it true that state legislatures,
responding to reports, often set new
requirements without providing sufficient
funding to implement them? Rental replied
that university presidents must play a
mediating role because their own institu-
tions are at risk as long as the public school
system fails to function. "I think in the short
run these reforms are almost at the mercy
of university presidents."

Fourth, does the fifth year guarantee a
better-prepared teacher? Subject matter
knowledge might be improved, but isn't
classroom experience also an important
form of preparation? The Holmes Report
makes it clear, he said, that "better
educated means the more liberally, more
thoughtfully educated."

Fifth, doesn't excellent teaching have
more to do with personal factors than with
professional training, important as that is?
Responding, Rentel mentioned that the
school of education can train teachers
to select content appropriate to differ-
ent levels and give them the ability to
transform and tailor that content in ways

appropriate to different learners.

Sixth, isn't having starting teachers without training in pedagogy like playing Russian roulette? Rentel agreed, although he countered that because 55 percent of those who presently start as teachers soon leave the profession, we are playing Russian roulette now. He went on to say that according to the Holmes plan, novice instructors would be closely supervised by a lead teacher, master teacher, or career professional. This would be an improvement over the way new teachers have generally been "tossed to the wolves." The gain here for both the unions and the districts is that although teachers would start at lower salaries than normal, the jump to a higher career level would be worth working for.

In conclusion, Rentel observed that we are seeing the longest-sustained concern for the quality of public education in the last fifty years. Public support is strong, and state governors are keenly interested in satisfying voter concerns.

Group Five

PARTICIPANTS

Michael D. Day, Mark Hamilton, Sherron Hill, Robert Marshall (Brigham Young University)

Beverly Krieger, Marvin Moon, Terry Morrow, Kim Smith (Texas Tech University)

Wayne Enstice, W. Dwaine Greer, Jean C. Rush (University of Arizona)

John E. Eadie, Maurice Sevigny (plenary session presenters)

The Holmes Report increases requirements, not salaries, one participant remarked. It's hard enough now to attract good teachers. Won't this make it harder? John Eadie said that this represents a common misperception. There is an abundance of applicants; most large institutions have a good ratio of applicants to openings. However, he agreed that the Holmes proposal had mainly looked at research institutions, which might be limiting.

Another participant asserted that "the definition of liberal arts" needs to be clarified and expanded. The small number of art education students in most programs will not warrant a larger program; only if art education serves general education needs (while continuing to maintain programs for gifted and talented young people) will this pattern change.

The situation facing preservice art educators was seen by some participants as complex and political. Decision-makers

need to be persuaded to favor the new program over others. Support must be elicited from other disciplines, such as cognitive psychology. Department structures need to be rethought if reform is to succeed. Someone with cross-disciplinary interests at the dean's level may be needed to coordinate appointments.

Concern was voiced by others about the notion that reform is needed. Resources exist already within art departments for meeting many of the new requirements without having to go outside for expert help, they suggested. For instance, in many good studio classes these disciplines are covered. More direct communication might eliminate the supposed need for structural reform. Existing resources may be adequate, supplemented by occasional outsiders. Why overintegrate? In so doing, we risk a loss of discipline coherence. And why institute a five-year program instead of intensifying the existing four-year one?

One argument for interaction among the disciplines was that teachers usually teach as they are taught. They need many models in order to learn different teaching skills. Nevertheless, art-related subjects should be taught "on their home base" wherever possible, not "farmed out" to other departments.

"Foundations" courses were proposed to ensure a common base of information; scope and sequence are as important to DBAE as integration. Mastery of terms and concepts requires long exposure to art in a variety of contexts.

A studio participant agreed that students should "rattle around" and absorb a variety of good models before specializing. They may never take art again after being undergraduates, but as teachers they would have a strong general foundation.

"How Might Art Education and Discipline Faculty Profitably Interact?"

Group One

PARTICIPANTS

Tom Anderson, Jerry Draper, Robert Fichter, Jesse Lovano-Kerr (Florida State University)

Mary Burkett, Eldon Katter, Marilyn Stewart, Peter Traugott (Kutztown University)

Michael H. Ferris, Daniel J. Reeves, Howard Risatti, Joseph S. Seipel (Virginia Commonwealth University)

Joseph Goldyne, Franz Schulze (plenary session presenters)

Marilynn J. Price (seminar director)

One participant expressed concern that teachers will be prepared on too general a level, that they will know a little about a lot but be skilled at nothing. Concurring, another participant stressed the need for teachers who are committed to one specialty. A lifelong approach to learning must be sought, one that will not sacrifice a broad exposure to all the disciplines. The ideal would consist first of a breadth of knowledge, followed by an in-depth study.

A second concern, shared by several participants, was that art might become an academic subject, when in fact it is an emotional activity. In trying to make the subject respectable, the expressive heart should not be lost.

Team teaching was suggested as a means of achieving an intentional integration of knowledge. This approach would be administratively difficult but more cost-efficient than the mentor concept, although the mentor concept has merits.

The mentor concept was discussed further, its chief advantage seen as a sense of caring for the student that goes beyond that of ordinary advisers. It was noted that even though many students seek out their own mentors, this approach may not be right for everyone. Further, the mentor concept may leave one faculty member with thirty students and others with none. A combination of team teaching and mentoring was suggested—an interdisciplinary mentor or tutorial group—with four faculty members from the four disciplines.

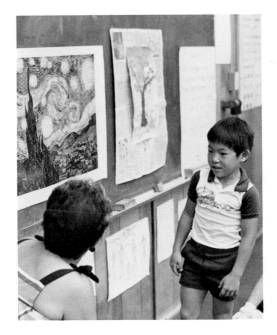

Group Two

PARTICIPANTS

Wayne Enstice, W. Dwaine Greer, Jean C. Rush (University of Arizona)

Margaret DiBlasio, Kerry Freedman, Keith Gunderson, Sheila McNally (University of Minnesota)

Margaret Battin, Joseph Goldyne, Franz Schulze (plenary session presenters)

Stanley Madeja (seminar committee)

———————————————

The opening question, "Should teachers integrate the disciplines or teach them separately," provoked a second: "Are we seeking equal time or equal emphasis for each discipline?" Margaret Battin said she opposed the idea of equal time for all the disciplines. Once you say, "Monday is art history, Tuesday is criticism," the distinctions become artificial. Aesthetics should be taught in conjunction with history, criticism, and production, she said, but at the same time, a distinction among the disciplines should be maintained. An art educator pointed out that DBAE has never intended to teach on a mechanical Monday-is-art-history level.

One of the studio artists remarked that although drawing boundaries may be essential for education, the myth that artists can't talk should be questioned. He cited the duality of artists as makers and critics: "An artist works on a thing and the work begins to speak to the artist." From working artist to one who can find a language to express his thoughts on art is not that great a leap.

Students do not understand that the creative process involves an application of intelligence, intuitive time, and reflection, he went on to say. History, criticism, and aesthetics are an organic part of this process, and separating these disciplines can help understand them. But to think that this compartmentalization is a reality in the making of art is not acceptable.

Joseph Goldyne stated that the disciplines are ancillary to the creation of art and must begin with the work of art. Until we know about the process of artists' creation, or perhaps until the DBAE model has been explored, breaking down the disciplines for greater understanding is part of the questioning process.

The belief that artists cannot become great without contact with art history was questioned by some participants. Goldyne stated that artists should proceed at their own peril without prior knowledge, but he admitted that something could be said for the opposite view. Franz Schulze, though stressing that he was not against art history, said that it is not necessary to the education of artists, whose only requirement is that they receive what they need for their work.

The question of how to distinguish between relevant and irrelevant characterizations of artworks elicited a variety of responses. One participant regarded orientation as the key factor, mentioning that personal enthusiasms must be a source of input in determining relevance. Another argued for theoretical constructs having a great bearing on this

determination. A third wasn't convinced that there are any irrelevant facts, only constructs in which relevance is different for different interests. An aesthetician disagreed with the idea that the critical process will ever be explainable, even in the distant future. It's like saying that the appreciation of a Chippendale chair could be explained.

It was observed that ambiguity may be an important issue in teaching. When students realize how often one thing can have many meanings, they tend to become anxious and insecure. It is one of the teacher's responsibilities to create the friction that causes students to grow.

Group Three

PARTICIPANTS

Michael D. Day, Mark Hamilton, Sherron Hill, Robert Marshall (Brigham Young University)

Faya Causey, Thomas Ferreira, Howard Hitchcock (California State University, Long Beach)

Donald W. Herberholz, Kurt von Meier, Marie Winkler, Joyce Wright, (California State University, Sacramento)

Beverly Krieger, Marvin Moon, Terry Morrow, Kim Smith (Texas Tech University)

Mary Ann Stankiewicz (seminar committee)

A comment about how valuable the seminar was in bringing together people from many different disciplines to share ideas "without violent disagreements" sparked the question: "Why do we protect our turf?" One explanation offered was that specialization has caused people to establish their own domains, that this has encouraged competition, which may not always be bad. Another participant noted that in the state universities, the problem of compartmentalization is caused by enrollment-driven budgets, a problem that could be alleviated if the departments shared common goals.

Participants expressed reservations about defining new boundaries and making new fences. For example, one Art educator projected collective opposition in his department if someone from art education

set up a criticism course. But an art historian from the same institution observed that it would depend on whether the class was a history of criticism course or one that applied certain periods to the world today.

It was observed that few universities consider criticism and aesthetics to be part of the mainstream of art education, and the question of qualifications for teaching criticism was raised. Would one graduate-level class or a few art history classes be adequate preparation for teaching criticism? The suggestion was made that the most important criteria would derive from how the department conceived the course. Would it be the history of art criticism, or a course geared especially for art historians, or one that would serve educators and studio artists? There may be nobody who is equipped to do the job that each segment of the department would see as important, unless someone is hired on a visiting or rotating professor basis.

An art educator—one of the writers of the monograph on DBAE—stated that he wanted to clarify some of the thinking that went into developing that paper. The intention was never to change art departments in higher education or to force teachers to integrate their different disciplines, though that might be a good idea. Just as public school students can gain from a general knowledge of science and language skills, so can they benefit from a fundamental understanding of art.

The expectation is not that studio art departments should change their

approaches, he went on, only that the content of what is taught to children be valid content, not something that art educators make up. The content needs to be derived from the four disciplines, and artists, art historians, art critics, and aestheticians are the ones who need to validate the content that the educators are organizing. The integration of the content is intended for general education. It is the role of the art educator to integrate the disciplines for public education.

Group Four

PARTICIPANTS

Gilbert Clark, Bruce Cole, Jean Paul
Darriau, Enid Zimmerman (Indiana
University)

Carmen Armstrong, William Kolomyjec,
Jerry D. Meyer, Terry Zeller (Northern
Illinois University)

Michael Chipperfield, Myroslava H.
Ciszkewycz, Louis Lankford, Kenneth
Marantz (Ohio State University)

Stephen Addis, Ann El-Omami, Eugene
Harrison, S. Lee Mann (University of
Kansas)

Marvin Spomer (University of Nebraska at
Lincoln)

Thomas Majeski, Frances Thurber
(University of Nebraska at Omaha)

Rogena M. Degge, Jane Maitland-Gholson,
Kenneth O'Connell (University of
Oregon)

Nancy P. MacGregor (seminar committee
chair)

———————————

One participant observed that, although he
enjoyed talking with colleagues from the
various art disciplines, he hoped that art
historians and studio artists would not be
concerned with fourth graders, but with
being the best art historians and studio
people they could be. He suggested not
a merging, but a friendly coexistence
between art and education. What is
wanted, expressed another participant, is
for the disciplines to be more sensitive to
art educators' needs.

It was noted that—in discussion of
the four disciplines—the need for an
acquaintance with a wide range of art
history is sometimes overlooked. Though
an introductory course may constitute
students' first exposure to art, perhaps
students should learn more about less.
One suggestion was an initial course in
the language of art, along with a survey
course, as an introduction to historical
methodology.

An art educator described asking
artistically talented junior high and high
school students which artist they knew
best; they told him they didn't know any
artists. This caused him to wonder what
selection of slides should be used in pre-
sentations—a question for art historians.

In the discussion of introductory
courses, several participants agreed that to
limit the course to textbooks would be a
mistake. Teachers should help students
find an intrinsic love for art, should
develop a passion and enthusiasm in
students, should ignite an ''art spirit''
in them.

A studio artist agreed with one of the
major concerns voiced several times during
the seminar, that history and art criticism
are not receiving their due. Nevertheless,
he expressed concern for the need for a
strong studio base for preparation of art
teachers. Agreeing with this point of view,
another studio participant explained that
artists are trying to teach students to see
things in a completely different way, to
reveal the student to himself. If we take out

the studio, he went on, we take out a way
of experiencing and revealing the self.

Other students, an art educator
observed, whose skills are primarily verbal,
might enter art through art history, but
struggle with studio art. Their verbal skills
may make them very expressive, eloquent,
and capable of tremendous understanding
about art.

The group agreed that the most
important question that educators must ask
themselves (and each other) is what it is
they want the students to learn. And, one
person pointed out, what to leave out.

Post-Snowbird Activity

Post-Snowbird Activity

The expectation after Snowbird was that the fifteen university teams that participated would return to their respective institutions better informed about and oriented to preservice art education that incorporates a discipline-based art education approach. The presentations, discussions, and other activities at Snowbird were designed to familiarize the participants with discipline-based art education and to encourage them to think about how they might reform and strengthen their own programs along such lines. Consequently, among the most important features of the seminar were the planning sessions at which the university teams developed ideas for program redesign at their respective campuses. Because each team included not only art educators, but colleagues from the respective art disciplines, in many cases this may have been the first time that art educators planned common curriculum with artists, art historians, critics, and aestheticians. The variety and innovation that were apparent in these planning sessions suggested that the Snowbird participants were doing an excellent job of assimilating the content provided by the seminar for subsequent use.

To further encourage the design and development of discipline-based art education preservice programs, the Getty Center for Education in the Arts offered Snowbird participants support for their specific projects. A Request for Proposals (RFP) was issued toward the end of the seminar, requesting universities apply for funds of up to $25,000 to support projects of up to one year's duration that would have significant consequence in the development of discipline-based art education in their respective preservice programs. The RFP emphasized that what was being sought was not merely a one-time program but long-term change that reflected a commitment by art educators and discipline representatives alike. Plans needed to be drawn demonstrating that courses could be developed and implemented, degree requirements altered, instruction materials designed, or other measures taken to firmly install DBAE in art education preparation programs.

Applications for preservice contracts were received from fourteen out of fifteen universities that participated at Snowbird. The fifteenth university requested a considerable time extension for submittal of its application, which the Center was unable to grant. The fourteen applicants submitted specific plans with personnel, tasks, timelines, and budgets described in response to the RFP. The review process for these applications was extensive, including the convening of an external review panel consisting of professional peers, none of whom were from any of the universities applying. Based on the panel's recommendations, a decision was made to fund more than two-thirds of those applications submitted. In January 1988 it was announced that contracts for preservice education would be made with the following institutions:

Brigham Young University
California State University, Sacramento
Florida State University
Indiana University
Northern Illinois University
Ohio State University
Texas Tech University
University of Kansas
University of Nebraska, Lincoln and
 Omaha
University of Oregon

These ten institutions will each pursue their own specific projects designed to develop a DBAE emphasis in their preservice programs. Some of the schools will be creating new courses designed to address the deficiencies in professional preparation in such art foundational areas as aesthetics or criticism. Other institutions will be developing materials for instruction, including the use of videotape and media resources. Still others will be making significant changes in their entire programs, including requirements and courses.

The contracts will run during the spring 1988 and fall 1988 semesters or quarters. At their conclusion, final reports will be prepared and submitted to the Center, including evaluations by outside observers who are not connected with the projects. These final reports will be reviewed and a meeting of the project directors convened in the spring of 1989.

In addition, a study of the impact of Snowbird in the first year after the seminar on all fifteen of the institutions that participated will have been completed by the original planning committee by summer 1988.

The Center intends to publish a summary of the accomplishments of the ten projects and the impact study. This report will be disseminated widely, thus completing the Center's initial effort in preservice art education. We hope that the information and ideas contained in the final report will be of use to other institutions that seek to strengthen their preservice programs.

Universities and Participants

Universities and Participants

GETTY CENTER FOR EDUCATION
IN THE ARTS
1875 Century Park East
#2300
Los Angeles, California 90067

Leilani Lattin Duke,
Director

Stephen M. Dobbs, Senior
Program Officer

Vicki Rosenberg, Program
Officer

Gwendolyn Walden, Intern

SEMINAR COMMITTEE
Marilynn J. Price
Seminar Director
Consultant, Getty Center for
Education in the Arts
1470 South Rexford Drive
#301
Los Angeles, California 90035

Nancy P. MacGregor
Seminar Committee Chair
Associate Professor of Art
Education
340 Hopkins Hall, 128 North
Oval Mall
Ohio State University
Columbus, Ohio 43210

Stanley Madeja
Dean
College of Visual and
Performing Arts
Northern Illinois University
DeKalb, Illinois 60115

Mary Ann Stankiewicz
Associate Professor of Art
University of Maine
1812 Huntington Lane
Redondo Beach, California
90278

UNIVERSITY TEAMS
Arizona: University of Arizona

Art Education
W. Dwaine Greer
Associate Professor
Department of Art
University of Arizona
Tucson, Arizona 85721

*indicates Holmes Group university

Jean C. Rush
Director
Department of Art
University of Arizona
Tucson, Arizona 85721

Studio Art
Wayne Enstice
Associate Professor
Department of Art
University of Arizona
Tucson, Arizona 85721

*California: California State
University, Long Beach*

Art Education/Studio Art
Howard Hitchcock
Professor of Art
California State University,
Long Beach
Long Beach, California 90840

Studio Art
Thomas Ferreira
Associate Dean
School of Fine Arts
California State University,
Long Beach
Long Beach, California 90840

Art History
Faya Causey
Assistant Professor
Art Department
California State University,
Long Beach
Long Beach, California 90840

*California: California State
University, Sacramento*

Art Education
Donald W. Herberholz
Professor
Art Department
California State University,
Sacramento
600 J Street
Sacramento, California 95819

Joyce Wright
Assistant Professor
Art Department
California State University,
Sacramento
600 J Street
Sacramento, California 95819

Studio Art
Marie Winkler
Associate Professor
Art Department
California State University,
Sacramento
600 J Street
Sacramento, California 95819

Art History
Kurt von Meier
Professor
Art Department
California State University,
Sacramento
600 J Street
Sacramento, California 95819

Florida: Florida State University

Art Education
Tom Anderson
Assistant Professor
Department of Art Education
123 Education Building
Florida State University
Tallahassee, Florida 32306

Jesse Lovano-Kerr
Professor
Department of Art Education
123 Education Building
Florida State University
Tallahassee, Florida 32306

Studio Art
Robert Fichter
Chair and Professor
Department of Studio Art
236 Fine Arts Building
Florida State University
Tallahassee, Florida 32306

Art History
Jerry Draper
Dean and Associate Professor
School of Visual Arts
236 Fine Arts Building
Florida State University
Tallahassee, Florida 32306

*Illinois: Northern Illinois
University*

Art Education
Carmen Armstrong
Professor
School of Art
Northern Illinois University
DeKalb, Illinois 60115

Terry Zeller
Associate Professor
School of Art
Northern Illinois University
DeKalb, Illinois 60115

Studio Art
William Kolomyjec
Associate Professor
School of Art
Northern Illinois University
DeKalb, Illinois 60115

Art History
Jerry D. Meyer
Assistant Chair
School of Art
Northern Illinois University
DeKalb, Illinois 60115

Indiana: Indiana University

Art Education
Gilbert Clark
Professor
School of Education 002, IU-B
Indiana University
Bloomington, Indiana 47405

Enid Zimmerman
Associate Professor
School of Education 002, IU-B
Indiana University
Bloomington, Indiana 47405

Studio Art
Jean Paul Darriau
Associate Professor
School of Fine Arts
Fine Arts 123
Indiana University
Bloomington, Indiana 47405

Art History
Bruce Cole
Professor
School of Fine Arts
Fine Arts 123
Indiana University
Bloomington, Indiana 47405

*Kansas: University of Kansas**

Art Education/Art History
Ann El-Omami
Assistant Professor
Visual Arts Education
311 Bailey
University of Kansas
Lawrence, Kansas 66045

Eugene Harrison
Assistant Professor
Visual Arts Education
311 Bailey
University of Kansas
Lawrence, Kansas 66045

Studio Art
S. Lee Mann
Associate Professor
Chair, Department of Design
Art and Design Building
Room 300
University of Kansas
Lawrence, Kansas 66045

Art History
Stephen Addis
Chair, Professor of Art
 History
209 Spencer Museum of Art
University of Kansas
Lawrence, Kansas 66045

*Minnesota: University of
 Minnesota**

Art Education
Margaret DiBlasio
Head, Art Education Program
Department of Curriculum
 and Instruction
135 Wulling Hall
85 Pleasant Street SE
University of Minnesota
Minneapolis, Minnesota
 55455

Kerry Freedman
Associate Professor
Art Education
135 Wulling Hall
85 Pleasant Street SE
University of Minnesota
Minneapolis, Minnesota
 55455

Aesthetics
Keith Gunderson
Professor of Philosophy
Department of Philosophy
355 Ford Hall
University of Minnesota
Minneapolis, Minnesota
 55455

Art History
Sheila McNally
Professor Art History

107 Jones Hall
27 Pleasant Street SE
University of Minnesota
Minneapolis, Minnesota
 55455

*Nebraska: University of Nebraska
 at Lincoln**
University of Nebraska at Omaha

Art Education
Marvin Spomer
Professor
13 Henzlik Hall
University of Nebraska at
 Lincoln
Lincoln, Nebraska 68588-0355

Frances Thurber
Assistant Professor
212 Arts and Science Hall
University of Nebraska at
 Omaha
Omaha, Nebraska 68182

Studio Art
Thomas Majeski
Assistant Professor
212 Arts and Science Hall
University of Nebraska at
 Omaha
Omaha, Nebraska 68182

Art History/Art Criticism
Martin Rosenberg
Associate Professor
212 Arts and Science Hall
University of Nebraska at
 Omaha
Omaha, Nebraska 68182

*Ohio: Ohio State University**

Art Education
Louis Lankford
Assistant Professor
340 Hopkins Hall
128 North Oval Mall
Ohio State University
Columbus, Ohio 43210

Kenneth Marantz
Chairperson
Department of Art Education
340 Hopkins Hall
128 North Oval Mall
Ohio State University
Columbus, Ohio 43210

Studio Art
Michael Chipperfield
Associate Professor
045 Hopkins Hall
128 North Oval Mall
Ohio State University
Columbus, Ohio 43210

Art History
Myroslava H. Ciszkewycz
Associate Professor
100 Hayes Hall
108 North Oval Mall
Ohio State University
Columbus, OH 43210

*Oregon: University of Oregon**

Art Education
Rogena M. Degge
Head, Department of Art
 Education
School of Architecture
and Applied Arts
University of Oregon
Eugene, Oregon 97403

Jane Maitland-Gholson
Assistant Professor
Department of Art Education
School of Architecture
 and Applied Arts
University of Oregon
Eugene, Oregon 97403

Studio Art
Kenneth O'Connell
Head, Department of Fine
 Arts
University of Oregon
Eugene, Oregon 97403

*Pennsylvania: Kutztown
 University*

Art Education
Mary Burkett
Chairperson
Department of Art Education
 and Crafts
Kutztown University
Kutztown, Pennsylvania 19530
Eldon Katter
Associate Professor
Department of Art Education
 and Crafts and Crafts
Kutztown University
Kutztown, Pennsylvania 19530

Studio Art
Peter Traugott
Chairperson
Fine Art Department
Kutztown University
Kutztown, Pennsylvania 19530

Art Criticism
Marilyn Stewart
Associate Professor
Department of Art Education
 and Crafts
Kutztown University
Kutztown, Pennsylvania 19530

*Texas: Texas Tech University**

Art Education
Beverly Krieger
Assistant Professor
Department of Art
Texas Tech University
P.O. Box 4720
Lubbock, Texas 79409

Marvin Moon
Associate Professor
Department of Art
Texas Tech University
P.O. Box 4720
Lubbock, Texas 79409

Studio Art
Terry Morrow
Professor and Chairperson
Department of Art
Texas Tech University
P.O. Box 4720
Lubbock, Texas 79409

Art History
Kim Smith
Associate Professor
Department of Art
P.O. Box 4720
Lubbock, Texas 79409

Utah: Brigham Young University

Art Education
Michael D. Day
Professor of Art
Department of Art
Brigham Young University
C-502 Harris Fine Arts Center
Provo, Utah 84602

**indicates Holmes Group university*

Sherron Hill
Department Chairman
Department of Art
Brigham Young University
B-509 Harris Fine Arts Center
Provo, Utah 84602

Studio Art
Robert Marshall
Associate Professor of Art
Department of Art
Brigham Young University
B-551 Harris Fine Arts Center
Provo, Utah 84602

Art History
Mark Hamilton
Associate Professor of Art
Department of Art
Brigham Young University
D-501C Harris Fine Arts
 Center
Provo, Utah 84602

*Virginia: Virginia
 Commonwealth University*

Art Education
Michael H. Ferris
Associate Professor
Department of Art Education
Virginia Commonwealth
 University
P.O. Box 2519
325 North Harrison Street
Richmond, Virginia 23284

Daniel J. Reeves
Professor
Chairman, Department of
 Art Education
Virginia Commonwealth
 University
P.O. Box 2519
325 North Harrison Street
Richmond, Virginia 23284

Studio Art
Joseph S. Seipel
Associate Professor
Chairman, Department of
 Sculpture
Virginia Commonwealth
 University
P.O. Box 2519
325 North Harrison Street
Richmond, Virginia 23284

Art History
Howard Risatti
Associate Professor
Chairman, Art History
 Department
Virginia Commonwealth
 University
P.O. Box 2519
325 North Harrison Street
Richmond, Virginia 23284

PRESENTERS

Margaret Battin
Associate Professor
Department of Philosophy
University of Utah
Salt Lake City, Utah 84112

Frances S. Bolin
Assistant Professor of
 Education
Teachers College
P.O. Box 36
Columbia University
New York, New York 10027

Martha E. Church
President
Hood College
Frederick, Maryland 21701

Kathleen Cohen
Professor of Art History
San Jose State University
San Jose, California 95192

Michael D. Day
Professor of Art
Brigham Young University
B-509 Harris Fine Arts Center
Provo, Utah 84602

John E. Eadie
Dean
College of Arts and Letters
Michigan State University
East Lansing, Michigan 48824

David Ebitz
Head, Department of
 Education
 and Academic Affairs
J. Paul Getty Museum
17985 Pacific Coast Highway
Malibu, California 90265

Edmund Burke Feldman
Professor
University of Georgia

Jackson Street
Athens, Georgia 30622

Thomas Ferreira
Associate Dean
School of Fine Arts
California State University,
 Long Beach
Long Beach, California 90840

Joseph R. Goldyne
Artist
One Maple Street
San Francisco, California
 94118

Stephen S. Kaagan
Commissioner
Vermont Department of
 Education
Montpelier, Vermont 01267

Susan Adler Kaplan
High School Teacher
90 Taper Avenue
Providence, Rhode Island
 02906

Richard C. Kunkel
Executive Director
National Council for
 Accreditation of Teacher
 Education
1919 Pennsylvania Avenue
 NW
Suite 202
Washington, D.C. 20006

Benjamin Ladner
President
National Faculty of
 Humanities, Arts, and
 Sciences
1676 Clifton Road
Atlanta, Georgia 30322

Lewis B. Mayhew
Professor of Education
Stanford University
945 Valdez Place
Stanford, California 94305

Denis C. Phillips
Professor of Philosophy and
 Education
School of Education
Stanford University
Stanford, California 94305

Victor M. Rentel
Associate Dean

College of Education
127 Arps Hall
1945 North High Street
Ohio State University
Columbus, Ohio 43210

Franz Schulze
Professor of Art
Department of Art
Lake Forest College
Lake Forest, Illinois 60045

Clyde McGeary
Chief, Division of
 Arts and Sciences
Bureau of Curriculum
 and Instruction
Pennsylvania Department
 of Education
333 Market Street, 8th Floor
Harrisburg, Pennsylvania
 17108

Linda Peterson
High School Art Department
 Chair
1145 South Carterville Road
Orem, Utah 84058

Maurice Sevigny
Chairman
Department of Art
Fine Arts Building
University of Texas at Austin
Austin, Texas 78712

Anita Silvers
Professor of Philosophy
Academic Senate Office
New Administration
 Building, #552
San Francisco, California
 94112

Jerry Tollifson
State Art Education
 Consultant
Ohio Department of
 Education
Columbus, Ohio 43215

SEMINAR ARRANGEMENTS

Hunt Marmillion Associates
10880 Wilshire Boulevard
Los Angeles, California 90024

Valsin A. Marmillion,
 Director

Daylanne Johnson,
 Coordinator

Anne Elmajian, Assistant

SEMINAR REPORTING

William Keens, President
Keens Company
261 West Fourth Street, #23
New York, New York 10014

GRADUATE STUDENTS FROM
BRIGHAM YOUNG UNIVERSITY

Joann Blackburn
C-502 Harris Fine Arts Center
Brigham Young University
Provo, Utah 84602

Sharon Cannon
1165 West 1600 North
Orem, Utah 84057

Sharon Gray
181 East 300 North
Orem, Utah 84057

LaVelle Moss
848 North 750 East
Orem, Utah 84057

Barbara Wardele
1666 North 1350 West
Provo, Utah 84604

Complete Texts of Presentations

THE IMPORTANCE OF THE ARTS IN UNDERGRADUATE EDUCATION

SPEAKER

Benjamin Ladner
 The National Faculty of Humanities,
 Arts, and Sciences

"The world is not what I think but what I live through."

Maurice Merleau-Ponty

There is every reason to suppose that the drumbeat of educational reform, which by now has penetrated every fiber of our individual and collective academic sensibilities, is losing its resonance; that the refrains of "mediocrity," "at risk," "career ladders," "professionalization," "excellence," and "core curriculums" have pounded the impulses of even the most enthusiastic reformer into a tangle of insensitivity.

We might legitimately conclude that there is little new to consider that could enhance the quality of our teaching in the university. Nevertheless, I want to make several proposals that, significantly, have not been a part of recent national discussions on education but which could dramatically alter what and how we teach in the university generally and in the arts in particular.

The philosopher John J. McDermott has said: "The art process is the human process brought to a specific angle of vision, with a claim about man's activity which throws light on the entire range of human affairs." In order to understand the role of the arts in education, instead of looking directly at the obvious aspects of educational reform—teachers, students, courses, schedules, budgets, testing, teacher preparation, art education as a discipline— we must first become aware of the "angle of vision" through which we view these things; in other words, we must ask *how* we are looking at what we see, not just *what* we see in the educational landscape.

The perspective we now have in the university on knowledge, teaching, and inquiry is fundamentally incompatible with what a university education has traditionally sought to accomplish. My first proposal is that this perspective should be changed, for the simple reason that education—including education in the arts—cannot finally be based on the prevailing assumptions of that setting.

I

In order to understand the place of the arts and art education within undergraduate education we must reassess the structure of the modern university itself. A British poet, Elizabeth Sewell, has described the American academic structure as

> *a huge dream mansion, a kind of crazy*
> *skyscraper continually being added to in*
> *all directions, up, down, sideways, a*
> *fantastic superstructure . . . stand[ing]*
> *on its ownWe are quite familiar*
> *with closed worlds of this kind*
> *functioning efficiently on their own*
> *terms, producing plenty of results— only*
> *these results make sense only inside the*
> *system and bear no relationship*

whatever to real life. . . . Maybe it's not a horrid accident but a logical conclusion of how we all think.

So that my position is clear from the outset, I contend that the modern university resembles the form of reflection espoused by the contemporary intellectuals who live and think inside it, and which it in turn nurtures and rewards. The university is, in other words, made in our own image. It is an extension of what and how we think.

Since this observation is quite unexceptional, it is important to add that this form of reflection is bankrupt. However, its fierce grip on our imaginations permits it to function as the definitive conception of what we are doing and ought to be doing as academicians. Therefore, we rely on it unwittingly to think about the various things we do, *including* our thinking about this form of reflection itself. We are hardly aware of it, since our very awareness is upheld by it.

The origins of this perspective—this angle of vision towardthe world and toward educating people to understand it—can be traced to the seventeenth century. It was the philosopher Rene Descartes who carefully formulated a detailed account of our powers of knowing that became the philosophical foundation for the Enlightenment and subsequently for the formation of the Western imagination. The methodological assumption that undergirds the Cartesian system is an intellectual vision of clear ideas that cannot

be doubted. "The things which we conceive very clearly and distinctly are all true," says Descartes in the *Discourse on Method*.

This reduction of knowledge to a single, powerful image of clear and distinct ideas radically altered previous and subsequent images of reflection, inquiry, discovery, knowledge, and understanding. The unfolding of this model of human intellection over the past few centuries has led to the absolutizing of the explicit, the mathematicizing of space, and a loss of confidence in our ability to comprehend our own minds, our bodies, and our world. In other words, we have been progressively losing our minds even as we have been losing our world.

The most important consequence of the elevation of the explicit to an authoritative position as the final arbiter of truth and knowledge is that whatever is obscure, ambiguous, silent, or indefinite has been banished from the realm of genuine knowledge. The arts have been relegated to a status of epistemological embellishment—art as decoration.

It is the nearly total commitment of the university to the implications of this perspective that has led to the unfortunate but officially sanctioned separations within the undergraduate curriculum: splits between teaching and research, between generalization and specialization, between thinking and feeling, and between the arts and sciences. If we are to avoid deepening these chasms, we cannot accept at face value the addition of education in the arts as one more specialized field in a

disconnected array of university disciplines. We must expose and transform the subtle though pervasive model of human intellection that presently dictates the substance and direction of epistemic activity within the university.

The first task of art educators on the way to staking out the boundaries of a discipline is to offer a radical critique of the received tradition of the disciplines as they have become embedded in the institutional structures of colleges and schools. Before rallying to a popular cry for doing our bit to get students and future teachers better educated in the arts, before succumbing to the professional temptation to be seated at the disciplinary roundtable that daily serves intellectual pablum to under-nourished students, there is the prior and urgent task of reconceiving inquiry itself. Understanding the arts is dependent on a reformulation of the art of understanding.

II

An observation by the scientist-philosopher Michael Polanyi can serve as a point of beginning for the critique that is a necessary prerequisite to reconceiving the status of the arts in the university and to fashioning an effective approach to art education.

> With his unique figure of conscious mind-body, man is part of the total situation in which he thinks. That is, thought is never, despite appearances, a detached activity or product of the brain nor even a sole and pure

> relation between intellect and phenomena. It is always also involved with man's living self as a whole.

Contrary to our inherited ideal of knowing, which has reduced knowledge to disembodied, abstract ideas, what we think and understand is always a part of our "living self as a whole" and of "the total situation in which [we] think." One implication of this fact is that ideas have the power to mean what they do, not because we look *at* them but because we can see *from* or *through* them to something else. What we see is never merely another idea "in itself," because the moment we take up the next idea, we discover its power to release us to the shape of an already emerging idea that is on the verge of replacing or reshaping the original idea.

Understanding this process is crucial. Ideas attract and move us not into "clear an distinct ideas" but into what cannot be clearly seen at all. They negotiate that about which we have no idea. This idea of ideas changes the locus of knowledge from the clarity of ideas "in themselves," or from the ideal of the totally explicit, to the silent and *pre*reflective domain into which and out of which persons move and act. "The 'shape' of the world in which we live," says William H. Poteat,

> is not given only, perhaps not even primarily, in concepts. It certainly can only be talked *about* with concepts. . . . But it is lived in *through our bodies, our choices as they are manifested in our actions, our movements, our routines,*

*gestures, rituals; through our expectations
as they are manifested in what surprises
or disappoints us; through the way our
affections are related to, evoked and
structured by shapes, colors, and sounds
which have undergone a symbolic
transformation and which, therefore,
constitutes for us an "atmosphere."*

An adequate account of the emergence of meaning and the formulation of knowledge must include this "atmosphere" even as it focuses on the *person* who himself or herself takes responsibility for integrating disparate and unspecifiable clues, the performance of which can never be made fully explicit. These acts of integration and coherence that make up the process of understanding are always, at bottom, acts of personal judgment.

Ideas, then, are rooted in and shaped by what is ambiguous; and, in the final analysis, they are what they are by virtue of enabling us to move further into what is ambiguous. The personal capacity to have ideas and to use ideas to move beyond them to what gave rise to them, however fundamentally obscure, is not susceptible to further disassembling. Indeed, moving beyond ideas in the act of having them is what to have ideas *is*.

III

I have taken pains to establish what may seem an obscure and difficult philosophical point because I believe it is crucial for reconstituting an angle of vision that can enable us to perceive the place of the arts in the university. Such reflection has consequences for how we deal with ideas, especially ideas about art, and for how we engage the arts in the process of teaching. It requires a different way of seeing— different, that is, from the regnant and accredited modes of academic inquiry practiced in the traditional disciplines in today's undergraduate curriculum.

I can now offer my second proposal. In the setting of the university, the primary role of the arts at this juncture in our cultural history is to be an instrument of inquiry to deepen our understanding of and access to reality. A distinguishing mark of the arts in the university must be their unparalleled capacity to provide a paradigmatic form of inquiry on the basis of which other disciplines function and cohere.

Furthermore—and this is my third proposal—the arts must reestablish what is now in danger of being dissolved, namely their crucial link to culture. Art educators must be willing to take on a larger task than that of establishing yet another discipline, important as that may be in the short run, for the simple reason that our culture is at stake.

According to Hannah Arendt, the word *culture* (as well as the concept) is of Roman origin. It derives from *colere*, meaning to cultivate, to dwell, to take care of, to tend and preserve. Cicero's use of the word for matters of spirit and mind was suggestive of taste and sensitivity to beauty. Thus, says Arendt, "we mean by culture the mode

of intercourse of man with the things of the world."

Cicero was also one of the first to use the term *humanitas* to refer to a capacity for humanizing beautiful things in order to create a culture. What does it mean to "humanize" what is beautiful? For the Greeks the difference between a barbarian and a cultured person was the difference of being able to make judgments and set limits, even to beauty, for the sake of maintaining a uniquely human culture. The barbarian was not a crude, bumbling desecrator of beautiful things; he was someone with *indiscriminate* sensitivity, someone who did not know how to choose and to set limits. It was the exercise of taste and judgment that debarbarized the world and created culture, which could only exist by taking care of those things that make the world a fit place for human presence.

Understood as a mode of intercourse with the things of the world, culture is essentially dependent on the arts and on the taste and judgment of those who preserve the arts. The arts arise from, generate, and move toward a richer, more meaningful perception of reality. The university is obligated to present and to elicit from undergraduate students potent forms of meaning in the arts and in human reflection that will empower students to exercise taste and judgment in creating, securing, and preserving those objects, ideas, and words that make the world a home for the human spirit.

Unfortunately, in the university we have too often succumbed to the tempta-tion to use the arts as ornaments for other disciplines or to present them as nonserious and nonsubstantive. (By contrast, notice how few "Chemistry Appreciation" courses there are.) Students understand that the wares offered through courses in the arts are peripheral, are entirely optional, are for those with natural artistic talent, or that they may be useful for persons with low-grade anxiety about entering an upscale society without at least a smattering of name-dropping knowledge of the arts sufficient to provide an aura of refinement. They believe that the arts exist in a world apart, private and inaccessible to ordinary undergraduate students. They believe this because schools and colleges have led them to believe it.

Art has been pushed to the periphery of our cultural experience through its roles as consumer product, decoration, and entertainment. At the same time, human feeling has been preempted academically by the science of psychology. Responding to the burdensome legacy in our schools in which art has been reduced to the psychology of self-expression, artists and educators eventually acquiesced in the present curriculum arrangement in which the arts are epistemologically impotent and academically irrelevant. As a result, undergraduate students typically come to the arts not only without knowing what is going on, but without expecting anything significant to happen through the medium of expressive form. Rarely do students feel themselves on the verge of a deeper experience of reality that can shape their

lives. They almost never feel that by studying art they will be making important choices about the kind of world in which they will live. Hence, they are denied the difficult and rewarding task of matching their feelings to words and ideas or to concrete shapes that can become negotiable currency for better understanding.

Some have suggested that in order to recover the importance of the arts in the undergraduate curriculum we must embrace the other side of the affective/ cognitive pole in hope of demonstrating that artists and art educators do know something, and that this "something" can be boundaried and studied in the same way as other disciplines. In this scenario, art educators are poised to leap across the chasm from epistemological irrelevance to accredited knowledge. It is a pivotal moment, a pivotal position. My advice is, don't leap.

IV

The human form—my body—is porous and interpenetrates the forms within and among which it (I) exists. In the context of education, the purpose of which is to facilitate discovery and understanding, art forms are modes of intercourse by means of which we lay claim to that which we already possess. Though paradoxical, it is through this process that we "in-form" ourselves.

Although they are immersed in and surrounded by fabricated and natural forms, our students are distressingly distant—perhaps even alienated—from the significance of the world. And yet, they yearn to give voice to the unspoken, to the whole range and modulation of that which lures and frightens and impresses, which they feel deeply about, and which they want to discover and to affirm.

As silence is both source and destiny of our most ordinary and most profound utterances, so the arts uphold and fulfill what we think and feel and say. They are not merely "basic" in the popular sense; they are essential to the resolution of the human condition. Reflection that leads to understanding—including reflection about the arts—is always a joining of our lives with the shapes and forms in which we dwell, which we create, and by means of which we discover and declare significance of any kind.

The purpose of the arts in undergraduate education is to engage students and teachers with potent configurations through which self and world can be figured. It is also to enlarge the powers—imaginative, reflective, tacit, somatic, social—by means of which such figures are created and preserved. We have seen that this cannot be solely a conceptual activity. For this reason the arts do not, cannot, and should not have equal status with other subject areas in the university. They are, instead, the heart of the university curriculum and life insofar as the raison d'etre of the university is inquiry, discovery, and the shaping of insight and meaning into expressive,

comprehensible forms. Discipline-based art education must be reconceived as art-based education for the disciplines.

To say that the arts are paradigms of the discovery and translation of meaning and should be placed at the center of the undergraduate curriculum is not a matter of professional arrogance or naive exaggeration. It is a matter of cultural necessity. The primary task of art educators is to educate the citizenry about the whole range of human experience. They are uniquely prepared to say what the concrete, tactile world *is*, to give insight into the unique fit of the human form among worldly forms, and to help us understand the possibilities and the dynamics of the interaction of forms. It is a ceaseless, maddening task that requires thinking, talking, imagining, and understanding through the forms we make, the forms we inhabit, and the forms we *are* as embodied, living images.

We humans can only do what we first imagine. Providing access to the imaged world—which is the concrete world of human presence—and exploring the contours of its depths is, in fact, the vital precondition for the wedding of passion and intelligent human action.

V

There is a final task to be undertaken if the arts are to move to the center of the university curriculum and to the center of our shared cultural experience. "The fate of any true culture," says the classicist William

Arrowsmith, "is revealed by the value it sets upon the teacher." Hence, my final proposal: artists and educators, relying on art forms as the source and direction of their own meaning, must self-consciously and deliberately reinvent preservice and inservice education. The arts must give us more than valuable cultural objects and effective forms of inquiry. They must give us teachers.

"It is now a nationally observed phenomenon," says John McDermott,

that despite good intentions on the part of teachers and generally intelligent students, even those students who proceed on to colleges and universities seem culturally deprived. They exhibit a staggering ignorance of history and letters, and their symbolic resources for imaginative reconstruction seem bankrupt. It is as if the soul has disappeared, leaving only a more or less satisfactory standardized test as the approach to learning.

Teaching the arts is an urgent professional and cultural necessity. It can only be accomplished by engaging students in a process of inquiry through the arts that draws them irresistibly into a more profound relation to the world and enables them thereby to feel the lure of sharing their understanding, even as they continue to deepen it.

When taught effectively, art makes teachers as surely as artists make objects. This is because we cannot help wanting to

share with others what we see and hear and feel about what matters deeply to us. This sharing for the sake of the delight of mutual understanding is what teaching is all about, and it is why it is the most natural of human acts. Before teaching is chosen as a profession it is felt as an ingrained necessity. There is no one who does not want someone to know what he or she knows. Everyone wants to teach, to share what they have found out.

Therefore, the case for the arts in the undergraduate curriculum is always at the same time a case for teachers who are passionately engaged in the process of integrating their own lives with objects, words, ideas, and meaningful forms that ennoble their own lives and the human community. It is this relentless engagement—intense, bewildering, risky, ambiguous —that is the sine qua non of teaching and inquiry.

The Great Education Reform Movement of the past few years had had little to say about such matters. But, says the critic Benjamin DeMott,

> *a serious injustice is done . . . when we persuade ourselves that Instant Voluntarism or Higher Pay or Longer School Days or Key Schools or intricate combinations of these and other schemes speak adequately to our situation. For generations we have been skidding over the surface of our "education problem." For generations we have pretended that we can have good schools without possessing a clear sense of the genuine. We have pretended that we can have good schools without possessing a citizenry aware of the difference between base and worthy desires, between acts of skill and inside-the-law rapacity, between primary purposes (renewing the pieties from generation to generation) and secondary purposes (profiting, entertaining, exciting ourselves). We have pretended that we can have good schools without having a close-grained knowledge of how the generations can speak truthfully to each other, how to confront what is ignoble or embarrassing or self-involved or contradictory in ourselves and our values. We have pretended that we can have good schools without empowering our teachers to speak candidly to the young about the impossibility of sane coexistence between the philosophy of dog eat dog and the ideal of fraternity—loving concern by the strong for the weak.*

Teaching in the arts must shatter these pretensions and permit access to the unavoidable conditions of human life in the world: birth, death, sexuality, breathing, hurting, having a past, lying, forgiving, remembering, weeping, dreaming. These conditions have given rise to the configurations of meaning that constitute for us a world, a culture. Out of these patterns of meaning that make up the atmosphere of our lives, reliable imaginative structures have been built that we can pass on to our students. Teaching them is more a matter of courage than of pedagogical technique or curriculum design.

IMPLICATIONS OF DISCIPLINE-BASED EDUCATION FOR PRESERVICE ART EDUCATION

PANELIST

Kathleen Cohen

San Jose State University

In addition to our desire to add art history, art criticism, and aesthetics to the secondary and elementary school curricula, many school districts have been mandated to offer a multicultural perspective to their students. This mandate was echoed last year by a number of the groups at a California State University symposium sponsored by the Getty Center for Education in the Arts and the California State Department of Education. The new expectations are truly overwhelming: we must teach prospective teachers not only studio competency, but also art history, art criticism, and aesthetics, and instead of just the Western tradition, we must now deal with the art and culture of the whole world.

As we all know, any attempt to add material to the curriculum, whether at the university or secondary level, is bound to be met with cries of "with all the state requirements, there is no more room; we already have too much to teach; we can't possibly add anymore"; etc.

How do we deal with such concerns? My answer is to *infiltrate* and *integrate*. We must make certain that prospective teachers have significant studio experience, a course in art appreciation, an introduction to the problems of aesthetics, the basic survey of Western art, and at least one course in the art of a non-Western culture. But for art to have a significant impact on the professional lives of our students, we must find additional opportunities to make them aware that art is an integral part of human life and civilization. We need to think about ways we can infiltrate literature and social studies classes, whether in American history, world history, or ethnic studies. We want, as much as possible, to saturate the students with art, to make it seem like a natural activity, and we want them to see good art images in many contexts, to create them and study them in art classes, and to see and use them in courses that span the curriculum.

I would like to give an example of what I mean, using a page from an early fifteenth-century book of prayers. We might ask the students why someone would make a work like this, pitching the complexity of the questions to the level of the students. Why would a picture of men planting crops in front of a castle be in the middle of a book of prayers? What purpose did it serve? What does it tell us about society, and where does it fit into the development of art history?

As we examine the work, we see that it can help us understand aspects of the history of agricultural technology, transportation, economics, ecology, architecture, warfare, astronomy, medicine, as well as the history of art itself.

The horse pulls a wooden harrow, an important agricultural implement for the heavy soils of northern Europe. The medieval invention of the horse collar increased the utility of horses as draft animals by transferring the bearing

pressure from the neck, where increased effort caused strangulation, to the shoulders. With the aid of the strength of the horse, the rich but heavy soils of northern Europe were open to the plow, and more work could be done more quickly, with increased crop yields and consequently increased population.

The boats on the riverbank illustrate the major medieval mode of transportation, while a wagon, the other important conveyance of the time, appears in a fanciful version in the sky. The buildings in the background illustrate the growth of cities that was made possible by increased agricultural production and better transportation.

The depiction of the heavy walls allows us to study the development of defensive fortifications. The illustration is particularly useful for the history of architecture since it depicts the old palace of the Louvre in Paris, which was destroyed to make way for the present building.

The black-and-white jackdaws indicate the spread of these birds, while the state of the trees along the riverbanks indicates the practice of pruning twigs for wattle-and-daub construction of houses and fences.

Science, too, is represented here. We can study the use of astronomical calculation, for this page from a medieval agricultural calendar illustrates the months for fall planting. The corresponding signs of the zodiac, Libra and Scorpio, are shown, along with the stages of the moon. The best days for bloodletting, an important medical practice of the time, are indicated on the calendar.

The medieval use of classical motifs is apparent from the figure of the Greek sun god Apollo in his chariot, who is portrayed as a medieval king.

Tying the image to all these other fields is used not only to reinforce what students are learning in history classes, but also to capture the interest of students with varied concerns. We can then lead them to a consideration of the work as an important monument of art history, for the minute description of the details of nature found in the early fifteenth-century manuscript set the stage for subsequent developments in the art of the northern Renaissance.

We might ask the students to try to figure out how the picture was made, what size it was, what medium was used, what size the brushes would have to have been, etc. We could ask them what terms would be useful in order to talk about this work. What would we need to know in order to place the work in its art historical context? How would we analyze its style? Is this work any better or worse than others done at the time? What else would we have to know in order to answer that question? We might ask the students to imagine that they were critics working for the Duke of Berry, who commissioned the work and who wanted a report comparing the work of the Limbourg brothers, who painted this manuscript, to that of other artists working at the time. Should he commission a work from them or from someone else?

Students could be asked to try their hands at doing a modern version of the work, which is a medieval calendar depicting the work appropriate for each

month. What would they draw to depict the key activities of their lives each month?

We might even get the English or history teacher to allow students to use this picture as the basis for an essay, asking them to imagine themselves as one of the characters in the scene and write an essay describing what that person might do in one day, and what his or her thoughts might be.

We all know that connected learning is more effective than separated bits of information; yet as academics we are trained as specialists, we get our rewards from publishing carefully researched articles within the narrow range of our expertise. How are we to guide our prospective teachers into making connections between ideas, between disciplines, between cultures?

As art historians we are used to professing, to lecturing, and some of us do it well. But is this going to be the best way to integrate art history into the elementary and secondary curricula, for remember, our students will do what we do. Might we think about what we can learn from the approach of our studio colleagues of assigning problems, of allowing students to discover for themselves, of teaching them to ask questions about particular works of art, and about how those relate to other things they are studying.

As art historians we try very hard to give students as much information as we possibly can, because it is so interesting. We want them to know all the answers, and are disappointed when they don't. But while we can't give them all the answers, perhaps we can teach them to ask the right questions.

Next question: Where do we learn the right questions? I would suggest that we learn them from our colleagues in other disciplines, that we set up opportunities on our own campuses to do the kind of thing that the Getty Center is doing here, to bring together people from various disciplines to learn from each other.

I became aware of how stimulating this could be several years ago when I served as director for a project to develop six interdisciplinary courses in world civilization, each taught by one faculty member from the humanities and one from the social sciences. I worked with them to develop common themes among the six courses and helped them find the images they needed for their courses. I also tried to make them realize that they needed images, and I was successful when they discovered how much easier it was to get the students to talk when they were stimulated by works of art illustrating the life of the time. We all worked very hard, learned a tremendous amount, and had a very good time. One of the evaluators commented that the project had the unplanned, but very effective, result of a sort of do-it-yourself faculty renewal.

When I studied for a teaching credential many years ago, I was bored by the methods classes, and as I studied for my Ph.D. and during most of my academic career I concentrated on content. Now, in my old age, I am getting more and more interested in how we teach and how we learn to teach. I am also becoming convinced that we learn best from each

other, that is, if we can set up the appropriate circumstances.

It may just be that the challenge we face will provide the appropriate circumstances for using our best resource: each other. We truly are faced with a tremendous challenge: how to prepare students to teach art from a much broader perspective than we were taught. In order to teach them, we must first teach ourselves. The way we teach sets the model for the way our students will teach. If we give them lectures, they will give lectures. If we give them technical studio projects, they will give technical studio projects.

In order to deal with the challenge that faces us we must be willing to take risks, to experiment with the ways that we teach. I would like to share with you an experiment I tried last year in an undergraduate art history class I was teaching. The purpose of the class was to teach students research skills, and I decided to focus on teaching them to find out the levels of meaning in a particular work of art in contrast to doing formal analysis of it. I gave them a general bibliography, told them each to pick a partner, and then asked each team to select one of the many reproductions of artworks that I had xeroxed. They were to go forth and find out what the artwork meant. One of the pair was to be responsible for giving a report to the class on their conclusions, while the other was responsible for preparing an annotated bibliography. Roles were reversed for the next problem. I was truly amazed at the amount of work they put out. My own role was as questioner

rather than professor. I will have to admit that I felt very lazy not doing my usual performance, and I will also have to admit that I suspect that the students learned more that semester about learning and the excitement of the scholarly hunt than they did when I did my usual lecture routine.

I believe that working as a member of a team was an important part of the process. In our disciplines, we usually work alone and teach our students to work alone, but much of the work of the outside world is done as a member of a team. I decided to try it in my own class after I had experienced it in an aeronautics class I was taking in order to get my license. I had found that it was a much easier way for me to learn, so I thought I would see if it was a better way for my students to learn. It was.

I find that I learn the most, not from people or books in my own discipline, but rather from those in other fields. It was a computer expert, not an academic, who stressed the fact that we must teach a tolerance for ambiguity, that there are no definite answers to difficult questions. Instead of teaching our students to memorize, we should teach them to build what he called "knowledge coupling tools," using a model like the following:

- define your problem
- define your options
- ask questions
- connect to the library

I would add one more element: go to the art medium of your choice and create. For there students will find the element that we

as artists and art educators can best add to the sum of human experience: the element of creativity, of the new and unexpected solution. One need not seek answers only in authority, but also within oneself, through the expression of one's art.

I am now doing another experiment: creating a videodisc that contains over 15,000 art images from many cultures and many periods. It is accompanied by a computerized database that will allow search of the images by subject as well as artist, style, medium, country, and period. I know it will change the way I teach, for I want to use it as the basis for designing experiences for students, of setting up problems of comparison between cultures and styles.

I am also interested in the resource that such a compact and inexpensive collection might provide for high school teachers who now must teach art history. This brings up a problem that we must think about in training students to teach art history in the public schools: Where will they get the visual resources they need? We must teach them how to make slides and to start building their collections!

As you discuss plans for teacher training on your campuses, let's see if you can infiltrate at least one course in the program—perhaps a final seminar—in which you can give students the experience of creating integrated lessons, not listening to theoretical lectures, but rather experiencing the unified core, not only of art history, but also of art expression itself, which lies at the heart of civilized life itself.

PANELIST
Edmund Burke Feldman
 University of Georgia

———————————————

One of our most cherished buzz words is "bottom line," an expression that has made "What is the bottom line?" a virtually universal question. It probably reflects our impatience with long, careful, reasoned presentations that go on and on without coming into focus. Hence, let me present my idea of the DBAE "bottom line" at the outset, keeping in mind that we are primarily interested in its bearing on the education of art teachers.

I think discipline-based art education is fundamentally an endeavor to produce balance and comprehensiveness in teaching and learning about art. That balance seeks reconciliation between praxis and theoria, between depth and breadth, between doing and undergoing, between the present and the past, between the forest and the trees. Educators might well keep these polarities in mind, both for the sake of authenticity with respect to art itself, and in order to make art instruction a worthy and integral part of the total educational enterprise. Let me add that I have been advocating just such a balanced approach to art instruction for more than thirty years. This is not merely to claim primacy, but to point out that the notion of a multidisciplined sort of art teaching has been around for many years. Indeed, if we study what the best teachers, scholars, and critics of art have said and done we come away convinced

that they command knowledge of many disciplines: history, philosophy, psychology, anthropology, sociology, and so on. What characterizes the great thinkers about art, I believe, is the ability to integrate diverse modes of studying a subject—art—that tends to be grossly oversimplified in teaching and in common discourse.

Notwithstanding the wide knowledge and personal culture of outstanding art critics, scholars, and educators, there has been a narrow technical bias in the preparation of art teachers. The reasons for this bias are too complex to analyze here. Suffice it to say that the typical graduate of a college or university art education program usually feels prepared to conduct studio instruction, but not much else. Furthermore, that teacher tends to believe that the various art disciplines or bodies of ideas dealing with art are best approached via drawing and painting, modeling and carving, ceramics and printmaking. Indeed, many a doctoral dissertation has been written to prove that tempera painting or clay modeling teaches us all we need to know about art. In other words, a great deal of educational research has been devoted to confirming "scientifically" that our well-established educational practices are right. The received wisdom is that to study art one must make art, and, like the folklore that accumulates around any important enterprise, there is some truth in the proposition. However, it isn't the whole truth.

What must impress any outside observer of art instruction is the considerable amount of nontechnical knowledge that can be imparted in courses ostensibly devoted to mastery of particular artistic media. This is a tribute to the teaching instincts and wide experience of our best studio instructors. Still, we cannot expect whole courses of study, the general education of citizens, and the training of competent art professionals to succeed by virtue of spontaneous connections made by inspired teachers. We need more deliberately planned strategies for reaching the broadly humanistic goals envisioned by those who want art to play a significant role in our lives.

We come, then, to the idea of curricular strategy and especially of disciplinary collaboration in the education of prospective art teachers. At present, our teacher education programs require a great deal of studio work, some art history, some so-called methods instruction, and a smattering of art criticism and philosophy of art. In many situations, criticism and philosophy of art are taught only at the graduate level. To complicate the picture, art educators, perceiving serious philosophic and critical blanks in the education of art teachers, attempt to make up the deficiencies through their courses in methods of art education. Such courses usually last only ten or eleven weeks, and they must of necessity include a great deal of professional education subject matter. To make matters worse, the typical professor of art education may not be especially well prepared in criticism and the philosophy of art.

So it would appear that we need to enlist

the services of philosophers, aestheticians, and art critics for the preservice education of art teachers. (I am assuming that specialists in the studio disciplines and in art history already teach their subjects in any certified program of art teacher education.) Does this mean we need at least a five-year program for the preparation of a competent art teacher? It does.

Now, assuming that colleges and universities will move toward five-year programs of art teacher education, certain questions remain: Do we deal with our problems by adding new courses to the curriculum? If we do, is there any sequence that we can recommend for these courses? Then how should the new instruction be delivered? And what sort of persons ought to be assigned to teach this "new" material?

First, should we add new courses? Simply stated, yes. My generation of art students discussed criticism, philosophy, aesthetics, etc., outside of class because our regular instruction did not cover this material—not, at least, in sufficient depth to satisfy us. I think a licensed art teacher ought to have passed a course in the philosophy of art just as a physician ought to have passed a course in medical ethics. By "philosophy of art," I mean instruction in the functions, purposes, and values of art in human societies. I think such courses should examine the status of art as knowledge, the morality of art, the grounds of critical judgment, and the relation of art to major social institutions such as family, community, church, state, industry, commerce, and education.

I tend to distinguish between philosophy of art and aesthetics. By aesthetics I mean essentially psychological aesthetics —the study of the art experience in the Deweyan sense, including the nature of artistic expression and the nature of representation. Ideally, we should have a separate course in aesthetics. If that is not possible, the subject matter of aesthetics can be introduced in a philosophy of art course. But if there is limited curricular space, I recommend that psychological aesthetics be sacrificed in favor of a thorough exploration of the above-mentioned topics in the philosophy of art.

Second, is there a desirable sequence of DBAE studies? I recommend that the sequence (outside of studio courses) be from art criticism to art history to aesthetics to the philosophy of art. It is not a good idea to study aesthetics or to philosophize about art before one has had considerable experience with individual artworks *in depth*, as well as experience with the *varieties* of visual art. It is mainly through art criticism that we study individual artworks in depth; and it is mainly through art history that we encounter the many kinds of art styles, media, and genres distributed in time and space, that is, in their geographic, political, religious, and social variations. Only then are college students, much less students in the schools, equipped to make philosophic observations about art—observations that are hopelessly distorted by familiarity solely with one's own culture or one's own artistic endeavors.

Third, how do we deliver the material?

Generally, I favor "courses" as the best way to transmit the DBAE subject matter we have mentioned. Team teaching, I think, is a good thing provided *someone* has the responsibility for organizing and integrating the contributions of the various team members. That "someone" is usually more qualified by personality and teaching skill than by academic discipline. In my experience, art educators do well here: they often exhibit more catholicity than the other art specialists, possibly because art education is itself a hybrid discipline. A caution here: we should be somewhat skeptical about anyone's claim to have devised an incredibly innovative course that integrates philosophy, history, music, drama, dance, theatre, anthropology, and right-brain thinking. A certain amount of modesty becomes those of us who work in college and depend on the contributions of colleagues to provide students with a comprehensive education in art.

Fourth, whom would we engage, assuming we have the luxury of choice? I would want my critics, historians, and philosophers to know a lot about the *visual* arts. We have not had many universal men or women since the Renaissance; hence we should beware of dilettantism masquerading as liberal education, holistic education, or whatever. There are really important differences between architecture and painting, between industrial design and cinema, between Gregorian chant and hard rock. Our instructors should be serious students of those differences. To be sure, one can find superficial analogies between any two phenomena but such analogies are more in the nature of entertainment than instruction. Besides, the fun of integrating the various disciplines should not be denied to our students. Too much advance mastication of art subject matter reminds one of the way certain birds feed their young: the fledglings are nourished by that mushy stuff, but it doesn't teach them to find food.

Fifth, a further word about the integration of DBAE and related disciplines. As mentioned above, I am skeptical about the wisdom of doing the work of integration *for* students. We must bear in mind that the work of art, the artistic image, is already a highly integrated phenomenon. That is, a good many personal, social, religious, economic, and historical events have been embodied in its more or less unified form. Our task as teachers is really a matter of teasing out the social, psychological, etc., meanings of particular artworks. What this implies in terms of instructional strategy is that we should talk less about art in the abstract and more about particular buildings, pictures, and statues.

I would urge, even plead, that our precious instructional time be centered on the examination of artistic images, with teachers and students jointly endeavoring to extract their meanings from a variety of disciplinary standpoints. A negative stricture here: don't encourage teachers and students to talk grandly about art and revolution; instead, make them look at a David or a Delacroix or an Orozco, and let

them specify the objects, shapes, colors, etc., that justify their talk. In other words, let us not engage in *theoria* until we have earned our spurs in *praxis*. It seems to me ludicrous to listen to pupils talk about the Aristotelian concept of *mimesis* when they are unacquainted with classical Greek sculpture, or the realism of seventeenth century Dutch still-life painting or Ivan Albright or Edward Hopper or contemporary American photorealism. What I am saying seems obvious, but it may be heretical in certain educational circles: studying instructional strategies is fine and dandy but it is no substitute for studying art. Incidentally, when studying instructional strategies, make sure they have been dreamed up by persons who have taught art.

If you wanna integrate, you gotta have some stuff to integrate with. So let's get a reasonably comprehensive fund of artistic images into our students' minds. I see no way to duck this task and I don't see why we would want to duck it. As to the process of delivering the images—without behaving like undertakers, without converting teachers into tourist guides, without slighting the world's major traditions, without overlooking the art of this century, without falling victim to "presentism," and without boring students to death—that would be worth a seminar.

Finally, there is the problem of instructional leadership. I shall not attempt to offer advice about how to get painters, potters, and printmakers to fraternize with art historians and aestheticians. But obviously, they must fraternize before they can collaborate in the presentation of the material that will become the stuff that students integrate. So we must meet together to develop a modus operandi if not a modus vivendi in order to plan courses and curricula. Persuading the prima donnas who populate our faculties to consider questions of instruction (and perhaps to change what and how they teach) is no small feat. That, too, is an art, an art that might well be added to the four DBAE disciplines.

PANELIST
Anita Silvers
San Francisco State University

———————————

Some say that nothing short of a time machine to transport American education back to its purported Golden Age could satisfy the current educational reform movement. The message broadcast by a multitude of reforming commissions and best-selling authors like Allan Bloom and E. D. Hirsch has appeal because it promises that we can retrieve an ordered, purposeful curriculum and world. Nor should we too hastily assume that the past is impossible to recreate, especially when the past's most desirable features are its ideals.

After all, the attraction of ideals lies in their being sought, not necessarily in their being attained. But to be realistic in pursuing ideals, we must comprehend how what is essentially abstract nevertheless is learned concretely. We need to understand how the direct, concrete perception of an ideal instance or paradigm or key image can communicate what is general, and consequently can have significance beyond the immediate moment. To the extent we master this crucial cognitive strategy, we can improve how we train teachers to teach tradition and values, as well as how we teach them to teach art.

For many reasons—among which is the affinity of contemporary psychological theories with the nineteenth-century romanticism that celebrated artistic creativity—the shift from teaching common content to developing individual potential proved fertile for education in art. Departing from their academic predecessors, twentieth-century art educators displayed reluctance to rely on the masterworks of the field as guides, even though the appreciation of modern and postmodern art incorporates essential references to historical masterworks. But perhaps because of the critical linkages of art to its own history, art studies did not beat as hasty a retreat from subject-matter content as happened elsewhere in education.

Nothing could diverge further from the approach of an art educator like Joshua Reynolds, founder of the Royal Academy, than John Dewey's approach to education in art. Post-Deweyan art educators avoided inhibiting students by imposing paradigms of great art. For shared images, shared tradition, and shared values, they substituted appeals to students' common psychological development to justify a curriculum. Despite them, Dewey himself observed, learning about art remains part of learning about cultures. So, art education can play a very special role in conveying tradition from past to present.

Whereas we cannot directly encounter events or persons from the past, art objects available to past persons can be equally available to us. Through direct, concrete perception of the objects our ancestors also perceived, informed by the narrative and theoretical frameworks through which they looked at these same objects, we can share appreciation of Raphael's paintings with

Vasari, Joshua Reynolds, and Clive Bell, and appreciation of Chartres with Henry Adams as well as with its Gothic builders. In so studying art, we can look directly at the perceived ideals, visual paradigms, or key images of present or past persons or societies. Thus, to master the subject-matter content of art is to possess at least partial mastery of tradition and culture.

What is the subject-matter content of art? A way of answering this especially attuned to Postmodernism is what aestheticians call "the Institutional Theory of Art." This theory posits a special kind of world, the art world, as a fundamental explanatory concept. The art world has a special kind of history, methodologically different from the history of events. The art world is delineated by certain institutions constructed out of characteristic practices informed by commonly acknowledged, but not necessarily commonly accepted, narrative histories and evaluative theories. The art-world institutions define, at any time and place, what objects are included in the collection of works of art. Consequently, mastery of the subject matter of art requires participation in the art world's institutions, which means skillful engagement in the art world's institutional practices, which in turn presumes facility in furnishing and framing narrative histories and evaluative theories, so as to be able to distinguish between art and nonart in producing and in appreciating aesthetic objects.

A corollary of the institutional account is that mastering the disciplines of art mak-

ing, art historical narration, art criticism, and aesthetics is central to participating in the art world. To teach teachers to devise concrete learning activities for engaging students in the art world requires collaboration among the practitioners of the art studies' disciplines. The special character of the art world prohibits divorcing instructional strategy from content. This is an implication of one of the romantics' important insights: that art cannot be constrained according to rules. Because each work, and each style or period, is the ultimate arbiter of which theories or principles illuminate it, one cannot understand what teaching strategies effectuate learning about a work, style, or period prior to understanding the work, style, or period itself.

To be concrete about what teachers would be taught, let us explore a concrete instance of what they should teach. The following example of a DBAE lesson was adapted from an article in the *Los Angeles Times Magazine* (1985) to serve to introduce the essay "Becoming Students of Art," by Clark, Day, and Greer (*The Journal of Aesthetic Education*, Vol. 21, No. 2, Summer 1987).

The fourth-grade students examine the face of a woman projected on the wall in their classroom. The face is expressionless and the children describe it, noting the kinds of lines and colors used by the artist. The image changes as another face is projected. The woman has a different expression; her eyebrows are

knit and her mouth takes a dive. After mimicking her attitude by pulling their own faces into dramatic frowns, the children agree. This is not a face that expresses joy.

Lights snap on and the children go to work drawing and painting expressive faces. After assessing their own artwork, the children see a picture of a sculpture by German artist Wilhelm Lehmbruck and hear that his melancholy bronze figures reflect his depression about World War I. So ends a session on the shape of human emotions.

"Bring me a van Gogh, a Homer, and a Renoir," the teacher suddenly instructs the boy in her class. Reacting as though these are his best friends' names, he quickly extracts reproductions of the artists' paintings from a large bin of prints. "Who painted this picture?" the teacher asks, elevating a Vincent van Gogh Self-Portrait. Several hands shoot up. Having dispensed with artistic identification, the youngsters analyze the painting's swirling strokes, intense color, and, again, the sadness of the face.

The class moves on to Winslow Homer's Snap the Whip, noting the artist's penchant for dramatic movement, and then to a sunny French Impressionist landscape by Pierre-Auguste Renoir. Wildly waving a hand until he's called upon, a dark-haired boy offers his interpretation of Renoir's painting. "Oh, you do love the Impressionists," laughs the teacher.

During this lesson, the fourth graders have engaged in various activities that might be elements of developing their mastery of art:

1 They have *attributed expressive properties* to drawings of the human face by identifying the lines and colors constitutive of pictured expression and by associating the looks of the drawings with the looks on their own faces when they express emotion.

2 They have *given meaning* to a sculpture by connecting its expressive properties with both the feelings and the historical situation of the artist who made the sculpture.

3 They have *evaluated* new works of art.

4 They have *recognized the styles* of various artists.

5 They have *interpreted* some well-known works.

Or have they?

A skeptic might claim that these fourth graders are mimicking, rather than mastering, the appreciation of art. Suppose that their identification of van Goghs, Whistlers, and Renoirs results from their having memorized who painted each painting, much as they memorize the multiplication table, rather than from their recognizing stylistic characteristics? Suppose what they mean when they attribute expressiveness to the drawings is simply that the drawn faces reproduce the looks

typically adopted when humans emote, so that their reason for saying that Hals's and Cassatt's portraits of elderly women express happiness is merely that both paintings depict smiling faces. If this is the case, how can they perceive pictures without faces as expressing happiness? Suppose that, having heard Lehmbruck's story (i.e., the story *about* him), they decide his sculptures must be melancholy before they see them. If these are the sorts of reasons that guide children's activities, the skeptic might charge that their teacher's approach inhibits rather than improves their competence to deal with the aesthetic domain.

From the *Los Angeles Times* account, we cannot tell whether the youngsters are genuinely studying art, or whether they are misled into thinking that learning about art is just like learning math and social studies. While I have no quarrel with those who contend that the classroom activities depicted in this account may be effective introductions to art, I am sure that a crucial test of how effective such introductory studies are lies not in whether children learn to deal with clear cases, amenable to noncontroversial resolutions, but in how they respond to cases in which rote learning, rules, and recipes do not suffice.

For one thing, such puzzling cases probably are more reflective of the high points of art study than are unchallenging ones. In attributing, interpreting, assessing, and in other characteristically aesthetic activities, we enjoy artworks for their individuality by rendering their idiosyncrasies intelligible. It is in appreciation of the uniqueness of art that our most memorable aesthetic enjoyment lies.

Also, challenging cases invigorate the process of reason-giving. Puzzle cases are intriguing in virtue of their omitting, or violating, conditions otherwise assumed, relied on, or taken for granted in clear cases. As a result, we must puzzle out what we see in the absence of some of the reasons and cues usually available to inform our perception. In so doing, we attend more reflectively to those features of the work that remain available to serve as illuminating reasons.

Pedagogically, puzzling out and thus developing conclusions affords two related benefits. First, typically overlooked features, those obscured in straightforward instances by the very clarity with which the cases are resolved, have a chance in puzzling cases to receive their appreciative due (this phenomenon is taken advantage of in much postmodern art). Second, reason-giving itself becomes a more explicit and reflective process, more masterfully commanded by the reason-giver.

As instructional strategies and subject matter content are inextricably intertwined, so mastery of appreciative skills is inseparable from knowledge of art. This promotes a curriculum in which challenging cases occasion students to acquire a knowledge of art, to exercise skills in creating interpretive and evaluative conclusions, and to prompt reflection on the aesthetic

concepts and methodologies invoked during these processes. Such a course could suit both the general-education and teacher-education curricula, particularly if it were designed and taught collaboratively.

Here is a sample college class that is structured somewhat unrealistically so as to parallel the fourth-grade class. It is essential to this class's success that the course or curriculum in which it is embedded has given students foundational learning in the history and theory of art. Only when on a firm foundation of knowledge are students secure enough for puzzles to be productive for learning.

The college students examine the face of a woman projected on the wall in their classroom. The face is expressionless and the students describe it. The image changes as the same face, now thickly covered with white makeup, is projected. The students consider whether the second picture is more expressive than the first. Da-wei, who accompanies his grandfather to performances of Chinese opera, proposes that the second picture reveals the subject's craftiness. Tanya, who has recently seen Walt Kuhn's *The White Clown*, agrees that the second image is more expressive than the first, but she attributes an expression of sadness to it. The students discuss whether they are contradicting each other when one says the face expresses craftiness because it is white and the other says

it expresses sadness because it is white. One of them wonders whether the paleness of the face portrayed in Roger van der Weyden's *Portrait of a Lady* makes the lady seem sad or crafty.

"Bring me a David, a Chardin, and a Fragonard," the teacher suddenly instructs. A student quickly extracts reproductions of the artists' paintings from a large bin of prints. "Who painted this picture?" the teacher asks, elevating a copy of the portrait of *Mademoiselle Charlotte du Val d'Ognes*, which was bought by the Metropolitan Museum of Art in 1922 to represent the work of Jacques-Louis David in its collection. Several hands shoot up. Having dispensed with artistic identification by noting the 1951 discovery that the work probably was painted by David's student Constance Charpentier, one of the students quotes a critic of the 1950s to prove that the Met's curator had been negligent or incompetent in attributing the painting to David: "Its poetry, literary rather than plastic, its very evident charms, and its cleverly concealed weaknesses . . . all seem to reveal the feminine spirit." The students argue about whether interpreting the painting as poetic and feminine is the cause, or the effect, of attributing it to a woman painter. They compare its charm, its femininity, and its weaknesses to the other pictures pulled from the bin: Chardin's *The Young Governess*, David's

Madame David, and Fragonard's *A Young Girl Reading*.

Next the students see a picture of Veronese's painting titled *The Feast in the House of Levi* and hear that its original title was *The Feast in the House of Simon*, i.e., the Last Supper. Veronese was accused of heresy because he included a figure whose nose is bleeding, another who flourishes a toothpick to clean his teeth, and St. Peter carving while the apostle next to him holds out his plate impatiently. The judges of the Inquisition believed these images mocked church doctrine and gave Veronese three months to revise the painting by eliminating them. Instead, Veronese renamed the painting *The Feast in the House of Levi*, and it no longer struck the inquisitors as expressing scorn of the church. The students consider whether Veronese's painting is still a painting of the Last Supper, whether changing the title could change what the picture expresses, and why Veronese took the risk of revising only the title but not the painted surface.

The class moves on the Leonardo da Vinci's *Mona Lisa*, noting the artist's penchant for ambiguity, and then on to some variations on the image: Duchamp's and Dali's mustached paintings, an ad for Levelor blinds, a reproduction of da Vinci's painting on which one of the students has painted a pink and green punk hairdo and a spike necklace. Wildly waving a hand until he's called on, a pink-and-green-haired boy insists that all the versions of Mona Lisa are equally art. ''Oh, you do love Postmodernism,'' laughs the teacher.

How is the college lesson advanced beyond the fourth-grade one? The college students engage in the same characteristically aesthetic activities that the younger students do. They attribute expressive properties, recognize styles, interpret, give meaning, and evaluate. But, unlike the fourth-grade lesson, the cases that constitute the college-level lesson do not admit of a single clearly correct response, nor could any student succeed with a simple yes or no. Addressing any of the cases convincingly is a complex cognitive activity requiring the giving of reasons of various kinds, all of which derive their relevance by appeal to implicit or explicit art historical, art critical, or aesthetic narratives or theories.

What point is there in worrying about whether Veronese's painting glorifies the sacred or the profane or profanes the sacred? If we were teaching biology or French, it probably would be an instructional error to present students with complex or borderline examples until their mastery had become sophisticated. But the subject-matter content of art is unlike that of naturalistic studies. We bring students to appreciate nature by revealing the lawlike operations and systems and reiterated

regularities that underlie what may first appear chaotic and unorganized. In contrast, we bring students to appreciate art by revealing the novel or original method of effecting intelligibility in what may first appear chaotic and unorganized.

In the Veronese case, confusion is exacerbated by the insouciance with which Veronese changed the painting's name. Veronese's action appears to rule out our taking the painting to depict a historical event, because changing the reference to a depicted event did not require changing the picture. Often, titles are relied on to provide evidence of what paintings depict, and what a painting depicts indicates what the picture means. Here, this kind of clue is eliminated. We can identify the referents of at least some of the figures (for instance, Christ and the apostles), but the title change obscures our identifying the depicted event.

Without clearly recognizing the event, can we determine how the pictured sacred and profane figures relate to one another from internal evidence alone? What is the composition of the work, and in what patterns does it draw the eye? What is the function of the architecture in the composition? These questions, although they are internal, are illuminated by contrasting Veronese's painting with other treatments: Veronese's overcrowded dinner compared with Leonardo's less populated one, Raphael's imposition of unifying geometrical shape upon architecture and gesture compared to Veronese's more distracting uses of the same shapes.

Successful comparisons enhance our perception of whatever is compared, and we come to perceive Veronese against the contrast of his predecessor painters.

Art critical and art historical reason-giving effectively draws attention to, rather than abstracts from, the directly perceived properties of the works themselves. Even that part of the process that might be thought to direct our perception away from the Veronese to other paintings actually helps us see more about each painting, including the Veronese. Does the Veronese have a crowded, chaotic look, or is it dense but organized? How does it appear when considered as a successor to Raphael's *School of Athens*? How does it appear when considered as a predecessor of Frith's *Paddington Station*?

And in looking at and thinking about this puzzle, do we not also address another, more abstract puzzle: the interfacing of the sacred and the profane in the physical world? By struggling to resolve this puzzle as it appears in the case of the Veronese painting, we can retrieve understanding and revitalize experience of abstractions that are crucial elements of culture and tradition. We bring our mastery of the skills and knowledge of art criticism and art history to bear to adopt or construct a conceptual or philosophical framework that places this Veronese painting in perceived relationships that expand our aesthetic and cultural appreciation.

To reflect the individuality of appreciative experience, to promote the integration of application and theory, and

to stimulate sensitivity to the conceptual framework itself (for Kant and Coleridge, a key element in aesthetic experience), treatment of challenging cases is crucial to the curriculum. I have used a college-level class to illustrate the mastery we should expect from our preservice students. The skills acquired in such a challenging col-ege course can be used with advantage to create appropriately similar challenges for younger students. Here the experience of art educators is particularly important. To provide the foundation on which students can engage art puzzles, art historians, critics, and aestheticians can use guidance in sequencing their presentations of foun-dational knowledge. For example, we are inclined to introduce art history to adults chronologically because its methodology is so profoundly evolutionary, but this may not be the best pedagogical sequence to employ for children.

Because art studies cannot abandon the concrete, they are anchored in immediate perception and consequently are suited to children's cognitive abilities. For children as well as adults, the process of unlocking key images can retrieve or recreate crucial cultural principles and occasion compre-hension of abstractions that have informed cultures of the past. This potential permits art educators to respond to the reform movement's call for education that retrieves and revitalizes tradition and culture. If art educators accept the challenge, the growth art education enjoyed during the shift away from core curricula can be maintained now that education is shifting back.

POTENTIAL IMPACT OF RECENT NATIONAL REPORTS ON PRESERVICE ART EDUCATION

PANELIST
Martha E. Church
Hood College

Association of American Colleges Report,
Integrity in the College Classroom:
A Report to the Academic Community

I shall refer periodically to the pieces of paper that start out, "The Association of American Colleges," and my hope is that before you start writing your contract plans you will read through these. The second set, prepared by Arthur Chickering at Memphis State University, gives you a handy guide to what's going on and what has been talked about in the three major reports: Association of American Colleges (AAC), National Endowment for the Humanities (NEH), and National Institute of Education (NIE). In addition, if you don't want to read the whole book by Ernest Boyer on *College: The Undergraduate Experience in America*, I would urge you to read the epilogue. If you are a parent getting young people ready for college, if you are faculty at an educational institution, or if you are just interested in what makes for a cohesive college experience, I think Boyer—with his advisers and his many surveys conducted on campuses—has diagnosed some of our weaknesses and suggested ways to improve what's going on in the undergraduate educational area.

I worked for the most part on the Association of American Colleges report

entitled "The Integrity in the College Curriculum." My colleagues included Charles Muscatine, professor of English at Berkeley; Frederick Rudolf, who has written a great deal about the history of American higher education; and Arnold Arons, a physicist and retired professor from the University of Washington who really set the tone for the report. Throughout our nearly three years of discussion, Arons persisted in stressing that although content is critical, you must be able to deal with analytical work, to produce and test in your classes, to assess whether or not what you say in your catalogues is indeed being conveyed. Arnold kept asking, How do you do it? What goes on in your classes that is convincing evidence that you have transmitted that particular quality or skill in the classroom?

When we finished our work, I recognized that virtually no faculty member on my campus could deal with what was in our report. They have not been prepared to teach in a way that would force collaborative learning, that would put a real focus on analytical skills, that would allow for a meaningful test of true accomplishments near the end. Our folks, and I think many folks, are wonderful at conveying information and raising questions and trying to get at the issue of developing these skills, but we're a long way from it. And yet it was interesting to hear so many deans announcing that they have been doing this for years on their campuses. My thought was, Not really; not if you really read and analyze the report.

In the report we observed that the area of fine arts is very important. If you scrutinize the list, you will see that item seven incorporates a focus that should appear in all college curricula, across the campuses: a focus on the appreciative experience of the fine and performing arts. On the Diploma Task Force in Maryland, I fought hard to get something in the arts included for high school diplomas. We did get something included, just as we had something in math, but we knew that what is to be in that course—that one lone course that might show up in the curriculum—will be decided at the local level.

Where have we made or suggested changes? I think the key that emerges in every one of these reports is that the focus is not on the number and variety of courses offered but rather on writing skills, speaking skills, listening skills, critical analysis, inquiry, understanding numerical data, work and values, and gaining some sort of historical perspective. In the August 5 [1987] issue of the *Chronicle of Higher Education*, there is a report on a three-week-long meeting of sixty English teachers, curriculum experts, and professors who specialize in both literary studies, and rhetoric and composition. For three intensive weeks, they tried to determine what ought to happen in the teaching of English from kindergarten through college, and tried to look at the future of their discipline. I found it fascinating that they realized they had never before really talked to one another in any serious way. Now they have a unified

set of classroom goals; they are going to recommend an emphasis on how students read, write, and think, rather than on familiarity with specific literary works. In other words, they were saying, Less is more. They are calling for classes that involve students in learning.

When you go back over the recommendations from the National Institute of Education, the researchers in the learning process who arrived at those recommendations are convinced that active involvement of students is tremendously important. These colleagues and those in English speak about turning instructors into coaches who, like athletic coaches, really work *with* their students—learning with them rather than talking *at* them. When I think back on my four years at Wellesley, I remember having wonderfully able teachers; but I was talked at. Rare was the experience of really learning *with* a faculty member, until the honors project near the end of my college career. The NIE report makes it very clear that the researchers are not advocating process at the expense of content; it's a delicate balance. And that delicate balance was what we were worried about in preparing the Association of American Colleges report. We were concerned that it might look as though we were favoring process at the expense of content. But we were well aware that you cannot deal with process without content.

The other revolutionary part of the curriculum we were announcing in the AAC report was our tackling of the most

unexamined area in the college curriculum: the major. (If you want to read a little further in this area, read some of the writings of Jonathan Smith, who was dean of the college at the University of Chicago.) I looked at all the majors at Hood, and I found wonderful elaborations on doctoral theses, special interests, and faculty predilections. But I've been talking to our faculty about my feeling that they could move from four-course loads to three-course loads if they would prune. Of course, this is a revolutionary statement to make to them, because they think that there is nothing that could be let go; if anything, they think the major ought be larger and more extensive. And I have to admit that it was our art colleagues who got some of our students up to ninety hours out of 120 when we had a much less structured curriculum. They had a way of weaving more and more "goodies" into the major. Psychology and biology did the same thing, but our colleagues in art seemed to be the most adept at luring students into their web and giving them no way out!

What I'm trying to get at here is the issue of study in depth. What does it mean to go into study in depth? Our feeling on the study committee was that once you've exposed the student to your modes of inquiry and the structure of your discipline, you don't have to keep elaborating "horizontally." Instead, you provide a "vertical" introduction into the thinking, which is the quality that distinguishes your

area from neighboring disciplines. This has not necessarily gone down well in academe. It does not sit well with departments, and I realize that you represent departments. But I suggest that when you are looking for the latitude to introduce new things, pruning may be essential. This was also born out in the report I saw emerging from those professors and teachers who got together at the Wye Plantation on the eastern shore of Maryland to discuss the future of English as a discipline.

I've just spent two days in Washington reading nominations for the $50,000 awards that the Charles A. Dana Foundation is going to make in November. What was fascinating was the evidence that these reports have been read and are being absorbed. We had several hundred nominations to sift through, and in those I have read so far, some common themes are emerging, and the work that is going on is very heartening. At such institutions across the country as the Rensselaer Polytechnic Institute, the University of California, Los Angeles, and Boston College, there is a tremendous range of faculty development programs, programs that are really assisting faculty in the work that goes on in their classrooms, helping them to work on their students' thinking, writing, and analytical skills. There were many nominations in the area of collaboration between liberal arts colleges and the great research universities, the hope being that some of the deep commitment to, and love of, teaching that liberal arts teachers

possess will rub off on the research faculty and maybe lure some of the young graduate assistants into teaching.

At the University of California, Irvine, I saw another kind of collaboration. There were a number of proposals for projects that represent a collaboration between the university and the school system in which it is located, so that dialogue was going on between and among the school principals and the school teachers in particular disciplines or colleges. They are getting ready to establish an educational park, where there will be dialogue all along the educational continuum on what belongs at particular points in that continuum, dialogue on how to focus the thinking, writing, and analytical skills within a context that would make that kind of effort work.

I felt very proud of the projects that we finally sent to the blue-ribbon panel that will make the final selections in the education area, because we had sifted through such a strong field of applicants. There were many extraordinary examples of curriculum experimentation, of interdisciplinary dialogue, and dialogue among all the different educational levels. Betty Edwards, who has worked in "seeing creatively," was among those nominated. She was one among a wonderful spread of individuals who have made an impact in their particular institutions.

I saw that a number of places are beginning to take the issue of teacher preparation a lot more seriously. In the past, some art faculty have seen this as a sort of peripheral responsibility—you gotta prepare 'em, but that's not really what I want to do with my time. But I think that's changing as we look at what is going on in our schools, what our children are experiencing. I think our attitudes are changing on how critically important elementary teachers are.

I also have watched closely what has gone on at the American Association for Higher Education. Dr. K. Patricia Cross at the Harvard Graduate School of Education has launched a research project that is helping faculty at the college level look at what they do in the classroom. I've taught at several colleges, and I always prided myself that I never had an education course. I was lousy at putting a syllabus together. I knew nothing about testing. Now I'm looking at people coming up for tenure at the institution, and I'm looking at some of their syllabus materials and saying, They really would benefit if they got acquainted with so and so, who really can put a course together that's meaty and challenging, that works in those skill areas, and perhaps even gets some evidence that something is occurring in those areas.

As her next major effort, Pat Cross will be helping faculty members to examine how learning takes place in their own classrooms. She's experimenting with faculty members at Bradford College, and she's taken on some faculty colleagues at various colleges around the Boston area. She had a packed session at the American

Association for Higher Education—which told me something. I think a number of us know we could do better in our classrooms, but we've not been able to articulate our concerns. Now exemplary faculty development projects are emerging and being offered up for the Dana awards. I wanted to photocopy some of those applications and put them under the noses of my own faculty and say, Look, if Rensselaer can do it, maybe you can admit you could use some help in some areas. I did not get to copy those reports, so I can only use the projects anecdotally. But I can tell you that Pat Cross is someone you should watch, and if she comes to a disciplinary meeting in which you are involved, go listen to her. She has insights that I think are going to make a differ- ence. They will make a difference for *you*; they will make a difference in what you do in preparing people who are going out to teach in the elementary and secondary schools.

Where do I see some obvious impediments to reform? As trustees of the Carnegie Foundation, we are completing what will be a trustee statement on urban schools. In many urban areas it is going to very hard for teachers to put into effect what they get in preservice, without having burnout remove them very rapidly from the schools. But there are glimmers of hope; there are lights. Deborah Meier is a beacon of hope in East Harlem, even though she is working against tremendous odds. She went into that urban-school situation with a tremendous bureaucracy

blocking her every step of the way, but she's making headway with some new structures to give support to students.

I think the major concern of the group of English educators who met in Maryland was: Are we getting into a situation in which we are going to be teaching to tests? In one of the resolutions put forward at their meeting, they observed that, in states where extensive testing has been the practice, "such arrangements led to a fragmented and incoherent approach to English." They are going to fight very hard to ensure that the primary way of assessing what has happened at a particular level or during a particular school year is not simply a raft of tests.

We have a group within our faculty who always look back to better days. "It was better in the fifties," they say. I'm not sure it was. When I went through college, for the most part I got talked *to*. Maybe our scores looked better, but I'm not sure we were any better as students than the current batch coming through. Today's students are different in terms of what they've been exposed to, and the great concern for English teachers is that what students have been exposed to more than anything else is television. It's a television-educated generation; they're not readers. But still, what is happening in the classrooms may just be getting better.

Where do these reports and discipline- based art education come together? The critical area of involvement is learning, the issue of collaboration in learning. We've learned alone; we ought to be learning

together. This is one of the key findings we're getting from individuals hiring our graduates. They wish our students had learned how to work collaboratively on projects.

Finally, we've got to know more about how to respect diverse talents and diverse ways of learning. The key is to communicate high expectations to students. If you expect something, the student feels that and responds; if you expect nothing, the kid knows that and feels thrown away.

What all of these reports are focusing on, in the undergraduate liberal education area, is the need to create a classroom environment that is favorable to good practices for teaching and for learning.

PANELIST
John W. Eadie
 Michigan State University

Tomorrow's Teachers: A Report of the Holmes Group

Unlike the Carnegie Forum report, *A Nation Prepared*, or the *Governors' 1991 Report on Education*, the Holmes Report does not link new directions in teacher preparation with the national goal of increasing American competitiveness. Instead, it concentrates on the fundamental deficiencies in the higher education of teachers and proposes three fundamental changes in existing curricula and expectations: (1) a requirement that all teachers complete a major in the liberal arts and sciences; (2) abolition of undergraduate degrees in schools of education; (3) the reconstruction of teacher education as a graduate-degree program.

In arguing for the abolition of under-graduate education degrees, the Holmes Group candidly admits (p. 14) that such degrees have "too often become a substitute for learning an academic subject deeply enough to teach it well." In their reformulation of teacher education they insist that "professionally certified teachers should teach only subjects they both know well and can teach well." At the same time, the Holmes Group has recognized the parlous state of undergraduate education in this country and has called for major changes in the curriculum that should become, in their view, the common experience of tomorrow's teachers.

Specifically, they have endorsed two principles they hope will inform future discussions of undergraduate reform:

1 The curriculum should be reshaped "so that future teachers can study the subjects they will teach with instructors who model fine teaching and who understand the pedagogy of their material."

2 "Academic course requirements and courses [should be organized] so that undergraduate students can gain a sense of the intellectual structure and boundaries of their disciplines, rather than taking a series of disjointed, prematurely specialized fragments."

As one would expect, the Holmes Group has emphasized the attributes and approaches that will benefit principally those in preservice curricula, but the deficiencies they have identified differ only marginally from the agenda proposed by national commissions and other critics of higher education over the past two decades.

This is not to suggest, of course, that the report has met with universal acclaim. In the Spring 1987 issue of the *Columbia Teachers College Record*, to cite only the most recent example, a substantial number of reservations were expressed by individuals who share their dissatisfaction with the present. The most trenchant of the critics, in my judgment, is Walter Feinburg, who points to two defects that he believes will inevitably impede implementation. First, restricting preservice training to a major

(supplemented by a minor field of study) will not meet the needs of primary school teachers, who, unlike secondary teachers, must pass through a more diverse preparation in order to address the wide range of students' needs. Given the nature of their probable teaching assignments, they cannot afford to limit their preparation to a singular subject matter. Second, the emphasis on subject matter, moreover, "seems to inhibit the establishment of experimental, interdisciplinary programs by reinforcing departmental boundaries and legitimizing the view that the line between subject matter areas are fixed by some unbending laws of nature."

That the Holmes Report might legitimize disciplinary intractability in colleges and universities is a charge that must be taken seriously. Doubtless, its authors would respond that they had nothing of the sort in mind and would oppose certification of "business as usual." Still, it is important at the outset to combat misuse of their recommendations and to ensure that the report does not support, and is not thought to support, disciplinary claims against programmatic improvements in both graduate and undergraduate curricula that depend on crossdisciplinary initiatives. To avoid this misalliance, some modification in nomenclature may be required. At minimum, a less conventional definition of the major should be devised, one that does not preclude the interdisciplinary inquiry that animates and integrates many existing "majors." Whether such "enriched" majors can meet the needs of the primary teacher

is admittedly uncertain, but there is no reason to believe that a preemptive return to the developmental model, in which subject matter is more often than not subordinated to child psychology, would yield greater results. The notion that primary teachers teach "children, not subjects" has clearly not produced satisfactory results and should be resisted.

Nothing in the Holmes Report, in my judgment, is at odds with the objectives of DBAE—i.e., that the art education curriculum integrate the "domains" of studio art, art history, criticism, and aesthetics, and thereby make more coherent the sequencing of art education in the public schools. These criteria are entirely consonant with the report's insistence on greater disciplinary content in teacher education and on the centrality of subject matter in K-12 curricula. Though neither the authors of the report, nor their critics, have given attention to preservice curricula in art education, or to the proposals designed to strengthen art education in the public schools, many of the questions they raise have figured in recent discussions of DBAE. From the published accounts, I gather that the initial resistance to DBAE centered on the objectives outlined by Greer (1984) and others, and on the intellectual claims and curricular compatibility of the now canonical four "domains." Over the past two years, I would say, from the literature that I've read, the debate seems to have shifted from these articles of confederation to questions of implementation. And with

this refocusing of the issues, as some observers have already pointed out, DBAE has entered a new and more unpredictable political arena. It is one thing to ask whether prospective teachers of art education in primary and secondary schools should be required to complete a disciplinary major. It is quite another to determine whether the curriculum of preservice art education should differ from other undergraduate curricula. The former is a matter for specialists in art education, the latter for the entire college faculty. And as any university faculty member can attest, when the discussion is expanded to include the entire college and its administrators, any decision to change is likely to be made at glacial speed, if at all.

Even among those who might be considered natural allies of DBAE, the visual arts departments in colleges and universities, the characteristic response to date has been indifference. In spite of repeated attempts to alter graduation requirements over the past few decades, as Professor Sevigny has pointed out in a recent survey, studio art remains the preeminent component of preservice training in art education in most colleges and universities. The other domains—art history, aesthetics, criticism—continue to play a secondary role at best in the education of tomorrow's elementary and secondary teachers. How does one account for this intransigence?

Part of the resistance to reform may be attributable, of course, to those who serve as the arbiters of our primary and

secondary schools—principals, board members, parents—who simply refuse to pay for something they either do not feel children need or can do without in order to assure the continuance of other activities. Anyone who has observed the political context of today's elementary and secondary schools will know just how difficult and fraught with combat that arena is. Schools are asked, usually by boards of education, sometimes by parents, to make impossible choices among goods, to devote their energies and their resources to the achievement of particular objectives, some of which may not even fall into the category of education. And so they are confronted with a task that is probably not do-able. It is in this context that decisions about curriculum are made. It is in this context that the teacher must decide whether to give time and energy to one enterprise or another. And so to some extent the disinterest that's frequently shown by school boards and by school districts may be reflected in higher education's response to the claims of DBAE. That is to say, it may well be that departments of visual arts in universities, observing the indifference of schools districts, may in fact emulate that indifference. The Getty Center, of course, has been actively engaged for the past few years in putting right that situation, trying to make some inroads into the political arena of the nation's schools and, I think, with some signal success. But even if the Getty Center is successful in achieving some purchase on the attention of the

arbiters of our schools, I'm inclined to believe with Professor Sevigny that systemic change will not occur "unless *political backing* [author's italics] in the universities will support development in this direction."

Within higher education a fundamental deterrent is the lack of agreement among professors of art concerning the proper preparation for teaching careers in the public schools. Put baldly, there is widespread disagreement in university departments concerning the need, asserted by proponents of DBAE, for historians, critics, and aestheticians rather than "crayon pushers." Clearly, to reconstruct the curriculum of art education, one must first win the hearts and minds of colleagues within the arts. Only then will it be possible to confront the more difficult question: How to persuade the rest of the college faculty to approve a revamped, integrated program? Allies from other disciplines and departments, especially those who may have a proprietary, and altogether legitimate, interest in one of DBAE's domains, must be solicited and secured if there is to be any chance of success.

Even if the disputes over boundaries and subject matter can be resolved among these faculty, a significant impediment remains. How will the proponents of DBAE manage to secure the "political backing" of liberal arts deans? The competition for scarce resources within colleges and universities is in fact increasing, as successive national commissions announce plans to assure a

new level of civic responsibility, civility, or competitiveness in the graduates of our colleges and universities. In such an environment, the dean of a college must be persuaded that the courses required for DBAE are intellectually defensible, serve more effectively the needs of prospective art education teachers, and provide new and attractive educational opportunities *for all students*.

In the two universities that I know best—the University of Michigan and Michigan State University—the prospects for adoption of DBAE are at best uncertain. Both institutions are members of the Holmes Group, with Michigan State under Judy Lanier's leadership having the more significant role in its formation and early development, and both have already moved some distance toward the implementation of two of the Holmes Group's recommendations: the abolition of the undergraduate degree in education and the concentration of effort and resources in graduate training. This has meant, of course, that the preparation of teachers through disciplinary departments will become normative. Neither university, however, has adopted DBAE or has attempted to remove the structural-organizational constraints that prevent its adoption. At the University of Michigan, for example, the School of Art and Art History are totally separate, not only physically separate—that is, on two different campuses—but they don't talk to each other. No one in studio art would deign to give much time to art history, which, after all, is a lot of critics who know

nothing about production. Nor would the art historians be terribly interested in dabbling in paint or in sculpture or anything else, and may well have no talent in that at all. So they don't talk to each other. In such an environment it's obvious that DBAE will never be installed, will never be institutionalized. At Michigan State the situation, I have found, is a little bit better. The art history faculty is housed in the department of art, and so there is a close, even workable association, but even so, even with those two ingredients, those two domains in place, there is nothing in aesthetics or criticism, that I can find anyway, in the catalogue descriptions of courses of the department of art. For the most part aesthetics is covered in philosophy, having nothing to do at all with either art or with art history. Moreover, in the preparation of teachers in the preservice curriculum there is still a glaring preponderance—and I say glaring because it is so dramatic—of studio art, so that the blending that is being recommended in DBAE hasn't occurred.

This puts me in a very difficult position as a dean. When someone proposes interest in DBAE, how am I going to respond to that? If I envisage a positive response, it will first be necessary clearly to revamp the curriculum to accommodate in an identifiable jurisdiction the four domains of DBAE and to identify, either from existing faculty or through new appointments, the specialists who can implement DBAE at Michigan State University. Neither course, I suggest, can

be accomplished, can be undertaken, without some reallocation, redistribution of resources. And that's my problem. As a dean I have, of course, a lot of people asking for the redistribution of resources. But the situation is not hopeless—bleak, but not hopeless.

Inspection of some of the undergraduate curricula proposals put forward recently by Ernest Boyer, notably his prescription for an "Integrated Core," suggests that the extension of DBAE to other sectors of the university can be achieved. Included in his "Integrated Core," designed to serve as the matrix for general education, is an "area of inquiry" entitled "Art: The Esthetic Experience." Such a course, at least as he envisages it, would clearly be unthinkable without the participation of professors from the four domains of DBAE. Now I recognize that in making that observation I'm entering tough terrain. No one wants to be *relegated* to general education, and I'm sure that professors of art of all stripes have the same disdain for general education that most of my colleagues do. I don't think that varies terribly across the campus. It's unfortunate but true. I say it's unfortunate because, of course, this is one of the areas of undergraduate education that is most in need of renovation. A course such as that described by Boyer would clearly provide a means of integration, would clearly bring together the proponents of DBAE—maybe the crafters of the new curriculum in DBAE—with others on campus, some of whom are going to be required in order to teach DBAE, or at least to cover all of the

domains. To assure the success of such a course, however, I believe that it will be necessary to ensure that responsibility for the crafting of DBAE and its implementation—a responsibility now wholly resident in the Schools of Art and Schools of Education—must be shared, or surely will be shared, with the central core of the university, the College of Arts and Sciences. And I don't say that out of any propriety interest. I am not advocating the abandonment of preservice training, which will doubtless remain the focus of development. Rather, I am recommending the mainstreaming of DBAE, translating specialized preservice curricula into a fully developed component of liberal arts education. Making a significant contribution to the revitalization of undergraduate education, and general education in particular, is unquestionably the most promising way to secure the approval of the "authorities" and to facilitate the intellectual integration of DBAE in the college curriculum.

The past that I am recommending has already been charted by other disciplines within the arts and sciences, many of which have transcended departmental boundaries to include the crossdisciplinary and the intercollegiate. With its integrated approach, DBAE has a better than even chance of survival in a reconstructed liberal arts college. On some campuses, it may be possible to construct the new curriculum and courses from existing resources, recruiting the requisite faculty from departments of art, philosophy, and the

cognitive sciences. On other campuses, with a less developed tradition of interdisciplinary teaching and research, the task may well require thorough reassessment of college objectives, coupled with a reallocation, modest though it may be, of resources. In any event, success in exploiting available resources, and in laying claim to the additional resources that may be required, will depend in large measure on "political backing," both from the relevant deans and the college faculty members to whom they are accountable.

PANELIST
Susan Adler Kaplan
 Providence, Rhode Island, Public Schools

Carnegie Forum on Education and the Economy Report, *A Nation Prepared: Teachers for the 21st Century*

The John and Catherine MacArthur Foundation announced its awards on June 16, 1987, and cheers of jubilation from public school teachers could be heard throughout the nation. Deborah Meier, a teaching principal in an East Harlem, New York, public school, was named a MacArthur fellow and received well-deserved recognition for being a "creative self-starter." Deborah epitomizes for many of us just what the Carnegie Forum on Education and the Economy says in its task force report, *A Nation Prepared, Teachers for the 21st Century*. Deborah's philosophy emphasizes democracy; with her colleagues—in a restructured school—she creates the opportunities for her students to be good students, thinking, articulate, and caring. Teachers, teacher education, and teaching conditions are the critical aspects of *A Nation Prepared* that we will examine today. The eight points of the task force report represent a set of ideas calling for revolutionary changes that will turn teaching into a true profession. The MacArthur Foundation is, indeed, on target in recognizing the work of Deborah Meier, who is also a member of the National Board for Professional Teaching Standards. Her MacArthur grant of over $300,000 is

encouraging at this time when education reform is at such an important juncture.

Let me begin by reviewing some history of *A Nation Prepared*. A task force, chaired by Lewis Branscomb, then chief scientist and senior vice president of IBM, met during 1985-86 to respond to the needs of American education; Marc Tucker, executive director of the Carnegie Forum on Education and the Economy, prepared briefings for the members of the task force. Through a sometimes difficult and intense process, members of the task force arrived at their conclusions and recommendations, which included a scenario of what schools might look like in the year 2000, assuming that a new policy framework was in place. The task force reviewed many drafts, resolved many problems, and on May 16, 1986, the report was introduced to the public. It sent shock waves into the entire educational and political communities; legislators placed education reform at the top of their agendas. Its tenets provide a powerful and creative opportunity to improve public education. The eight major recommendations follow:

1 create a National Board for Professional Teaching Standards, organized with a regional- and state-membership structure, to establish high standards for what teachers need to know and be able to do, and to certify teachers who meet that standard;

2 restructure schools to provide a professional environment for teaching, freeing them to decide how best to meet state and local goals for children while holding them accountable for student progress;

3 restructure the teaching force, and introduce a new category of lead teachers with the proven ability to provide active leadership in the redesign of the schools and in helping their colleagues to uphold high standards of learning and teaching;

4 require a bachelor degree in the arts and sciences as a prerequisite for the professional study of teaching;

5 develop a new professional curriculum in graduate schools of education leading to a Master in Teaching degree, based on systematic knowledge of teaching and including internships and residencies in the schools;

6 mobilize the nation's resources to prepare minority youngsters for teaching careers;

7 relate incentives for teachers to schoolwide student performance, and provide schools with the technology, services, and staff essential to teaching productivity;

8 make teachers' salaries and career opportunities competitive with those in other professions.

The task force stated: "If our standard of living is to be maintained, if the growth of a

permanent underclass is to be averted, if democracy is to function effectively into the next century, our schools must graduate the vast majority of their students with achievement levels long thought possible for only the privileged few. The American mass education system, designed in the early part of the century for a mass-production economy, will not succeed unless it not only raises but redefines the essential standards of excellence and strives to make quality and equality of opportunity compatible with each other."

Responses to the Report
Collaboration. Collegiality. Colloquy. Commitment. Caution. Those are but some of the terms that this report has elicited from supporters, participants, and critics. You, in the academy, and I, in the school-house, have been criticized, condemned, and castigated more often than we have been complimented, commended, or congratulated. However, the terms *collaboration* and *colloquy*—that signal this creative reform movement—describe the past year's work as we entered the first phase of implementation of the report *A Nation Prepared*. In August 1986, the Carnegie Corporation announced the appointment of a thirty-three-member planning group to establish the board. The participants included eight classroom teachers, our chairman James Hunt, who is former governor of North Carolina, John Gardner, Fred Hechinger, Thomas Kean, Judith Lanier, Arturo Madrid, Mary Hatwood Futrell, and Al Shanker, in

addition to school-board members, school superintendents, other teacher educators, and all the original task force members. Thus, classroom teachers, political, educational, and business leaders worked together to address issues of membership, assessment, definitions of roles, and the all-important issue of what a teacher needs to know and be able to do. We worked with attorneys to develop bylaws and articles of incorporation based on our deliberations. We heard presentations from Stanford researchers Lee Shulman and Gary Sykes of the Teacher Assessment Project. We listened, challenged, debated, and persisted. There was dissent; there was consensus. And in San Diego on May 15, 1987, we made history as we announced the incorporation of the National Board for Professional Teaching Standards. The board is the cornerstone recommendation of the task force report; it demands that we all participate in its resounding peals, which herald challenge, opportunity, and support for excellence in both the schoolhouse and the academy.

A Nation Prepared is pivotal to the second wave of reform, along with the Holmes Group report and the National Governors' Association Report, *A Time for Results*, and other works such as Ted Sizer's *Horace's Compromise*. This wave of reform moves from the first wave of just raising standards to initiating structural change that can give us schools capable of meeting that real challenge of raising standards. These changes affect you, in your role as teacher educators beginning to

implement discipline-based art education, and they affect me, in my roles as trainer of student teachers, classroom teacher, and board member.

As we go through the report together, let us imagine ourselves in our own roles, but also let us imagine we are prospective teachers. For if we are to attract new teachers, to fill the places of the 1.1 million teachers who will retire within the next six years, we must assure them that they will be welcomed into a true profession. How did Marc Tucker and the task force arrive at their recommendations? They looked at the shifting world economy and based their theories on its highly technical nature, which makes it imperative that we produce high school graduates who are far better educated than ever before. For the future of our nation—for our survival—we need to become a nation of people who think for a living, and the task force said that we need to produce young people who are articulate, imaginative, and confident, who can solve problems and can make decisions. Unless we have teachers who possess those same qualities, and who will have more productive schools in which to work, we will not graduate students with those abilities. The challenge will be not only to define high standards, but also to create the kinds of teacher preparation programs and the kinds of workplaces that permit men and women to acquire the skills, understandings, and dispositions that will allow them to work in effective schools (Shulman 1987).

The first recommendation is especially promising to graduates who want to enter a real profession.

The National Board for Professional Teaching Standards

This recommendation—to establish a National Board for Professional Teaching Standards—is now a reality. The board will, first, be comprised of sixty-three people in two categories of membership: teaching professional members and public and other education members. The majority of the board members will be classroom teachers. The board, according to the bylaws, is the "means by which the teaching profession and other educators, government officials responsible for education, and the public at large join to improve education in the United States by setting and maintaining high standards for teaching." Second, the board will create and administer a system for determining who meets those standards. Third, the board will issue certificates to those who meet the standards set by the board. The fourth tenet is that the board will enable teachers, superintendents, principals, and school boards to restructure American schools for improved performance. As a fifth point, the board will conduct related activities that set and maintain high standards for the teaching profession. Finally, it is designed to provide such services to teacher education institutions and other organizations and individuals as may be necessary to promote the development of a teaching profession that is broadly representative of the people of the United States.

The search committee has begun its work looking for a president; Mark Tucker, executive director of the Forum, has been named acting president. A key aspect of this board is that certification is voluntary and nongovernmental and will set high standards for what teachers need to know and be able to do. State licensure is a minimum standard. Although some states may call their license a certificate, it is in name only; it is the document the state issues and is, in fact, a license. The states will still license teachers; currently, the fifty states have different licensing standards, but the board promises uniformity and high standards. It is interesting to note that in 1975 eleven states required a teacher test; in 1987, forty-four states require a test for licensure. One of the positive outcomes that voluntary board certification promises is that the states will reexamine their own testing procedures, such research is currently under way in a cooperative venture between California and Connecticut. It will take time to certify thousands of teachers, and we will need public support to recognize teaching as a profession. A major project in conjunction with the establishment of the board this past year has been the development of sample exercises to measure the complexities of teaching.

National Board and Teacher Assessment Project
The Carnegie Corporation awarded a grant of $817,000 to Stanford University, where Lee Shulman and his colleagues have spent this year conducting research on assessments in other fields such as the foreign service, medicine, and law; they have looked at testing protocols, time lines for testing, and other related assessment activities in these areas for models. Another part of their research has been to study and document outstanding teachers in two areas: mathematics at the elementary school level (specifically, the teaching of fractions), and United States history at the secondary level (specifically, the American Revolution). Shulman calls these the "wisdom of practice" studies. The researchers have developed prototype assessments in the two fields. To help construct and evaluate the two prototypes, the researchers are working with a twenty-one-member teacher advisory board and two expert panels in each of the two above areas. Members of the advisory boards include subject-matter specialists, teachers, teacher educators, cognitive psychologists, philosophers, and testing experts. Minority groups are represented on all three panels and in the case studies of exemplary teachers. In May, a group of professors at the University of California, San Diego, and the Stanford research team held a seminar to discuss what Shulman believes is a central preoccupation with the work—and that is the performance of minorities. "If this whole standards-setting and assessment process further exacerbates the already unacceptable circumstances of minority participation in the teaching force, then the results will be totally unacceptable." Shulman continues, "We've simply got to figure out how to raise

standards and increase minority participation in the field, and I'm not prepared to view those as contradictory goals or intractable problems." Field tests conducted this summer included twenty elementary teachers and twenty secondary teachers who served as candidates. In addition, there were thirty examiners and observers. The candidates were videotaped in some instances and were audiotaped; they had planning interviews prior to each exercise and debriefings at the end. Most of the exercises in the prototypes are geared to "good" teachers with two to four years' experience. The field testing took four days in each of the two assessments. All the exercises took place in classroom situations; some involved group planning and others were self-administered. An interim report of the field testing will be issued to the National Board in October [1987].

The Stanford group has also developed case materials for the board exam to help teachers explore theoretical and practical issues; the cases can be used as part of teacher training as well as for the assessment. Discussion about timing of the assessment in a teaching career tended to support an assessment that would accumulate evidence over a period of years at the beginning of a teaching career, possibly starting with teacher education and extending one to three years into teaching.

Restructured Schools
A second recommendation of the task force is to restructure schools to provide a professional environment for teaching. This recommendation has caused the most activity at the legislative level. The nation's governors, in particular, have responded with great zeal to the idea of supporting restructured schools, and the term "Carnegie School" has begun to be used. The concept proposes more responsibility and decision-making power for the teachers. The National Governors' Association (NGA) voted to endorse the Carnegie plan and unanimously called for every state to consider the task force proposals. Additionally, the NGA received a grant from Carnegie of $890,000 to help states develop innovative programs consistent with the education-reform agenda of *A Nation Prepared*. In Louisville, for example, Jefferson County Public Schools received $25,000 to plan for Professional Development Schools, part of a larger plan in helping the school system to restructure its schools.

A restructured school provides opportunities for teachers to be instructional leaders, and to have the assistance of other personnel as well as technology to function as true professionals. Currently, in many districts, teachers have practically no say in scheduling, textbook selection, programs, and other such decisions that affect them. One school that has begun to follow Carnegie's recommendations has a team of teacher leaders and has decided not to replace the retired principal. That kind of decision supports the vision and the daring that Carnegie implies.

Restructure the Teaching Force

The third recommendation is to restructure the teaching force, introducing a category of lead teachers with the proven ability to provide active leadership in the redesign of the schools and in helping their colleagues to uphold high standards of learning and teaching. The objective posed for the lead-teacher position is professionalism on the part of all teachers in a school—by engendering a collegial, self-reviewing, and self-improving work culture (Devaney 1984). The Carnegie Task Force report establishes a scenario of lead teachers running a school in the year 2000; the teachers are zealous, creative, and collegial. Lead teachers will have to be visionary and powerful to implement the design the task force has outlined. To date, there are some schools in which the lead teachers operate by committee in running the school; the principal becomes part of the team. Willingness to experiment, to take risks, to create, to persist, and to trust are but a few of the qualities a lead teacher needs to possess.

Undergraduate Degree in Arts or Sciences

A fourth recommendation is to require a bachelor degree in the arts and sciences as a prerequisite for the professional study of teaching. This particular recommendation has engendered a great deal of discussion, as has the Holmes Group recommendation for a five-year program. As you know, many of the four-year institutions are concerned, for a myriad reasons—the criticism of this particular recommendation has been widespread. Both small and large liberal arts institutions have expressed concern about abolishing the Bachelor of Education degree.

Graduate Education and Internship

The companion to this recommendation is the task force's fifth suggestion: to have a new professional curriculum in graduate schools of education leading to a Master in Teaching degree, based on systematic knowledge of teaching and including internships and residencies. This suggestion is, I hope, part of your deliberations as you begin your important work in discipline-based art education. Sevigny (1987) in his informative study of the teacher training in the *Journal of Aesthetic Education* provides us with the data that support change: "Teacher education in the visual arts is at the threshold of significant opportunity." Indeed, the opportunity for implementing DBAE is just what Carnegie sees as an example of change—the opportunities for creative internships and preservice training with a variety of innovations. One hopes that the implementation that Sevigny speaks of will become a reality and an integral part of the Master in Teaching program that Carnegie addresses.

Not only are the graduate schools of education considering the recommendations for discipline-based art education, but also the colleges of art and design are conducting rigorous self-analysis of their programs.

Minority Participation

The sixth recommendation, and one so very critical to our changing school population, is to mobilize the nation's resources to prepare minority youngsters for teaching careers. As we know, the minority populations of our schools will soon reach one out of three students. To our great dismay, the number of minority college freshmen who expressed an interest in teaching as a profession is a paltry 1 percent. The time to excite minority students about a teaching career is early in the junior high school years. Many minority youngsters have been identified for math and science careers and have been nurtured throughout junior high and high school; we have not done so well in the arts and humanities. Some school districts are instituting tutoring programs where minority students can get experience in coaching as a preliminary step in teacher activities. Scholarship programs, not just the Eugene Lang windfall type, are becoming increasingly visible, particularly from the corporate sector. The Business Committee for the Arts, for example, might strengthen a program for aid to minority students who choose the teaching of art as a profession. Many communities have begun to expand their partnerships between the schools and the business community in order to assist minority students in academic and career choices. The challenge to us as educators is to provide those youngsters with compelling reasons to choose teaching over the myriad of other professions they presently choose.

Performance Incentives

One of the recommendations that has created concern is the seventh recommendation: to relate incentives for teachers to schoolwide student performance and to provide schools with the technology, services, and staff that are essential to teacher productivity. This recommendation implies that the teachers themselves will have a strong voice in establishing goals and objectives for their students; this kind of goal setting encourages teachers to work to ensure that their students progress. Shared decision making at the school site is one of the ways that some districts such as Dade County, Florida, and Toledo, Ohio, are implementing this recommendation of the Task Force.

Compensation System for Teachers

The eighth and final recommendation challenges urban and rural areas of this country particularly. Salaries are higher in suburban districts. However, the task force concluded with the concept of making teachers' salaries and career opportunities competitive with those in other professions. Such a compensation structure would provide teachers with an optimistic view of their long-term remuneration. Not only is a competitive pay scale crucial to prospective teachers, but also it promises that teachers would not have to become administrators to earn higher salaries. Very few professions "top out" in ten to twelve years. Creative ways of funding teachers' salaries must be explored; certainly,

changes can be effected through different structures of compensation, and through rewards for board certification and increased teacher responsibilities that restructured schools would provide.

Thus, we have in the task force report an evolutionary system of ideas; all the ideas should be addressed in some substantial way. The major message of the report is that teaching lies at the center of our schools; the excellence that we encourage in our colleagues, and that they seek in themselves, will be the excellence that their students will aspire to as well. For you, at this most exciting and critical conference on discipline-based art education, Carnegie's message of empowerment, ownership, esteem, and vision directs you toward effective integration of its tenets with your preservice art education. Shulman and Sykes define the knowledge base, pedagogy, and the certification process, and the task force report offers the prospects for restructured schools in which true professionals will practice their craft. These activities seem appropriate for discipline-based art education; teacher assessment activities for board certification in your field would certainly involve you and would reflect the concepts that you propose to implement. Increased dialogue between the schools and the teacher education programs are vital to implementation of Carnegie's recommendations; preservice and inservice education need to be more positive and encouraging than ever to attract and retain teachers. The spirit of collaboration, collegiality, and

colloquy that this second wave of reform has awakened must remain as powerful as it is today. Within the educational and political framework, we've begun to achieve a nation prepared. John Gardner summed up our challenge cogently when he stated these words on May 15, 1987, at the official incorporation of the board: "We would not want it said of us that the faith in human possibilities died in our generation because we were afraid or didn't trust one another or were too busy jockeying for advantage." We all need to heed Gardner's words and move forward together to encourage the best and brightest students to choose teaching as a truly professional career to be practiced in highly effective workplaces.

References

Carnegie Corporation. 1986. *A nation prepared: Teachers for the 21st century*. Washington: Carnegie Forum on Education and the Economy.

Darling-Hammond, L. 1984. *Beyond the commission reports: The coming crisis in teaching*. Santa Monica: Rand Corporation.

Devaney, K. 1987. The lead teacher: Ways to begin. Paper commissioned for the Task Force on Teaching as a Profession, Carnegie Forum on Education and the Economy.

Eisner, E. W. 1982. *Cognition and curriculum*. New York: Longman.

The Holmes Group. 1986. *Tomorrow's teachers: A report of the Holmes Group*. East Lansing, Mich.: The Holmes Group.

Noddings, Nel. 1987. Fidelity in teaching, teacher education, and research for teaching. *Harvard Educational Review* 56(4):496–510.

Sevigny, M. 1987. Discipline-based art education and teacher education. *The Journal of Aesthetic Education* 21(2):95–126.

Shulman, L. 1987. Knowledge and teaching: Foundations of the new reform. *Harvard Educational Review* 57(1):1–22.

Shulman, L., and G. Sykes. 1986. A national board for teaching? In search of a bold standard. Paper commissioned for the Task Force on Teaching as a Profession, Carnegie Forum on Education and the Economy.

PANELIST
Victor Rentel
 Ohio State University

Tomorrow's Teachers: A Report of the Holmes Group

Repeated calls for reform of elementary and secondary education in America have produced an outpouring of state legislation aimed mainly at assessing pupil achievements and at improving teacher salaries, but, surprisingly, state-level legislators did address many other recommendations included in these reform reports. Reforms directed at elementary and secondary education appear to have peaked with the publication of the "high school trilogy," Boyer's *High School: A Report on Secondary Education in America*, Sizer's *Horace's Compromise*, and Powell, Farrar, and Cohen's *The Shopping Mall High School: Winners and Losers in the Educational Marketplace*.

A second wave of reform in my view was ushered in with the Committee on Economic Development's report, *Investing in Our Nation's Children*. This report, while emphasizing the need to improve the teaching profession through higher salaries and better working conditions, also advocated an end to undergraduate teacher preparation, recommending instead that all prospective teachers obtain an arts and sciences baccalaureate followed by graduate teacher preparation. The CED's report, however, included no detail or elaboration

of these two recommendations. Between 1985 and 1987, nineteen other reports examined higher education, intensely offering recommendations that ranged from reforming teacher education to overhauling the entire undergraduate experience. Two of these reports, *Tomorrow's Teachers: A Report of the Holmes Group* and *A Nation Prepared: Teachers for the 21st Century*, are especially significant because vigorous, long-term efforts are under way to implement their recommendations. My presentation will focus on the Holmes reforms in an analysis of current activities being carried out at Ohio State University, Michigan State University, and the University of Nebraska at Lincoln.

The Reality of Teacher Education Reform: Three Holmes Universities
Reforming teacher education will be at least as difficult and complex as reforming public education. At least four huge obstacles must be overcome if reforms are to succeed. Because both the Holmes and Carnegie reports recommend substantive changes that would weaken state-level teacher certification, little support for national certification standards or changes in classroom teacher certificates can be expected from state departments of education. In fact, because states now totally control the certification process, state education bureaucracies will probably oppose attempts to change certification and will be unwilling to risk the support of local superintendents by endorsing changes in the teaching profession.

If graduate-level teacher preparation, aimed at preparing highly qualified teachers for elementary and secondary schools, is to succeed, then local school districts must show some enthusiasm for hiring more costly teachers with advanced preparation, and universities preparing teachers at the graduate level ultimately must demonstrate the superiority of their graduates over those with baccalaureate preparation. To expect districts to be enthusiastic about higher costs is unrealistic, and to show a direct relationship between teacher preparation and pupil attainment will be extraordinarily difficult, will take time, and will require, in addition to much more sensitive measures of pupil achievement than currently exist, considerably more experimentation and research on teaching and teacher preparation.

Even though the core of professional knowledge serving as a base for teacher preparation has improved markedly in the past two decades, the task of transforming a weak profession with marginal status is formidable. Unlike law and medicine, the teaching profession itself is not strong enough to support a research-based model of teacher preparation or a common logic about curriculum and instruction. In short, external forces such as state agencies, foundations, and the federal government will continue to exert strong pressure on the nature of teaching and indirectly on teacher education.

At the same time, the challenges being confronted by public schools, such as the spread of drugs, increased dropout rates,

the changing character of American families, the influx of non-English-speaking immigrants into schools, and the increasing aocial burdens placed on schools, will exacerbate the difficulties of demonstrating the effects of improved teacher preparation.

Faced with these difficulties, Holmes consortium schools of education will be critically dependent on their universities to sustain this reform agenda long enough for it to take hold. For several of the ninety-three Holmes universities, emphasizing teacher preparation and strong programs of research on teaching practice will mark a dramatic turning point in mission. For those with comprehensive missions—state and land grant universities by and large—any restriction of scope may be threatening to cherished traditions. Those with limited traditions of research face the very real and expensive challenge of developing and selecting faculties able to both train teachers and develop substantive research capabilities. These challenges, presumably, will inspire some institutions to opt out of the consortium or force the consortium to weaken its reform agenda. For some universities, the increased costs of graduate teacher preparation and looming market uncertainties may force a choice between survival and reform. Even a modest dip in the nation's or a given region's economy could have severe consequences for the consortium since so many of its members are state-supported schools whose funding is tied to heavily burdened state budgets. Institutional support and financing for the next three to four years will not be merely

a key to implementing the reforms envisioned in the Holmes manifesto, but will be critical to the very survival of the consortium.

Holmes institutions, in that they represent over half the nation's leading research universities, not only can be instrumental in providing the knowledge necessary for addressing a host of complicated problems confronting our schools, but seem willing as well to address the fundamental problems of restructuring the teaching profession and teacher education. In what follows, I will describe the recent efforts of three universities to grapple with the Holmes Group's ambitious reform proposals. My summaries were taken from institutional status reports submitted by the twenty member universities in April 1977 to the Midwest Regional Holmes organization's planning and technical assistance project, a "clearinghouse" established by the regional organization and the North Central Regional Education Laboratory to provide a database describing a variety of institutional characteristics and activities and sources of technical assistance within the region.

These status reports addressed the following topics:

1 the nature and extent of faculty involvement in decisionmaking and implementation activities;

2 major problems encountered and issues raised;

3 unique program features being considered or implemented;

4 conceptions of teaching and learning;

5 nature, scope, and sequence of programs;

6 articulation with the arts, sciences, and humanities;

7 professional development schools;

8 admission standards, recruitment and selection procedures.

To provide a general overview of developments within the region, I will summarize briefly the responses of all twenty universities. Then, to indicate the variation that exists among these institutions, I will report in some detail the developments in three of them: Michigan State University, the University of Nebraska at Lincoln, and Ohio State University. Finally, I will speculate on what these developments imply for discipline-based art education.

The Midwest Region
With just a few exceptions among these twenty universities, the dominant issue has been the reform agenda of the Holmes Group itself and the potential threat it represents to the survival of teacher education on these campuses. This fear arises from the Holmes and Carnegie recommendation to eliminate the baccalaureate degree in education. Many faculty are fearful that market forces will

drastically reduce their capacity to attract and place students, leading to a collapse of their teacher education programs. Others worry that insufficient political support exists within state governments and education agencies to warrant so drastic a move. Despite these misgivings, the formal governance committees that were asked by most deans to advise them on whether to affiliate with the Holmes Group did provide at least a tentative mandate to do so. Most institutions indicated that the entire faculty of education participated in the decision to affiliate with the Holmes Group, with most institutions also involving either a steering committee or a formal governance body in the decision.

Although the Holmes Group's desire to drop the baccalaureate in education is the most specific of its recommendations, not surprisingly, most institutional reports indicated that implementation of this recommendation would be some time in coming. Instead, most institutions plan to develop small experimental "Holmes" programs for the near future, some choosing elementary and others secondary education, biding their time for full implementation until risks become clearer. Within these experimental limits, at least four options are envisioned: (1) five-year programs with increased emphasis on subject-matter preparation, (2) an arts and science baccalaureate plus one year of intense professional prep, (3) a fifth year of preparation integrated with a teacher's first three years on the job, and (4) combined baccalaureate/graduate programs

integrating subject matter and professional preparation.

Little has been done in most of these institutions to articulate with arts and sciences colleges. Joint liaison committees, varying in formality, are envisioned, but only two institutions have formed such committees. Similarly, professional development schools are being discussed with local school superintendents, but no institution in the Midwest organization has actually created such a partnership. Nor have most midwestern Holmes schools gone beyond initial planning for either curricular redesign or admission standards.

It is probably fair to say that most faculties are just now getting over the shock of joining the Holmes Group. The most difficult tasks—curricular redesign, articulation with arts and sciences, creating professional development schools, changing the teaching profession, and establishing defensible entry and exit standards—still lay before them. My impression is that many schools joined the Holmes Group not because its reform agenda was compelling or its ideals were attractive, but because, as Derek Bok (1987) noted recently, they are "fighting for their existence." They cannot ignore the one national organization having their survival as its goal.

Significantly, however, schools of education in major research universities occupy a strategic position because of their ability to advance knowledge of teaching, learning, education policy, school adminis-

tration, and the structure of schooling. Each is vital to improving schooling. If schools of education ceased to exist, it is unlikely that these vital areas of knowledge and training would receive attention from traditional academic disciplines or professional fields. Thus, if schooling and its critical contribution to our society are to be improved, the real issue is not the survival of schools of education but their revitalization. For this revitalization to occur, university presidents must shoulder their responsibility, given the external forces arrayed against teacher education reform and the crucial dependence of the Holmes Group on university support during the next several years of transition. To succeed, Bok urged schools of education in major research universities to stick to a basic strategy of developing better methods of teaching, solid educational research, and intellectually sound training programs for teachers, school administrators, educational planners, policy advisers, educational specialists, and teacher educators. These sound very similar to the goals of the Holmes Group.

Teacher Education Reform at
Three Holmes Universities
The University of Nebraska at Lincoln. At the University of Nebraska, the entire education faculty participated in the decision to join the Holmes Group, led by a steering committee of twenty faculty members. They have decided to continue their baccalaureate program in teacher education while experimenting with (1) a

fifth-year internship program, (2) a five-year elementary education program emphasizing subject-matter preparation and the knowledge base for teaching, and (3) a transition program designed to prepare persons for teaching who have had successful earlier careers.

Creating these experimental programs will be the task of a joint education and arts and sciences liaison committee. In addition, this group will develop a model for the liberal education of teachers based on recommendations of the Chancellor's Commission on General Education. General education will focus on communication and critical reasoning skills.

Professional development schools, a prominent feature of the Holmes reform agenda, will be planned and instituted with a consortium of ten Nebraska school districts, the Nebraska Council for Excellence in Education. This council has just begun to select professional development school sites.

Like many other Holmes Group schools, the University of Nebraska plans to establish enrollment ceilings. The most unique features of Nebraska's planning to date are its intentions to have practicing teachers participate in admission interviews and to utilize portfolios to evaluate student progress. Interestingly, Carnegie's plan for national board examinations includes a provision for evaluating portfolios.

Michigan State University. Michigan State has taken a very different course from that followed by the University of Nebraska, but in many respects like that of Ohio State. The primary concern at Michigan State appears to have been one of carefully deliberating the processes of change and developing the conditions for widespread change throughout the university. With the Holmes Group reform agenda as the topic of discussion, faculty involvement has taken the form of discussion groups organized around special interests, colloquia on issues, and formal departmental, governance committee, and college faculty meetings. A universitywide teacher education council has examined a planning proposal that lays out (1) the responsibilities of Holmes Group members; (2) issues such as the establishment of graduate professional curricula, undergraduate minors in education of thirty to thirty-six credit hours, an advanced professional doctorate for career professionals, and deepening of subject-matter preparation; (3) relations with the profession, schools districts, and state agencies; and (4) implementation activities and a schedule for implementation.

Their implementation timetable envisions a ten-year process. The timetable's first two years are devoted to deliberation and planning. Establishing a graduate professional school is expected to take a full ten years parallel with the establishment of professional development schools. The timetable projects development of a minor in education over the next three years and a professional doctorate over the next four years.

In shifting the professional preparation of teachers to the graduate level, Michigan

State does not envision eliminating under-graduate offerings. The college projects two kinds of undergraduate programs. To address the need of undergraduates interested in teaching, an undergraduate minor in education would be offered, including both academic and clinical ex-periences. The college also is considering designing one or more courses for in-clusion in the general studies curriculum focusing on the nature, function, and ends of public education. These latter experiences are intended to contribute to the civic education of all students.

As career ladders become a reality, differentiated staffing will emerge as a pattern in most schools. Michigan State is considering a doctorate for career professionals who assume leadership roles in schools and for those who play a substantive role in the education of new teachers.

In addition to planning and actions more directly under the jurisdiction of the school of education, the entire university community is engaged in the process of reconstituting liberal studies at Michigan State under the direction of an all-university committee appointed by the provost. This committee has been assigned the task of examining fundamental issues in undergraduate education that are similar if not identical to Holmes concerns for liberally educated teachers.

Little headway has been made with professional development schools other than preliminary meetings with represen-tative school superintendents. Nor has much planning or development occurred in basic areas of curriculum or in establishing admission standards. As noted above, Michigan State is devoting much of its early energy to the process of change itself.

Ohio State University. There are striking parallels in the approaches being con-sidered by Michigan State and Ohio State. These include similarities in processes, types of programs envisioned, and in expected program outcomes. The most notable differences between them reside in the nature of faculty involvement and the degree of participation by formal governance committees through policy-framing mechanisms. Like Michigan State, faculty involvement in the decision to join the Holmes Group occurred in the form of discussion groups organized around special interests, colloquia on issues, and departmental and college faculty meetings with the Holmes Group reform agenda as the topic of discussion. The college's Office of Academic Affairs published and circulated a planning proposal that lays out (1) the responsibilities of Holmes Group members; (2) issues such as the establishment of graduate professional curricula, curricular design, minority recruiting, admission standards, the qualifications and employment of clinical faculty, and a doctorate for career profes-sionals; (3) relations with the profession, schools districts, and state agencies; (4) the design of professional development schools; (5) implementation activities and

a ten-year schedule for implementation; and (6) a five-year projection of development and implementation costs.

In contrast with Michigan State, Ohio State utilized its formal governance mechanisms to review, approve, and recommend all actions concerning membership in the Holmes Group. These ranged from the decision to join to formal planning and implementation requirements.

Unlike any of the midwestern universities, Ohio State's education faculty invited its president to participate in the deliberations. The president did so and informed not only the University Senate but the larger university community and the state's policy community as well of developments and reform goals.

The college's faculty senate developed implementation policies and approved policy guidelines authorizing initial planning and implementation activities. In brief, they were:

1 All forty teacher certification programs in the university were required to develop Holmes implementation plans. No exclusions were permitted;

2 All programs were required to create research-based rationales for their curricular planning activities;

3 All programs were required to submit a planning budget, timetable, and schedule of planning activities;

4 All programs were required to obtain approval of their plans from the senate;

5 Provisions were set forth for appointing a coordinator and teacher education coordinating body.

In response to this policy, the dean provided all certification programs with planning budgets specifying the character and scope of planning, based on the requirements of the policy outlined above.

Perhaps the most divisive issue raised by Holmes membership was the fear that market forces would lead to declining enrollments, a severe retrenchment, and the loss of faculty depth and breadth. Of nearly equal concern was the initial failure of the Holmes agenda to include equity issues and a thoughtful approach toward at-risk children.

Similar to Michigan State, Ohio State's provost appointed a blue-ribbon task force to review and recommend reform of the university's general education curriculum. A sweeping revision of general education has been approved and will be implemented over the next two years. Briefly, the revision requires that general education prepare a student to think critically; to understand the historical, social, political, scientific, cultural, and technological context of modern life; and to develop skills of reading, writing, computation, and practical reasoning. Teaching assistants are to be carefully prepared for teaching in the general education curriculum, and funds

have been allocated to establish distinguished professorships to attract outstanding teachers to the general education program.

Four models of teacher education are under consideration at Ohio State. These include a postbaccalaureate master's program devoted entirely to professional preparation; a five-year integrated curriculum combining subject concentrations with professional study in elementary education; a combined baccalaureate-master's program that includes three years of baccalaureate study, a year of master's-level study, and a final year of combined undergraduate-graduate study; and a more leisurely six-year program that adds an induction year to the above options.

For its professional development schools, Ohio State, in what may be a unique approach, has begun to plan a districtwide organization jointly with the Columbus Education Association and the Columbus School District. These training sites will mesh preservice teacher education with induction, continuing education, and advanced professional preparation. Curriculum development, instruction, research, administration, and budgeting will be the shared responsibility of the district, university, and teacher union.

Other professional development sites are being negotiated with two additional school districts and a countywide network of school superintendents. Each plan addresses working relationships and alternative conceptions of professional

development schools. Concepts range from specific sites analogous to teaching hospitals to a more abstract "school" with common standards, procedures, faculty characteristics, and curricular arrangements at multiple sites.

Implications for Discipline-Based Art Education

Regardless of the turns that teacher education reform may take in the coming decade, two trends now seem certain to affect not only discipline-based art education but teacher education in general. One is the movement toward greatly expanded teacher assessment. The Carnegie Task Force on Education and the Economy, the Holmes Group, and, particularly, the various state departments of education have tied teacher certification to teacher assessment. States have moved quickly to establish examinations connected with the issuance of a teaching credential. The Carnegie Forum has awarded Stanford's Lee Shulman a contract to develop assessment procedures for its national board examination, and the Holmes Group has assessment as a major priority.

What seems almost equally clear is that the knowledge base for teaching will expand enormously over the next decade. Two decades of cognitive science are now beginning to reveal much about the thought processes underlying complex skills. This research has already begun to supplement the wisdom of practice with knowledge about how expert teachers

think, and it has moved the field from its emphasis on laboratory and large-scale sociological surveys to studies of the reasoning processes that lie just beneath the surface of expert craft knowledge. Also, a substantial majority of today's teacher educators started their careers during the 1950s and 1960s. Many have retired and many more are nearing retirement. They are being replaced by a new breed of teacher educators skilled in the techniques of classroom research on teaching. To accommodate these changes, the next logical step the field of discipline-based art education must take is to explicate the reasoning that undergirds the selection of aesthetic, historical, critical, and art-production content for adaptation and tailoring to the needs and qualities of learners and to the contexts in which learning takes place.

Let me now explain teacher assessment more closely. Two assumptions undergird the push toward assessment. The first is that the knowledge base for teaching has grown sufficiently strong to permit the development of substantive measures of teaching skill, not just paper-and-pencil measures of subject specialties. The second is that assessment will take place over a considerable length of time, starting with student preparation and ending with achievement of the highest career levels in teaching. For example, Sykes (1987), in a recent paper presented at the Holmes Network Conference, described the four-part assessment being constructed for national board assessment. Shulman and his colleagues are developing (1) measures to assess liberal arts knowledge, (2) an in-depth assessment of specific teaching knowledge and skills to be carried out over three days at an assessment center, (3) the requirements for a portfolio of information and evidence to be presented by candidates covering student preparation through several years of teaching, and (4) an observational and evaluative system to be applied during residency.

With the exception of the test for liberal arts knowledge—what teachers need to know about content to teach well, and the reasoning underlying the selection and transformation of content into powerful instructional representation. Shulman's (1987) characterization of this knowledge is heavy with significance since it will form the basis for designing Carnegie's national board examinations. He defines pedagogical content knowledge as "the blending of content and pedagogy into an understanding of how particular topics, problems, or issues are organized, represented, and adapted to the diverse interests and abilities of learners and presented for instruction." Shulman argues, however, that what distinguishes teachers from experts in a discipline or field is their ability to transform knowledge into instructionally powerful representations sensitive to pupil and contextual variations through processes of pedagogical reasoning.

In Shulman's analysis, pedagogical reasoning proceeds from the comprehension of subject matter to the transformation

of it into forms understandable to students. Transformation, Shulman argues, involves the following: (1) critically interpreting content and representing it as examples, analogies, metaphors, descriptions, and the like; (2) selecting an appropriate mode or medium of presentations; and (3) adapting and tailoring these representations to the characteristics of students and situations.

In my brief acquaintance with discipline-based art education, I see little evidence that the field has gone beyond describing the disciplinary foundations for art education: aesthetics, history, criticism, and production of the visual arts (Clark, Day, and Greer 1987; Eisner 1987; Smith 1987). Beyond these, its historical sources of pedagogical knowledge appear to be child development (Feldman 1987) and traditional structural analyses of curriculum (Efland 1987). To my knowledge, discipline-based art education has not gone the next step to study either the nature of pedagogical knowledge in the visual arts or the reasoning process by which teachers make this knowledge accessible to students. Given the central role that national board certification will occupy in the near future and that state examinations now play in licensure, this void must be addressed.

Equally apparent is the impact that these examinations will have on all teacher education curricula. Even if teacher preparation moves wholly to the graduate level as suggested earlier, the need for curricular "space" will intensify. The breadth of knowledge and skill implied by the reforms under way seems to entail more than a

baccalaureate and a single year of graduate teacher education. Some form of residency appears inevitable. As indicated earlier, none of the Holmes institutions plans to abandon the undergraduate curriculum entirely. It is reasonable to assume that whatever curricular changes occur, they must either meet or exceed state-mandated requirements for teacher education (Green 1987). Added to these demands on the preservice curriculum will be those stemming from the reexamination of the baccalaureate degree now in full bloom on most campuses. If the Holmes and Carnegie recommendations are heeded, liberal studies undoubtedly will occupy a more prominent place in the under-graduate curriculum.

Ultimately, educational reforms must succeed or fail in classrooms. The shaping and transforming of art education from studio- to discipline-based education seems to be cresting at the historic moment when all of education is gripped in a tide of reform. It is extraordinary that this shift toward the disciplines of art is occurring at just the moment when a pedagogy of disciplines is near to being a reality. I can think of no greater improvement in schooling than to have my children learn to experience and understand the visual world and thereby gain access to its complex beauties, its subtle meanings, and its revelations about our civilization. Their imagination, their discernment, and their sensibilities await your efforts.

References

Bok, D. 1987. The challenge to schools of education. *Harvard Magazine* 87:47–80.

Boyer, E. L. 1983. *High school: A report on secondary education in America.* New York: Harper & Row.

Clark, G. A., M. D. Day, and W. D. Greer. 1987. Discipline-based art education: Becoming students of art. *Journal of Aesthetic Education* 21(2):129–93.

Committee on Economic Development. 1985. *Investing in our children: Business and the public schools.* New York: The Committee.

Eisner, E. W. 1987. *The role of discipline-based art education in America's schools.* Los Angeles: The Getty Center for Education in the Arts.

Feldman, D. H. 1987. Developmental psychology and art education: Two fields at the crossroads. *Journal of Aesthetic Education* 21(2):243–59.

Green, J. 1987. *The next wave: A synopsis of recent education reform reports.* Denver: Education Commission of the States.

Holmes Group. 1986. *Tomorrow's teachers: A report of the Holmes Group.* East Lansing, Mich.: The Holmes Group.

Powell, A., E. Farrar, and D. Cohen. 1985. *The shopping mall high school: Winners and losers in the educational marketplace.* Boston: Houghton Mifflin Co.

Shulman, L. 1987. Knowledge and teaching: Foundations of the new reform. *Harvard Educational Review* 57:1–29.

Sizer, T. 1984. *Horace's compromise.* Boston: Houghton Mifflin Co.

Sykes, G. 1987. Carnegie board assessment procedures. Paper presented at the Holmes Group Summer Leadership Conference, Snowbird, Utah.

Task Force on Teaching as a Profession. 1986. *A nation prepared: Teachers for the 21st century.* Washington, D.C.: Carnegie Forum on Education and the Economy.

SIGNIFICANCE OF RECENT NATIONAL REPORTS FOR PRESERVICE DISCIPLINE-BASED ART EDUCATION

SPEAKER

Maurice J. Sevigny
University of Texas at Austin

Introduction: Searching for the Perfect Wave
Because visual images are more lasting to this particular audience than volumes of critical verbiage, I have decided to expand on Joslyn Green's (1987) use of the wave metaphor, assuming that you have done your assigned homework and dog paddled through her splashy synopsis of the points of reform agreement and unresolved issues still to be addressed by higher education. Thus, for your entertainment and inspiration, I have highlighted my interpretation of the current wave of reform reports with an analogy to surfing.

At the outset, it is important to recognize that although the surge of reform recommendations are highly critical of teacher education programs, the actual reporting itself represents a new optimism for the profession that may well transcend any single weakness. Many of the reform reports are attending to more complex issues of schooling that were overlooked earlier, such as the need for students to be creative and more knowledgeable about the arts. The call for substantive content and rigor in teacher education provides new challenges to higher education in the visual arts, as we prepare to ride the parallel swell of enthusiasm that is cresting with the J. Paul Getty Trust's endorsement of discipline-based art education (DBAE). The climate and timing are optimal for revising the criteria for excellence in art education and for redesigning the courses and degree programs that prepare teachers to implement a discipline-based conception of excellence.

Your institutions have been selected to participate in the Snowbird Symposium because you have demonstrated an enthusiasm for getting into the swim of change, or because you have strong potential to ride the crest of DBAE. Some of you have come eager to demonstrate your teacher education surfing skills; others will be inspired to design better surfboards (degree programs); and others are here to learn how to wax and refurbish favored and familiar ones. We were fortunate this morning to have heard a variety of perceptions from a panel of seasoned educational surfers who spoke of education's general quests for "the perfect wave." During your small group session you will also have the advantage of hearing from representative faculty of the Getty Summer Institutes, who have been scanning the sea of reform for some time. They will share and advocate methods and perceptions of teacher education that have proved effective for inservice teacher education on the Los Angeles shores. This wide sampling of professionals from across the country is charged with a different task, that of developing alternative strategies and degree programs for preservice teachers. You will determine if the surfing techniques developed for the Pacific populations are as relevant for surfers on Lake Erie, the Colorado River, the Gulf of

Mexico, or the Great Salt Lake. Our challenge is to translate reform theory into goals for educating teachers.

The Clark, Day, and Greer monograph (1987) has served to stir the theoretical waters of reform in art education. And though its foaming interpretation of DBAE may still appear murky to some, as creative individuals you should be un-afraid to wallow in its soft theories for art curriculum reform. The mono-graph and antecedent papers [papers tracing the historical background of DBAE] (1987) would serve to launch new vehicles to implement our collective hunches for improving DBAE implementation in each of your respective teacher education pro-grams. My assignment is to inspire the redesign of degree programs by executing a one-and-a-half triple twist into the deep end of possibility, to snorkel the reefs of antecedent recommendations, and to skim the perceived connections to general edu-cational reform. The assumption here is that it is indeed probable, that somewhere in these melting streams of Snowbird, you can find, if not the perfect wave, one that will provide a respectable ride toward reform. If you are ready to try your luck at educational surfing, then put on your nose plugs—or your ear plugs—and get ready to catch the "Next Wave"!

The Essentials of Educational Surfing
Before you begin you had better know the condition of your program equipment and be well acquainted with the basic skills of educational surfing. Although the essential

characteristics of teaching and curriculum are analytically distinct, they are oftentimes indistinguishable in the everyday cycles of classroom life. As a result, too many have narrowly assumed that the solution to improved art education is improved curriculum. But when new curriculum concepts are separated from the models for teaching that can propel them, discontinuity and a short-term effectiveness have been the inevitable results. Any plan to alter subject matter must give parallel attention to related shifts in teacher attitudes, knowledge, and skills to ensure the attainment of the desired learning outcomes.

Let us prepare for educational surfing by waxing our definition of teaching. John Hough and Kelly Duncan (1973), the Ohio State University developers of an obser-vation system for instructional analysis, define teaching as "the process of arranging human, material, temporal and spatial resources, with the intent of facilitating the learning for the self or another." This definition portrays teach-ing as an adaptive planning behavior that involves the teacher in a continuous process of evaluating the structuring of four essential elements of instruction. From this definition, teacher education programs would prepare students for any decision related to how teachers will use their own, or another's particular knowledge or talents; how they would structure the development of the skills of classroom interaction; the allocation of both the student's and the instructor's time; the

arrangement or design of instructional materials; and the control of the motivational features of the classroom environment.

Reforming teacher education means altering its basic components. My investigation of DBAE and teacher education (Sevigny 1987) confirmed that although the perceptions, interests, skills, and experiences of art teacher educators differ significantly, most programs have developed a common structure that includes three major components: First, academic preparation in the discipline the student will be teaching (e.g., drawing, ceramics, art history, aesthetics, etc.); Second, theoretical foundations of professional education, such as the philosophy and history of education, educational psychology, and discipline-oriented methods and curriculum courses; and Third, field experience, student teaching, or some form of internship.

Annette and Frankie: The Surfing Idols of Our Past

The taken-for-granted components of teacher education are its sacred idols. Replacing idols is never an easy task for it often means the replacement of our former selves. Despite our natural desire to cling to the surfing idols of the past, we cannot disguise the fact that Frankie Avalon and Annette Funicello are getting older and it has become more difficult for them to maintain the popularity they enjoyed in the 1960s! Our teacher education program idols are destined for steep competition in the

sizable wake of current criticism. Over 1,200 teacher education programs are already confronting this turbulence and the majority of them are struggling to stay afloat in the undercurrent of dwindling enrollments, trying not to drown from parallel pressure to recruit and screen more able candidates. Ninety-three of our most prestigious colleges of education have already committed themselves to explore the extended programs advocated by the Holmes Group. And many of the rest are stroking feverishly to swim ahead of the *Jaws* of state-mandated reform. The examination of DBAE antecedents has shown that professional concern about the quality of art education seems to occur in cycles. Waves serve our purpose as an appropriate metaphor because they surge, swell, then flow into the mainstream. The DBAE antecedent reports (1987) document several cycles of subject-matter reform for art. It's no small wonder then, that our current state of affairs should foster a sense of déjà vu. What has linked one wave to the next is the inevitable optimism that has accompanied each peak of harsh criticism. No matter how bad reformers perceive teaching to be, critics never consider the cause as hopeless. And yet, previous tides of interest in teacher education reform have very often been followed by an ebb of public school indifference. As Fred Hechinger (1983), education writer for the *New York Times*, wryly observed, "Unprecedented opportunities have a way of knocking more than once." Once again, an unprecedented opportunity for

reforming art teacher education is knocking, but this time, more schools seem eager to open the doors.

In the past we have glossed over the novice teacher's transition into yesterday's classrooms. Is art education ready this time to channel the surge of criticism into action plans for altering previous approaches to implementation of educational reform? Let us attend to the lesson from *In Search of Excellence* (Peters and Waterman 1982), the best-selling analysis of successful companies in America. Its authors, Thomas Peters and Robert Waterman, conclude that the single most pervasive attribute of excellent companies is their profound respect for the individual. Peters and Waterman found the characteristics of corporate excellence at both McDonald's and IBM—in the production of the lowly hamburger and in the glamour of high technology. For them, the basis for excellence did not reside in the prestige of the product, but in the attitudes and enthusiasm of the workers. The message for DBAE is clear. Educational excellence will be the result of an unusual and enthusiastic effort on the part of ordinary teachers. Educational excellence is people-based; it is motivation-based, not just curriculum-based! As a point of fact, most of the reports on school reform pay surprisingly little attention to the incentive of "ordinary teachers." They imply that the rising tide of mediocrity is made up of an embarrassing number of ordinary people and that, if we wish to return to excellence, we had better go out and recruit more

"excellent people." This simplistic solution ignores the challenge for stimulating unusual effort from ordinary teachers. I will return to this point again, but first I want to caution you against other simplistic solutions—what I call "Mermaids and Other Fables of Integration."

Mermaids and Other Fables of Integration
As we explore the integration of DBAE into teacher education, we are cautioned to beware of mermaids who beckon from the treacherous reefs of "teacher proof" ideals. We are warned not to repeat the error of aesthetic education by forswearing innovation in favor of packaged tidiness. "Aesthetic scanning" is a useful tool, but don't be tempted to see it as the only mechanism for grafting teaching practice to DBAE goals. Be warned—mermaids may be beautiful, but they are packaged fantasies, designed to look good, but never marveled for their efficiency as swimmers! In its present form, DBAE is an extraordinary and beautiful concept. But it needs a variety of "instructional legs" to get its theoretical premises into classrooms. I suggest that we take lessons from *A Place Called School*, where John Goodlad (1983) resisted this temptation to force any particular course of action for every school. Like Peters and Waterman, Goodlad saw individualistic entrepreneurial spirit as the emerging hallmark of excellence. At the recent DBAE implementation issues seminar, held in Cincinnati, Ronald MacGregor (1987) echoed a similar perception. He stressed the importance of a DBAE framework that

would be to some extent "participatory," so that "ordinary teachers" might claim some degree of ownership. Brent Wilson (1987) explored issues related to the local and regional politics of DBAE implementation and theory interpretations. He offered three useful differentiations between what he called "Name-brand DBAE," "Generic-brand DBAE," and "Popular-brand DBAE." Brent suggested that all three types were needed for DBAE to succeed, and cautioned its current advocates against strict adherence to "Name-brand DBAE." He emphasized that the transition from theory to practice was turning out to be more difficult than originally anticipated and that the Los Angeles DBAE model may be guilty of making greater claims than it is capable of producing. Rogena Degge (1987) responded eloquently by further emphasizing that the end goal of DBAE is not the mere total of teaching content in the four disciplines of art. DBAE should not be seen as an end goal of itself. DBAE is only a means to priority art education goals that may yet need significant clarification. Although the DBAE monograph, recently published in the *Journal of Aesthetic Education* (1987), defines DBAE, much research is needed to understand effective teaching to enhance the student's acquisition of DBAE knowledge skills and values. As the interest in DBAE continues to rise, I find myself being confronted more and more with this typical response from art teachers. "I understand the basic theory behind DBAE, but how do you turn kids on to art history, art criticism, and aesthetics?"

The response infers a lack of enthusiasm on the part of the art teachers themselves. Indeed when asking about motivation, many earnest, dedicated art teachers seem to be searching for "mermaids," or tidy solutions to balance the inadequacies of their own knowledge or lack of training in the essential skills for arranging dialogue about art.

Teacher Motivation: Catching Surfing Fever
There is no one way that will motivate all teachers or students in the same way or to the same degree. The theory of change from within is central to the concept of personal causation (deCharms 1968), which emphasizes ownership of behavior. Simply put, people experience personal causation when they initiate, control, and are responsible for their own actions. When persons engage in activity by choice, they are considered origins. When they believe outside forces are in control, they are considered pawns. Motivation to implement DBAE could be enhanced if origin experiences would occur more frequently both for teachers and students.

The literature on motivation has expanded dramatically during the past decade (see Cohen 1987). Current theorists provide important insights for those of us who wish to control change through knowledge of intrinsic motivation. Whether teachers and students feel a sense of accomplishment and satisfaction with DBAE or a sense of dissatisfaction or failure will be influenced by their desire to attempt the task again. Motivation is a

complex blend of attitudes, aspirations, self-concepts, and situation. The research on teaching, however, does suggest that teachers need guidance and practice to understand student success and failure (Ames 1983).

Classroom activities for DBAE will also have inherent characteristics that can affect a student's motivation to respond. Hackman and Oldham (1975) are respected industrial psychologists who make us aware of five "Core Dimensions for Task Motivation":

• skill variety, the degree to which a task requires a variety of different skills, talents, or procedures to carry it out;

• task identity, the degree to which the task requires the individual to identify with the completion of the whole—that is, having visible outcomes or achievements at the completion of the task;

• autonomy, the degree to which the task offers substantial freedom, independence, and discretion in scheduling the work and determining the procedure for carrying it out;

• feedback, the degree to which carrying out the task activity would allow the individual to have clear feedback as to the effectiveness of performance.

Obviously, it is not just a subject matter that one teaches, but the conveyed status of that subject matter. The motivational potential for implementing DBAE activities relates these five core dimensions to three participant perspectives that I call the "critical psychological states." These three are:

• valance, the perceived attractiveness or experienced meaningfulness of the task;

• expectancy, the perceived value for outcomes of the task;

• instrumentality, the perceived relevance for the student's present values or goals for the future.

Teacher education will not make massive strides toward the implementation of substantive curriculum by simply increasing the preservice requirements in the four disciplines of art, or through token embellishment of its studio-dominated programs. The profession needs to examine issues of balance in required course work, but it will also need to alter the general perception of expectancy and instrumentality for the study of art history, art criticism, and aesthetics. Teacher educators have not always been able to do this. Not only is it important for teachers to understand the tenets of DBAE, but it is critical for them to have learned them within a framework and spirit of promoting change. Providing choices to preservice and inservice teachers—with the opportunity to take responsibility and control—and offering them information rather than control will enable teachers to act as models for their own students.

Teachers must understand how concepts of motivation are related to their own perceptions before they can apply such concepts to others.

New Surfing Heroes: Changing Our Role Models
New heroes in the visual arts have typically emerged from a valuing of originality and uniqueness. In doctoral-level research, the stress on individualism poses another significant challenge to continuity in art teacher preparation. As role models for preservice teachers, teacher educators are generally academically and creatively less accomplished than their colleagues in the art disciplines. University art educators are seldom perceived as "mainstream" artists or scholars. Any attempt to reform preservice education must attend to the career ladder and development of university art education faculty. It may be time for the profession to redefine the distinction and unique potentiality of the Ed.D. and the Ph.D. to better utilize both research expertise and master-teacher career-ladder specialists as suggested by the Holmes Group. I recently attended the annual spring meeting of the American Association for Higher Education and heard Patricia Cross, a Harvard professor of higher education, urge professors to become "classroom researchers," analyzing what about their own teaching was effective in particular situations. Her research demonstrates that college teachers are not always certain as to their impact on students or clear as to what they are trying

to do. To distill the recommendations from the myriad of higher education personnel reforms, a group of leading higher education scholars, including Ms. Cross, unveiled a seven-system list for improving university teaching. They claimed that an effective college professor:

- encourages contacts between students and faculty members;

- develops reciprocity and cooperation among students;

- gives evaluative feedback promptly;

- emphasizes time spent in class on particular tasks;

- communicates high expectations;

- respects diverse talents and ways of learning;

- uses "active learning" techniques that have students talk and write about what they learn and relate new knowledge to their personal backgrounds and daily lives.

Ms. Cross acknowledged that these recommendations may appear embarrassingly simple, but said "researchers consistently find that such commonsense practices do not exist in most university classrooms." As an art department chairman, I have observed that art faculty often lack understanding of pedagogy or hedge on the interpretation of

established course descriptions and goals to emphasize idiosyncratic scholarly or creative interests. The outcome for higher-education art education has been a weakened identity as a focused "profession." As is noted in my antecedent report, despite substantial calls for new content for teacher preparation, there has been minimal change in the way students have been educated over the past thirty years. Teacher demonstration or talk and student response has remained the dominant mode. The lack of significant change relates to the fact that there has not been a locus of power in the control of teacher education; that the characteristics of schools and the teaching workplace have stayed the same; and that the resources to support innovation in teacher education have not been sufficient to allow for extensive practice, demonstration, feedback, or follow-up coaching. Our profession can no longer afford to ignore the socialization process for beginning teachers, where the bulk of learning to teach is through entry into the work place. We must become more sensitive to the needs of teachers already in the field, where collaborative responsibilities for training new teachers are less clear-cut and less manageable. There is another lesson from David Hawke's 1980 investigation of first-year art teachers that effectively demonstrates how new art teachers quickly abandon the theories and approaches of teaching in which they were trained because such methods appear too theoretical or ideal for what they must confront in the schools. As a consequence, novice teachers substitute ideal theory with the formulas for success already being used by their colleagues. More often than not, efforts to improve higher education programs and efforts to improve school curriculum proceed with little mutual awareness. There is a lesson here for better collaboration with the support systems that will play the tunes for those who would dare to dance upon the DBAE waters. Significant reform can only rise out of an unbroken continuum that simultaneously manipulates all the components of this complex enculturating system.

New Directions: Jet Skis for the Next Wave
Having identified a few specific targets for reform in art teacher preparation, let us "splash around" a bit more in the tide pools of excellence that are embodied in some of the current reports. Metaphorically speaking, let us evaluate whether the recommended jet-ski approaches might be more effective than the surfboard ones that we have been riding since the sixties. The jet-ski recommendations center around three major issues: (1) the desire to improve on the professional image of teachers through attracting more able candidates and retaining them with incentive plans like better salaries and career ladders, (2) the need to increase training in the liberal arts, and (3) the need to reduce and restructure the sequence and content of professional education courses. Typically, the reports tend to focus on shortcomings and provide, at best, a skeletal framework

for program redesign. A similar observation can be voiced about the DBAE monograph, since most of our colleagues comprehend its basic premises, but have less confidence regarding its translation into teaching practice.

Of all the reform efforts, the Holmes Group offers one of the most comprehensive diagnoses of problems in the preparation of teachers. Its agenda includes the enhanced professional status of teachers, an expanded empirical base for guiding teachers, more time for the development of discipline knowledge, and the development of a career ladder. The Group represents a consortium of research-oriented institutions and, consequently, is most concerned with how teacher preparation efforts might be enhanced through collaborative research efforts with faculties from the liberal arts and social sciences. The Group's most revolutionary and controversial recommendation is surely the elimination of undergraduate teacher-preparation programs and the transfer of professional education to a graduate fifth-year level. Because only about 10 percent of the twelve hundred-plus institutions that prepare teachers will participate in the Holmes plan, we need to ask, What will become of the rest? The Holmes design incorporates a three-tiered career track. The assumption is that institutions outside the Holmes group would focus only on entry-level teaching roles. This may lead to the delineation of specialized missions for different types of institutions. As the previous panel just indicated, this scenario

is obviously not without problems or opposition. Another obvious shortcoming for art education is that the Holmes Group glosses over program recommendations for certification in specialty areas. In many ways, art education is already modeling teacher preparation from in-depth preparation in the studio. Nevertheless, the issue here is to justify whether extended programs or an enriched major for art deserve the status the Holmes Group has accorded them for general areas.

Increasing the costs for becoming an art teacher will reduce the attractiveness of art education as a profession unless these costs are offset by adding benefits, intrinsic and extrinsic, not now available. If we recognize that there is considerable risk and high cost in requiring teachers to have five years of college before they teach, we should expect those who wish to subscribe to this position to make a persuasive case that extending the preparation period will still attract the best candidates, as well as improve the quality of DBAE preparation for entry-level teaching. For those institutions already moving toward this direction, I recommend a fresh look at what has happened in California and another look at the structure and goals of Ohio State's 1967–71 Prospective Art Teacher Fellowship Programs. This short-lived but effective program required a two-year postbaccalaureate extension that provided in-depth study in the disciplines of art history, studio art, criticism, and aesthetics. Art education courses were designed to extend the skills of historical inquiry, art

criticism, and aesthetic analysis, and participants were trained to design innovative teaching materials for discipline-centered activities. A unique feature was the program's integration with the humanities through a supervised field practicum with English or history teachers. Its purpose was to refine verbal interaction skills and knowledge of the inter-disciplinary connections to the visual arts. For detailed information I would refer you to Arthur Efland, who twenty years ago was responsible for implementing that pioneer effort to extend the knowledge base of beginning art teachers.

Group efforts to redesign professional education courses for art teachers are not new to this profession. During the early part of the 1970s the Central Midwestern Regional Educational Laboratory CEMREL program for aesthetic education sponsored a collaborative effort with twenty-four higher education institutions. Harry Broudy was called upon to give the keynote address to encourage the participants to consider change. Broudy's (1970) core approach centered on methods to promote aesthetic perception. For him, the essential components for art teacher preparation were: (1) training in performance in at least one art discipline; (2) course work in the history of art, in art criticism, formal aesthetics, and the humanities; (3) professional study in the problems of aesthetic education. The problems include:

• consideration of aims, curriculum organizations, and teaching and learning in aesthetic education;

• laboratory experiences in each of the arts;

• clinical study in each of the areas of aesthetic, performance, and history;

• an internship in a public school receptive to the goals of aesthetic education.

The Broudy plan was derived from his graduate-issues seminar, "Foundations of Aesthetic Education." Consequently, the breadth of content and ambitious goals were dismissed as somewhat extensive for the nonspecialist preservice teacher—the focus of CEMREL efforts. His early vision has perhaps greater relevance today for DBAE and the preservice education of art specialists. As we reevaluate its potential, it may be important to recognize Broudy's close professional association with B. Othanel Smith during the 1960s. Smith headed the American Association of Colleges for Teacher Education's Task Force, commissioned to develop new alternatives for teacher preparation. An influential publication, *Teachers for the Real World* (Smith 1969), was the outcome. The text pioneered major reform in multicultural education and promoted a convincing rationale for adopting a clinical approach to teacher preparation that incorporated the use of "protocol materials."

Protocol materials are actual recorded classroom situations and episodes or simulated reproduction of teaching events that have occurred in an educational context. In terms of their format, they can take on a variety of forms, including:

recordings or transcripts of classroom dialogue events preserved in film or video, still photographs, audio recordings, descriptive ethnographies, student records and documents, micro computer-based simulations, and scripts for improvised drama. Whatever form they take they will share the following characteristics:

• They reproduce or record behavior or teaching events;

• They focus on events of educational significance;

• They represent educational settings, concepts, or instructional strategies;

• They are used to instruct students to analyze and prescriptively interpret events.

Their application rests on a premise that the most efficient means to develop teaching skills is to provide drill and practice for the interpretation of teaching theory to actual situations. Observation is focused through edited materials designed to guide student perception toward selected "slices of classroom life"—or events of educational significance.

The clinical method provides pedagogical structure to bridge the gap between theory and practice. Although field observation in actual settings also can be used to confirm theory, events of educational significance vanish as they occur, making their complexity and recall difficult for analysis and interpretation.

Teacher educators cannot assume that the observer's memory will replay a behavioral incident accurately and analyze the event in all its complexities. Learning to read the data captured in protocol materials helps the teacher educator to fine-tune observation skills and to broaden the novice's holistic sensitivity to the variables of effective teaching. It is my belief that this strategy could be adapted to ensure the acquisition of essential DBAE skills. I became inspired to explore the use of recorded and edited episodes from Asahel Woodruff, the 1971 workshop leader for the second CEMREL-sponsored teacher education workshop. Since that time, my own approach to teacher education has extended Woodruff's proposed method also to incorporate the qualitative research strategies of participant observation and classroom ethnography. But I think it would suffice here to resurrect Woodruff's four-step sequencing for your consideration of alternatives. He suggested that teacher educators:

1 identify a set of goals for students to reach through schooling;

2 determine from the research and data of human behavior the requirements for change and the conditions that are essential for changing student behavior toward these goals;

3 determine what teachers have to be able to do to set up and maintain those conditions;

4 determine again, on the basis of the same data about human behavior and requirements for change, how those competencies can be developed in teachers.

The Woodruff plan is dependent on phenomenal training, by means of carefully selected instructional behaviors that prospective teachers perfect through practice. In his terms, it is also dependent on "the development of a rich repertoire of self-study materials which would get teachers involved in the desired competencies." To adopt his method, DBAE supporters would have to define instructional competencies and to design and provide exemplary materials for trainees. These would be used to engage students in (1) theoretical interpretation and (2) practice in arranging the conditions of interaction for desired DBAE learning outcomes. How does all this relate to the current reform reports?

Eighty and Still Surfing
Harry Broudy is in his eighties, but he's still surfing on the current waves of reform. At the Holmes Group Wingspread Conference, in June of 1985, he resurfaced with a new twist to a familiar maneuver. Broudy advocated that increased familiarity with theoretical constructs of the liberal arts would help teachers achieve accurate critical analyses and perception skills to prepare them to generate valid interpretations of instructional events. To develop such skills, he recommended to the Holmes Group that teacher educators

give serious consideration to the case-study models of law, business, medicine, the sciences. Broudy referred to these case-study models as "portraits of teaching." Case-study portraits bear strong resemblance to Smith's notion of "protocols" and Woodruff's "repertoire of self-study materials."

What would portraits of DBAE look like? How might they provide exemplars that could be used to involve prospective teachers in the analysis and acquisition of DBAE teaching theory and the acquisition of skills relative to each of the four disciplines of art? To determine the essential features for such portraits, art education faculty will need to collaborate with colleagues from the four disciplines to select model portraits that strengthen the development of theoretical understanding and expand the adoption of appropriate teaching strategies. Here is where the Holmes plan to encourage research consortia may be adaptable for the acceleration of DBAE. The program development teams represented here could work together over time to share strategies and new approaches for educating art teachers. A variety of case-study protocols, parallel to those employed in legal training, could be assigned and generated for testing to be shared among cooperating institutions. Such a plan would rapidly increase the diversity of training materials that are needed. The effectiveness of experimental DBAE strategies could be studied by cross-institutional teams. The collaborative character of an evaluation effort of this

scope would favor the conditions to conduct significant inquiry and educational criticism, the character of which could be replicated for comparisons across populations and across geographic regions. The painting of DBAE portraits should also be executed in closer collaboration with faculty from the liberal arts. After all, an art curriculum that features looking at, talking about, and reading about art is a dialogue curriculum, dependent on visual perception, interdisciplinary understanding, critical thinking, verbal expression, and communication skills. However, the attainment of these goals has been slow in coming, for as *A Nation at Risk* (U.S. Department of Education 1983) sadly proclaims, better than 40 percent of tested seventeen-year-olds could not draw inzferences from written materials. Martin Engel (1976) observed, over a decade ago, that one downfall of aesthetic education was a failure to provide aspiring teachers with the basic skills of clear expression. As CEMREL and the Ohio State fellowship programs also discovered, effective teaching, for the critical, historical, and aesthetic components of art education, would require a special repertoire of knowledge and skills from the liberal arts, with heavy emphasis on the training of verbal communication and critical analysis skills. Yesterday, Kathleen Cohen called this "infiltrating the liberal arts." I liked her concept of "connective learning" to improve the quality of instruction in art history. This also suggests the need for strategies to train preservice teachers to

arrange instructional situations that differentiate between perceiving, analyzing, judging, talking about, valuing, and producing art. Such methods would address the criticism of the Education Commission of the States (ECS) that wishes to eliminate "soft" and nonessential courses and recommends that all disciplines enliven and improve curriculum by stressing the mastery of knowledge and skills that are beyond the basics. Their end goal is to alter schooling so that students are enthusiastically involved with active learning that incorporates problem-solving with critical analysis, interpretation, and persuasive writing skills.

Specifically, what ECS and others demand of teacher education is the development of broad knowledge in the liberal arts as well as a command of the logistics to manage the implementation of discipline-based curricula. This assumes as well that teachers will be trained to know when their teaching is substantive.

Rating the Ride: Evaluating and Teacher Effectiveness
One of the characteristics of surfing is an enthusiasm for rating and ranking the quality of each ride—how large the surf; how skillful the entry; how difficult the maneuvers; how aesthetic the overall effect. Similarly, as Susan Adler Kaplan just stressed about the Carnegie Commission, many of the reform reports are demanding increased accountability through the testing of teaching effectiveness and competency. The evasiveness of qualitative

measurement in the visual arts, where there are often no right answers, is now being challenged by the Educational Testing Service (ETS), through a five-year investigation funded by the Rockefeller Foundation. The project, called ARTS PROPEL, is a collaborative effort, involving seven ETS researchers and test developers, a research team from Harvard's Project Zero, and twenty inner-city teachers and administrators from the Pittsburgh schools. Drew Gitomer, a cognitive psychologist, is the project director. While arts production remains central to ARTS PROPEL, perception skills and the reflection process are the current foci of its cognitive research effort. Gitomer believes that the team will be able to help art teachers identify the cognitive elements that contribute to student learning. His hunch is that critical thinking in the arts is related to cognitive analysis processes that are specific to art (Educational Testing Service 1987). The ARTS PROPEL team has designed pilot exercises for cooperating teachers to implement as models for evaluating instruction. In this first year of the project, collaborators have been involved with clinical observation in pilot schools, collecting interview responses from the teachers and students. By studying sequence and decision making in perception, production, and reflection processes, planning teams hope to produce model portfolios to help teachers recognize the attributes of cognitive learning. In nautical terms, this wave could have hurricane impact for the profession. Any effort toward accountability that takes full

advantage of the collaborative resources and reputations of the Rockefeller Foundation, Harvard University, and the Educational Testing Service is bound to have a crashing credibility on the shores of public school administration. Let us not be caught with our backs against the sea as this wave builds momentum to propel us toward Gitomer's interpretation of teaching effectiveness.

Beyond Jet Skis: Alternative Standards for Art Teacher Certification
In your efforts to alter teacher education programs, you should be made aware of another wave, building potential momentum to alter the standards for art teacher preparation. The intensified effort of the Working Group on the Arts in Higher Education has produced a draft report, *Teacher Education in the Arts Disciplines*, that outlines a changing perspective for revising art education degree standards. It is being refined through a collaborative effort between the memberships of four art accrediting agencies: National Association of Schools of Art and Design, National Association of Schools of Dance, National Association of Schools of Music, and National Association of Schools of Theater. The document recognizes that rigorous, sequential arts education for all students has not been the norm in American schools. The revised standards will seek to change the outcomes of art teaching through a new emphasis on the function of art education. The initial report did make reference to the

other educational reform reports, but emphasized that most recommendations address problems that focus on method rather than function. It reminded us that the real question for any educational reform movement is in the extent to which eventual change makes it easier to accomplish the basic responsibilities of a discipline of study. The revised standards should promote art as subject matter that will involve students with individual means for in-depth access to the content of the four arts disciplines. If adopted, this new focus for teacher preparation should complement the educational goals of DBAE.

The report does not favor extended five-year programs because it acknowledges that the arts have been doing discipline-centered preparation all along, noting requirement ratios of over 50 percent in the art disciplines and the liberal arts accounting for one-third of arts education degree requirements. Art teacher preparation has to be centered with drill and practice for the acquisition of intellectual and physical skills to gain fluency in the art forms. No matter what certification structure institutions will select in the future, the report recommends that they continue to promote high expectations for discipline-centered art achievement and that their professional methods and content stress rationales that support the arts as basic to K-12 education. As was mentioned previously, it is not just subject matter than one teaches, but also one's perspective of the importance of that

subject matter. On the concept of rigor, the draft report recognizes that it is one thing to teach a subject deemed to be important, but quite another to teach a subject as a discipline that normally is associated with leisure, entertainment, and decorative embellishment. This changing perspective in the function of art education is viewed as a major change in responsibility for teacher educators.

It is significant that this report acknowledged the multiplicity of relationships that could affect the future quality of American arts education. It recommends several significant goals for parents, teachers, prospective art teachers, teacher educators, professional humanities committees, research groups, art philanthropists, the general education community, local, state, and national arts organizations, and the public media. Within the limits of this presentation there is not sufficient time to explore all of these recommendations and I assume that a more in-depth discussion of teacher credentialing will be addressed by Wednesday's panel on certification issues.

One caution seems appropriate for any revised standards that support a substantive approach to subject matter for art education. Many of the general reform reports attribute the erosion of quality to the permissiveness of the 1960s and 1970s. These reports propose to swing the pendulum in the opposite direction—toward more control, more requirements, and tougher standards that recommend simplistic solutions. "Not enough homework? Assign more." "Not enough curriculum

substance? Return to the disciplines."
Some of the current pessimism of teachers
regarding DBAE is related to their misper-
ception that its supporters have swung too
far away from creativity or what makes art
study enjoyable. We must be more sensitive
to this concern in how we state our individ-
ual cases for substantive teaching. Even
though the current disposition toward
DBAE may appear to be gaining favor,
many teachers are troubled by how much
they will be required to learn to implement
the plan. DBAE requires perceptive, knowl-
edgeable, and imaginative thinkers. This
may well mean, as the Holmes Group
suggests, the development of a new career
structure in which improved preparation
and professionally enforced standards of
practice combine with an increased respon-
sibility for instructional decision making by
those who successfully demonstrate pro-
fessional excellence. Upgrading the quality
of teacher preparation courses and degree
programs and creating more effective
instructional conditions are only part of
this structural solution.

As a consequence of being commis-
sioned to review the many recent reform
reports, I have formulated a series of fifteen
goals for potential change in art teacher
preparation. Allow me to summarize them
for reform consideration:

1 to clarify the teaching competencies
necessary to implement DBAE;

2 to develop action plans to recruit more
qualified candidates for implementing
DBAE concepts;

3 to raise the prerequisite requirement and
preadmission standards for art education
degree programs;

4 to restructure the academic requirements
in the four DBAE content areas;

5 to redesign professional courses that
make better use of clinical and field
observation;

6 to improve methods for the qualitative
evaluation of teacher knowledge and
competency;

7 to collect case-study models (protocols)
that take into account critical and verbal
skills and demonstrate the use of appropri-
ate instructional resources to implement
DBAE goals;

8 to better utilize and monitor academic
preparation in the liberal arts;

9 to explore the potential of postbac-
calaureate programs and extended
programs;

10 to influence changes that favor DBAE in
state-mandated requirements;

11 to examine the relationship of advanced
research degrees and career-ladder doctoral
study to improve on the professional stan-
dards for teacher certification;

12 to develop participatory incentives for
faculty in the art disciplines to better utilize

them as alternative role models in art teacher preparation;

13 to strengthen liaisons among the professional role models in the disciplines, art education faculty, the public schools, and personnel from state education agencies;

14 to implement collaborative teacher-training supervision teams—comprised of public school personnel, faculty from four disciplines, and art education staff;

15 to increase our knowledge about the optimum conditions for sequencing learning and integrating the four components of DBAE through increased support for descriptive, evaluative, and experimental research.

Our options are many and our search for massive change will need the intensity of Captain Ahab. Allow me to turn to the *Moby Dick* imagery to reach a closure to this presentation. A "whale" is uniquely defined by Webster's as a large mammal that "superficially resembles a fish." You are charged to provide more than superficial reform. The real "preservice challenge" is to determine attainable reform for art education. You must determine the answers to two questions. Are the basic tenets of DBAE curriculum realistic target goals or do they just superficially resemble attainable alternatives for our profession? Will your efforts have significant impact in advancing the basic tenets, or is DBAE destined to be beached alongside other visions of our past that have faded on the shores of good intention? The changes most of us desire undoubtedly will be at times experimental and partial; they will vary from place to place, and will never be as neat or as logical as educational reform or the initiators of DBAE might wish. Nonetheless, let us be refreshed by the current splash toward change that could inspire us to build the vehicles to carry our students to new educational crests. I hope the hunches from my antecedent report and my remarks today will contribute toward that end. Bon voyage, and good surfing"!

References

American Association of Colleges of Teacher Education. 1983. *Educating a profession: Extended programs for teacher education*. Washington, D.C.: The Association.

American Association of Colleges of Teacher Education. 1985. *A call for change in teacher education*. Washington, D.C.: The Association.

American Federation of Teachers. 1986. *The revolution that is overdue: Looking toward the future of teaching and learning*. Washington, D.C.: ERIC Clearinghouse on Teacher Education.

Ames, R. 1983. Teachers' attribution for their own teaching. In *Teacher and student perceptions: Implication for learning*, ed. J. M. Levine and M. C. Wang, 105–24. Hillsdale, N.J.: Erlbaum.

Barkan, M. 1968. Prospective teacher fellowship program. Unpublished proposal submitted to the U.S. Bureau of Educational Personnel Development by Ohio State University, Columbus.

Bennett, W. J. 1986. *First lesson: A report on elementary education in America*. Washington, D.C.: U.S. Department of Education.

Benson, C., and T. Stoddart. 1984. *The education of educators: Preparing and retaining excellent teachers*. Berkeley: Institute of Governmental Studies, University of California.

Boyer, E. L. 1983. *High school: A report on secondary education in America*. New York: Harper & Row.

Brophy, J. E., and T. Good. 1985. Teacher behavior and student achievement. In *Handbook of research on teaching*, ed. M. Wittrock. 3rd ed. New York: MacMillan.

Broudy, H. S. 1971. Preparing teachers of aesthetic education. In *Teacher education for aesthetic education: A progress report*, ed. Central Midwestern Regional Educational Laboratory (CEMREL), 5–20. St. Louis: CEMREL.

Broudy, H. S. 1973. Some decision points for the preparation of art teachers. Paper presented at the spring conference of the Institute for the Study of Art in Education, at Ohio State University, Columbus.

Broudy, H. S. 1985. Developing case studies in teacher education. *The Wingspread Journal: Special Section on Teacher Education* Summer:4.

Bush, R. N. 1987. Teacher education reform: Lessons from the past half century. *Journal of Teacher Education* (May–June). 13–18.

Carnegie Corporation. 1986. *A nation prepared: Teachers for the 21st century*. Washington: Carnegie Forum on Education and the Economy.

Central Midwestern Regional Educational Laboratory (CEMREL), ed. 1970. *The aesthetic education program: A brief*. St. Louis: CEMREL.

Central Midwestern Regional Educational Laboratory (CEMREL), ed. 1972. *Teacher education for aesthetic education: A progress report*. St. Louis: CEMREL.

Clark, G. A., M. D. Day, and W. D. Greer. 1987. Discipline-based art education: Becoming students of art. *The Journal of Aesthetic Education* 21(2):129–93.

Cohen, M. W. 1987. Research on motivation: New content for the teacher preparation curriculum. *Journal of Teacher Education* (May–June):12–26.

Commons, D. L. 1985. *Who will teach our children? A strategy for improving California's schools*. Sacramento, Calif.: California Commission on the Teaching Profession.

Cross, K. P. 1984. The rising tide of school reform reports. *Phi Delta Kappan*:167–72.

deCharms, R. 1968. *Personal causation*. New York: Academic Press.

Degge, R. M. 1987. Response. Response presented to the Seminar for Issues in Discipline-Based Art Education, sponsored by the Getty Center for Education in the Arts, Cincinnati.

DiBlasio, M. K. 1985. Continuing the translation: Further delineation of the DBAE format. *Studies in Art Education* 26(4):197–205.

Ducharme, E. R. 1986. The professors and the reports: A time to act. *Journal of Teacher Education* (Sept.–Oct.):51–57.

Ducharme, E., and R. Agne. 1982. The education professorate: A research-based perspective. *Journal of Teacher Education* 33(6):30–36.

Duncan, J. K., and J. B. Hough. 1975. *The observation system for instructional analysis: General classes of instructional behaviors and events*, Ohio State University, Columbus.

Educational Testing Service. 1987. ARTS PROPEL team develops exercises, portfolios to help teachers assess learning in the arts. *ETS Developments* 33(1):3–5.

Efland, A. D. 1968. Plan of operation for an institute for advanced study in visual arts curriculum content. Unpublished proposal submitted to Ohio State University.

Galambos, E. C. 1985. *Teacher preparation: The anatomy of a college degree*. Atlanta: Southern Region Education Board.

Gardner, J. 1961. *Excellence*. New York: Harper & Row.

Givens, S. 1986. Holmes Group Report gains praise, but stirs dissension. *AACTE Briefs* 7(4):1–7.

Goodlad, J. I. 1983. A study of schooling: Some findings and hypotheses. *Phi Delta Kappan* 64:465–70.

Goodlad, J. I. 1984. *A place called school: Prospects for the future*. New York: McGraw-Hill.

Green, J. 1987. *The next wave: A synopsis of recent education reform reports*. Denver: Education Commission of the States.

Hackman, J. R., and G. R. Oldham. 1975. Development of the job diagnostic survey. *Journal of Applied Psychology* 60:159–70.

Hawke, D. 1980. The life-world of a beginning teacher of art. Unpublished doctoral dissertation. University of Alberta, Edmonton.

Hawley, W. D. 1985. *Breaking away: The risks and inadequacy of extended teacher preparation programs*. Nashville, Tenn.: Peabody Center for Effective Teaching.

Hawley, W. D. 1986. Toward a comprehensive strategy for addressing the teacher shortage. *Phi Delta Kappan* 68(10):712–18.

Hechinger, F. 1983. *New York Times*, 13 November.

Heller, S. 1987. Collaboration in the classroom is crucial if teaching is to improve, educators say. *The Chronicle of Higher Education* 11 March, 17–18.

Hoffa, H. 1973. Area four: Teaching style. In *Content outline: Teacher education*. Central Midwestern Regional Educational Laboratory (CEMREL), St. Louis. Unpublished report.

Holmes, B. J., and R. Rosauer. 1986. *A compilation of the major recommendations on teacher education*. Denver: Education Commission of the States.

Holmes Group. 1986. *Tomorrow's teachers: A report of the Holmes Group*. East Lansing, Mich.: The Holmes Group.

Hough, J. B., and J. K. Duncan. 1973. *What is instruction?* Columbus, Ohio: Ohio State University.

Howey, K. R., and N. L. Zimpher. 1986. The current debate on teacher preparation. *Journal of Teacher Education* (Sept.–Oct.):41–49.

Imig, D. G. 1986. The greater challenge. *Phi Delta Kappan* 68(1):32–36.

Knieter, G. L., and J. Stallings, eds. 1979. *The teaching process and arts and aesthetics*. St. Louis: Central Midwestern Regional Educational Laboratory (CEMREL).

Lovano-Kerr, J. 1985. Implications of DBAE for university education of teachers. *Studies in Art Education* 26(4):216–23.

MacGregor, R. N. 1985. An outside view of discipline-based art education. *Studies in Art Education* 26(4):241–46.

MacGregor, R. N. 1987. Curriculum reform: Some past practices and current implications. Paper presented to the Seminar on Issues in Discipline-Based Art Education, sponsored by the Getty Center for Education in the Arts, Cincinnati.

Madeja, S. S. 1971. Foreword. In *Teacher education for aesthetic education: A progress report*, ed. Central Midwestern Regional Educational Laboratory (CEMREL), x–v. St. Louis: CEMREL.

Miller, P. K. 1983. Art teacher training must change! *Art Education* 24(1):36–37.

Minneapolis Star Tribune. 1986. Harris poll: Teachers dissatisfied with reform. 13 Nov., 16A.

Murray, F. B. 1986. Goals for the reform of teacher education: An executive summary of the Holmes Group Report. *Phi Delta Kappan* 68(1):28–31.

National Art Education Association (NAEA). 1970. *Guidelines for teacher preparation*. Reston, Va.: The Association. National Art Education Association (NAEA). 1973. Report of the mini-conference on art-teacher education. *Art Education* 26(8):2–5.

National Art Education Association (NAEA). 1978. Report of the Committee on Accreditation Standards for Art Teacher Preparation Programs. *NAEA Newsletter* Fall:15–18.

National Art Education Association (NAEA). 1979. *Standards for art teacher preparation programs*. Reston, Va.: The Association.

National Assessment of Educational Progress. 1981. *Art and young Americans, 1974–1979: Results from the second national assessment*. Denver: Education Commission of the States.

National Assessment on Excellence in Education. 1983. *A nation at risk: A report to the nation and the Secretary of Education*. Washington, D.C.: U.S. Department of Education.

National Commission of Excellence in Education. 1985. *A call for change in teacher education*. Washington, D.C.: American Association of Colleges of Teacher Education.

Nussel, E. J. 1986. What the Holmes Group Report doesn't say. *Phi Delta Kappan* 68(1):36–38.

Peters. T. J., and R. H. Waterman, Jr. 1982. *In search of excellence: Lessons from America's best-run companies*. New York: Harper & Row.

Romanish, B. 1987. A skeptical view of educational reform. *Journal of Teacher Education* (May–June):9–12.

Rosenshine, B., and N. Furst. 1973. The use of direct observation to study teaching. In *The second handbook on research on teaching*, ed. R. Travers, Chicago, Ill.: Rand McNally.

Sevigny, M. J. 1987. Discipline-based art education and teacher education. *The Journal of Aesthetic Education* 21(2):95–126.

Tucker, M., and D. Mandel. 1986. The Carnegie Report—a call for redesigning the schools. *Phi Delta Kappan* 68(1):24–27.

Wilson, B. 1987. Boundaries of DBAE. Paper presented to the Seminar on Issues in Discipline-Based Art Education, sponsored by the Getty Center for Education in the Arts, Cincinnati.

Woodruff, A. D. 1971. An approach to teacher education. In *Teacher education for aesthetic education: A progress report*, ed. Central Midwestern Regional Educational Laboratory (CEMREL), 21–37. St. Louis: CEMREL.

Working Group on the Arts in Higher Education. 1986. *Draft II: Teacher education in the arts disciplines*. Reston, Va.: Working Group on the Arts in Higher Education.

THE UNIQUENESS AND OVERLAP AMONG ART PRODUCTION, ART HISTORY, ART CRITICISM, AND AESTHETICS

PANELIST

Margaret Battin

University of Utah

The View from Aesthetics

The topic to which this panel is to address itself, as I understand it, concerns the relationship among the four disciplines on which discipline-based art education is grounded. This is a very important topic indeed, and will have clear consequences for the way in which art education is conducted. But before we can begin to address this topic, we must look at the question it asks.

The question itself—"What is the relationship among the four disciplines on which DBAE is grounded, art production, art history, art criticism, and aesthetics?"— seems to be a question about coequal elements in a larger scheme, and hence tacitly suggests that they all are, and should be, on a more or less equal footing in art education under the DBAE model. Indeed, from what I understand of it, I think DBAE treats them this way. But I think this approach involves rather too simple a view, and requires some background exploration. Rather than attempt to answer directly the question posed to the panel, we must address a prior question about the status of these four disciplines, namely in what sense and on what basis can we suppose them to be equal, and hence appropriately accorded equal treatment in DBAE? For I think they are not equal, in the usual sense

of that term, and that this has important consequences for the way in which these disciplines should be incorporated into art education programs.

Let me try to get at this issue by asking a question that is intended as a diagnostic one, phrased to apply to the practitioners of the various disciplines. The question is this: *Can artists, art historians, art critics, and aestheticians disagree?* Now this might seem to be the most elementary of questions, inviting the simplest, most direct of answers: Of course. One need think only of the more heated controversies in the art world—say, over sculptor Richard Serra's placement of his immense work *Tilted Arc* in such a way as to bisect and thus disrupt an outdoor plaza in New York, or over the cleaning of Michelangelo's frescoes in the Sistine Chapel, or over the discovery that *Man with the Gold Helmet* is not a Rembrandt—to find a vivid picture of artists, art historians, critics, and aestheticians embroiled in most vigorous disagreement and controversy. Some want *Tilted Arc* removed, some want it to stay; some want to postpone or discontinue cleaning the Sistine ceiling, others want to persevere, and so on. It would seem that these folks not only can disagree, but do so an astonishing amount of the time.

But we might look more closely at whether it really is *disagreement* that occurs in these cases. To do so, let us look at what an artist, an art historian, an art critic, and an aesthetician might say about a specific work—for instance, Caravaggio's *The*

Conversion of St. Paul. Here, for instance, is what an art historian might say about the *St. Paul*:

> Rejecting the traditional full-view position, Caravaggio chose to present Paul's body from an unorthodox and subjective viewpoint, foreshortening it almost orthogonally . . . Caravaggio's St. Paul recalls earlier representations of foreshortened, prostrate figures, such as that in the lower left corner of Signorelli's *Signs of Destruction*, Zuccari's *St. Paul*, and especially the slave in Tintoretto's *Miracle of St. Mark*. Most significant, though, is the relation of Caravaggio's figure to Raphael.

The art critic will have something rather different to say. For instance, the critic will also want to attend to the position of the body and its placement in the picture relative to the horse and other human figures, but the nature of this concern is quite different. According to one critic,

> One sees here, as elsewhere in Caravaggio's work . . . a striking carelessness in the construction of the figures. The foreshortening of the upper right leg of St. Paul is rather awkward, and the hand and legs of the man in the background do not correspond at all logically to his head and shoulders seen above the horses. However, Caravaggio succeeded in giving drastic expression to a sudden

happening . . . [It is a painting of] explosive power.

Do these two disagree? If we look at what kinds of things they have to say, the answer is no; they are talking about quite different sorts of things, and do not contradict each other at all. The art historian talks about the cultural circumstances within which the work was created, perhaps about the artist's life, about then-prevalent assumptions and expectations, and about currents in the history of art within which this work can be placed. But the art critic is not talking about these things at all. The art critic addresses primarily the issue of whether the work is a successful one or a good work of its kind. Does the careless construction of the figures spoil the painting? Does the painting succeed in expressing a religious verity? Isn't the *Conversion* a painting of "explosive power," and hence a remarkable achievement despite its defects? Is this a flawed work, or one of Caravaggio's greatest? And so on.

Do the art historian and the art critic disagree? No. Not only is it the case that they do not disagree, they *cannot* disagree. This is because they are talking about different kinds of things, and we can see that they are talking about different kinds of things by seeing what it would take to show them wrong. How do we show the art historian wrong? By pointing out that the painting was made in a different year, or that Caravaggio was part of a different school, or that the painting was originally titled something other than *St. Paul*—these are

ostensible *facts* of the history of art, and if we have adequate evidence we can dispute them by supplying other, more strongly supported factual claims. But the art critic is not talking about facts at all; the critic's discourse is about values. Indeed, the horse is large; this is a fact on which we all agree, but what the critic is talking about is whether the size of the horse is of positive or negative value in the picture. We can disagree with this too, but only by advancing other value judgments, not by supplying facts. (Actually, there's a considerable amount of scholarly dispute about this point; I've simplified it here.) Thus the art historian and the art critic cannot disagree; one trades in values, the other facts, and value judgments cannot unseat factual claims any more than facts can undo values. To be sure, practicing art historians and art critics are rarely purist in confining themselves to the appropriate sorts of discourse in their fields: art historians frequently indulge in value judgments, and critics marshal facts in trying to support their judgments. But when they do these things, historians are functioning as critics and critics as historians, and it is up to us observers to consider whether they are adequately skilled in these additional roles.

But what about the artist and the aesthetician? What, for instance, would the artist say about Caravaggio's *Conversion of St. Paul*? It might go something like this:

> The motionless bulk of the horse, filling almost the whole background, looks more enormous than it really is;

the body of the fallen soldier, with the help of rapid foreshortening, appears smaller than it is. The direction given by the length of the body cannot be carried visually beyond its own limit, for the bulk of the horse blocks any further extension into depth. It is this concentration of almost dialectically contrasted elements within an intentionally narrow and enclosed space that produces the explosive power.

Actually, with all due respect, I do not think that the artist here is saying much about the painting; what he is doing is *pointing* to the features of the painting that make it function the way it does. In general, an artist might point to the brushwork or the layering of pigment or deliberate foreshortening or the way light and dark shadowing accentuates the immenseness of the horse and the hardness of St. Paul's fall, but I do not think an artist will say very much at all. This is because artists, qua artists, are not talkers; they are makers, doers, in the world of art. Like the art historian and the art critics, artists too make use of facts and value judgments about artworks, but in their central functions as artists they do not really talk about art at all. But if this is so, they too cannot disagree with the kinds of things professionals in other disciplines have to say.

What the aesthetician has to contribute to the discussion of Caravaggio's *St. Paul* is of a different order as well. Characteristically, the aesthetician will ask background questions about the assumptions under

which facts are asserted about a work, value judgments are made of it, and features of its strategy are pointed out. In what sense is the painting a *picture* of St. Paul? What are the criteria for judging whether the figures are careless, the foreshortening is excessive, or the horse is too large, and what is the basis of these criteria? What are we talking about when we say that the painting gives "drastic expression" or has "explosive power"? What sort of a thing is a picture of this sort, anyway? Is it a representation, an attempt to convey feeling, a study in form, or what? But in asking questions of this sort, the aesthetician does not disagree with the art historian, the art critic, or the artist, for again, what the aesthetician contributes to the discussion is not the kind of talk that can disagree with assertions made in these other disciplines. The aesthetician inquires into the background assumptions made within the other disciplines, rather than contrasting their claims. The aesthetician raises issues foundational to art history, art criticism, and art production and considers various possible ways of resolving these issues; this is a very different thing from arguing directly against art historical or art critical claims or claims about artistic technique. Like the others, aestheticians often lace their talk with the kinds of facts, value judgments, and pointings-out that art historians, art critics, and artists properly do, but when they do this they too are slipping outside the boundaries of their proper discipline. They are functioning as aestheticians really only when they are making the kind of conceptual

inquiry—pointing out the unclarities, confusions, rifts in foundations—that it is the business of their discipline to do.

Can the practitioners of art history, art criticism, art production, and aesthetics disagree with each other? No. In talking about art, one of these disciplines assembles facts, one judges value, and one points to strategies by which the work's effects are achieved. But the last makes trouble for the other three, by pointing out shakiness in the foundations on which they rest; it also makes them secure, by showing where these foundations are strong. In this sense, these four disciplines are all unique; properly pursued, they all make unique contributions to the study of art.

Thus, the four disciplines of DBAE do not really overlap. In practice, of course, none of the practitioners are so purist that they confine themselves exclusively to the proper orbit of a discipline. Just to illustrate this point, we may note that all of the above discussion of Caravaggio is taken from a single author[1]—functions variously as historian, critic, and artist. The result of this kind of overstepping of bounds is a great deal of very vigorous, very fruitful, and very real disagreement among those concerned with the history, criticism, creation, and conceptual foundations of art. Indeed, it is in these areas of overlap that some of the most interesting discussion goes on, perhaps precisely because it involves the overstepping of proper boundaries by those trained in a variety of different ways. Yet if we are concerned with the true nature of the disciplines, we must recognize that

they are radically different in their core.

But if the disciplines are radically different, so different that they cannot really even disagree with each other, this may undermine the assumption that they should be equally treated in a discipline-based program of art education. With specific reference to aesthetics, in particular, it now becomes clear that this discipline is essentially metatheoretical—that is to say, as it were, it is parasitic on other disciplines having to do with art. It is not an independent field, with an independent subject matter of its own; it is talk about art, and so tied in a particularly intimate way to what the artist and art historian and art critic do in talking about art. One cannot really teach aesthetics *simpliciter* (except at the university level, where the concern is with aesthetic theory); one must always do it in conjunction with the other disciplines. It would be both a pedagogical and a theoretical mistake to relegate aesthetics to a separate set of lessons in the teaching curriculum (no doubt reserved for the end of the week). But it would be an even greater pedagogical and theoretical mistake to avoid aesthetics altogether. Rather, it must be taught as a natural, ongoing way of scrutinizing, testing, challenging the sorts of claims art historians and art critics make and of the sorts of pointings-out practicing artists do. This ongoing metatheoretical commentary on classroom activities in the other disciplines may seem to be easier to do at older ages, but it is of immense importance in the intellectual development of younger children

too, and shows the real reason for which aesthetics is so correctly included among the essential disciplines in DBAE.

References

1. W. Friedlaender. *Caravaggio Studies*. (Princeton: Princeton University Press, 1955).

PANELIST
David Ebitz
 J. Paul Getty Museum

The View from Art History

Art historians too rarely sit down with artists, art critics, and aestheticians to address educators. Our disciplines have become so specialized that they seem mutually exclusive. Fortunately, this is a recent state of affairs, and it promises to be temporary. Art historians, with their colleagues in the arts and humanities, are once again beginning to examine the methodological assumptions of their discipline and the nature of their practice. In particular, they are examining the relation between art history and her sister disciplines.

Nevertheless, the four of us have been invited here as specialists in four separate disciplines. Such specialization would have seemed an odd state of affairs to Giorgio Vasari, the sixteenth-century Florentine artist, biographer, critic, and modest aesthetician, who is generally credited as the father of art history. In cofounding the Accademia del Disegno, in writing his *Lives of the Most Eminent Painters, Sculptors and Architects*, and in practicing his own arts of painting and architecture, Vasari combined the activities that most of us in this room pursue, from making art to criticizing it, from tracing its history and pondering its nature to teaching it. Vasari was even an administrator.

Much of Vasari's effort was directed toward improving the social position of the artist. Hence the biographies of great artists, the emphasis on Michelangelo, a contemporary Florentine so extraordinary that by Vasari's account he surpassed the ancients, and the foundation of the Accademia del Disegno, an institution under the direct patronage of the Medici Grand Duke of Florence. The purpose of the Accademia was not entirely social, however. It had a practical educational program. As in the guilds, which the Accademia and succeeding academies displaced, the emphasis remained on art production, but art production informed by history, criticism, and theory. This is the model that, very roughly, we are proposing to implement in our schools with discipline-based art education. Might it also find a useful place again in our colleges and universities?

Specialization has brought us a long way from Vasari's day. As an art historian, I can say that specialization has increased the rigor and the intellectual—and therefore the social-standing of at least one of the disciplines in which Vasari engaged, art history. Whether this is also true of criticism and aesthetics, my colleagues know better than I. But this specialization has compartmentalized experience and knowledge, going so far as to separate the kind of knowledge that we acquire from reading—book knowledge—from the experience we gain from actually doing something—the skills acquired by hand and eye. Although most nineteenth-century art historians were also artists like Vasari—or at least had

significant training in art—my generation of art historians has experienced little more than that single two-dimensional design course I had to take as an undergraduate art history major. Later, I remember my shock as a graduate student at seeing a posthumous exhibition of watercolors by Benjamin Rowland in the Fogg Art Museum at Harvard University, where he had been one of the distinguished faculty in art history. That Benjamin Rowland was also a painter seemed to me then almost a contradiction in terms. I was fully inculcated in the virtues of specialization. Now that I look back I realize that among his contemporaries, my teachers, his was not an unusual combination of knowledge and skill. Indeed, until the last decades of the twentieth century, art historians not only made art, they also asked some of the basic questions of aesthetics and engaged in criticism. We have lost something in our increasing specialization. It is no wonder then that the art educator, whether a K-12 classroom teacher or university professor, finds art history so unsatisfying, so un-teachable, so inaccessible. If art history has dissociated itself from studio production, art criticism, and aesthetics, of what relevance can it be to the contemporary understanding of art?

The situation of art history today and the problems you may encounter in trying to put it to use may be clarified, I think, if we briefly consider two issues: first, the primary role that texts have come to play in the art historian's approach to art and, second, the tendency among art historians to focus on a content of knowledge rather than on the practice of inquiry. Texts and knowledge are intimately related, for all too often texts have become the sole source of the art historian's knowledge.

First, texts. In emulating its sister humanistic disciplines, an emulation that began with Vasari, art history has so come to rely on texts as its primary sources that there seems to be little place left for the art object and the artist. Words too often overwhelm the visual experience as the art historian studies the iconography of a painting examined in a black-and-white reproduction, for instance, or seeks to reconstruct the contemporary social, political, economic, or religious contexts of the work through studying the relevant written documents. And it is also texts, the texts that we publish, that inform the next generation of art historians in the school and colleges of this country, especially where students have so little access to original works of art.

The second issue is content versus practice. Again in emulation of history and other humanistic disciplines, art historians have come to concentrate on the content of what is known and transmitted to us, on tradition, rather than on how we go about acquiring knowledge, the new questions we could ask and the skills we could apply to answer them. This distinction is not just between whether we should teach K-12, undergraduate, and graduate students the facts of the history of art, or whether we should teach the processes by which these new facts come to be. This distinction is at

the center of any discipline with a tradition. Are we to relish what we know and increase this body of knowledge by adding more of the same kinds of information, that is to say, focus on the content of the history of art? Or are we as scholars to change our frames of reference, ask new questions, go about our jobs in other ways, think about how we are thinking, face the ambiguities of the art object directly, not through the simplifications of black-and-white reproductions and the words of our colleagues? Words are necessary, I have no doubt, but they are not sufficient, certainly not for the artist, not for the critic, not for the art historian, and perhaps not even for the aesthetician.

Having spoken in the abstract about art history, I should take my own advice and be specific. What is art history? It consists of a number of subspecializations that can be roughly divided into three groups: those that concentrate on the object of art, those that concentrate on the artist and his or her context of production, and those that concentrate on the changing perception or reception of the object and artist over time. First, the art object is the direct focus of the connoisseur, who attends to when, where, and by whom it was made. It is also, if only briefly, the starting point of the iconographer, who seeks to identify its subject matter by reference to the appropriate contemporary texts. Connoisseurship and iconography are the most venerable methods of the professional art historian.

Second, the artist and his or her social context are the focus of the biographer, who may use the tools of psychology and psychoanalysis, and of the social historian, who takes into consideration such conditions of production as the social, economic, political, religious, scientific, cultural, and intellectual life of the time.

Third, the changing perception of the art object and the critical reception of the artist over time are the focus recently of scholars who have brought to art history frames of reference from other disciplines. These frames of reference include the psychology of perception, structural analysis, semiotics, phenomenology, the sociology of knowledge, reception theory, and feminist history.

Taken as a whole, art history is a discipline of extraordinary breadth and complexity. But unfortunately there are few art historians today with the sweeping grasp of the nineteenth-century cultural historian Jacob Burckhardt, or, in the twentieth century, with the profound learning of Erwin Panofsky, the overarching psychological explanations of Sir Ernst Gombrich, or the insight into the relation of form and content of Meyer Schapiro. Art history generally functions at a more modest level as a discipline divided into specializations by specialists who do not speak to each other, much less to practitioners of other disciplines, not even to artists, critics, and aestheticians. Lack of communication breeds prejudice. The iconographer is suspicious of the intuitive methods of the connoisseur, and the connoisseur com-

plains that the iconographer never looks at original works of art. Both agree that the social historian, especially if a Marxist or feminist, ignores art altogether. And everyone complains uncomfortably of the jargon of the semiotician. Given this multiplicity of specialized approaches and the internal lack of communication among art historians, is it any wonder that art educators either find it difficult to understand what we are up to or that they simplify the richness of art historical practice to one or two approaches and a set of facts? These approaches then are promptly criticized by art historians as inadequate.

Art history has only of late begun to review again its own history and to examine the assumptions lying behind its methods. By comparison the level and kinds of questioning we see in art education are lively indeed, the evidence of enthusiasm in a youthful discipline seeking both to understand its nature and to establish its raison d'etre. Art history has not seen anything comparable since the beginning of the twentieth century. But it may now be entering a period of renewal. Evidence of such renewal is found in the comprehensive surveys of art historical method by Eugene Kleinbauer, who, you may note, wrote an art history for the DBAE issue of the *Journal of Aesthetic Education,* in Mark Roskill's *What Is Art History?*, and in Michael Podro's and Michael Ann Holly's recent intellectual histories of art history of the late nineteenth century and first half of the twentieth century.

Moreover, the College Art Association annual conferences began several years ago to devote sessions to basic methodological questions. The nature of knowledge is under review on so many fronts that the complacent assumptions of art history will not survive. At the very least the facts of art history—those facts that comprise the bulk of what is taught in the classroom from the fifth grade to graduate school—will have to be seen in new light, if they continue to be regarded as the relevant facts at all. Anthropologists, Marxists, and feminists are disabusing us of the not-so-innocent assumption that the only relevant focus of attention is fine art created by men living in Western Europe during historically documented periods.

As we reexamine within our discipline what we mean by the history of art, I hope, first, that we will improve relations with our sister disciplines, and, second, that we will develop new models for what can be taught by the art educator in the classrooms and art museums of this country. We should get together with historians, literary theorists, and semioticians. In fact, we are beginning to do so. But we must also knock down the walls that separate art history from the disciplines immediately adjacent to our territory, disciplines intimately engaged with art. We should begin to give thought to what we can learn from at least talking to artists, if not from making art. We should introduce with critics the issue of quality into our discussions, and clarify with aestheticians the nature of what we

study and the assumptions underlying our approaches to it. If art history is to say anything about the art of the past, it must come to terms with the practice, criticism, and understanding of art today.

As we inquire into what we do and why, I hope that this process of inquiry will come to be recognized as the most effective means by which to teach art history in schools and colleges. A chronological presentation of slides in a darkened room is an inadequate education for a college student, and a useless model for the teaching of art history in the schools. No wonder art history finds so little place in the curriculum. But art history understood as a process of inquiry has greater promise. Mary Erickson has been telling art educators this for some time. But the college art-history professor remains largely oblivious to this pedagogical approach, choosing rather to transmit information to a passive audience roused only by the professor's enthusiasm for the knowledge transmitted.

If we let students into the workshop to participate in the process, the teacher can become a facilitator for new discoveries rather than just the transmitter of received knowledge. Vasari, in his *Lives*, remarks on the difficulties of his task of gathering and verifying information, and he says what he thought of his material. We could do the same.

I am especially happy to have an opportunity to participate here with artists, critics, and aestheticians, at a symposium convened, significantly enough, by

educators. It is not simply because I think DBAE is good for art education. It is also because this multidisciplined approach, this respect for knowledge and skill, for object, artist, and audience, can offer a fruitful model for art history as well.

PANELIST
Joseph Goldyne
San Francisco

An Artist's Viewpoint

As an artist, I have wondered whether discipline-based art education can be more than a nominal linkage of allied disciplines, and thus whether, in consort, the sister disciplines of aesthetics, art history, art practice, and criticism can effect a change in the quality of our children's awareness of art. This question prefigured in the kind invitation to speak at this gathering, for it referred delicately to the difficulties within, and I might add between, the disciplines of art practice, aesthetics, art history, and criticism.

An awareness of the sticky and often destructive contentiousness that exists between many disciplines was for most of us, of course, initiated by C. P. Snow in his book *The Two Cultures and the Scientific Revolution.*[1] More recently, however, the scientist and writer Lewis Thomas, in a wonderful essay of 1981 entitled "On Matters of Doubt" contends that to take sides in the argument advanced by Snow or, at the opposite polemical extreme, by F. R. Leavis, is to take part in a hassle "shot through with bogus assertions."[2] Thomas sees a far more positive approach to the problem, stated in its simplest form as being between the illiterate scientist and the ignorant humanist. He has found a common ground—a shared view of the world—in that state of being we call *bewilderment.* He calls it "the family secret of twentieth-century science and twentieth-century arts and letters as well—something we choose to avoid discussing as we stake claim to each empirical insight or proclaim each little bit of knowledge we gain." Well, educators are certainly bewildered by how best to implement the ambitious concept of discipline-based art education; otherwise we would not be meeting here today.

With regard to arguments and orientations in the realm of the art disciplines, I feel sincerely, as I gather do the other participants in this program, that despite our respective prejudices, we all appreciate that if art is to be made by people who understand its past and its potential, and if it is, in turn, to be experienced by new generations who are prepared to address its many levels of meaning, it would be best to make a coordinated effort between the disciplines to those ends. Before suggesting what direction such a program might take to convey as effectively as possible what art can be for man, I would like to explain my feelings concerning the sister disciplines with respect to the making of art.

From my point of view, aesthetics, art history, and criticism—as disciplines—are ironically ancillary to the making of art. I say ironically because the concerns that these three disciplines represent are really of vital interest to working artists on an almost daily basis. We always critique our own work and understand that it is our own aesthetic and critical leanings that drive our production and that must be answered to provide a sense of completion

in our efforts. And past achievements in art provide visual standards against which every artist must measure his or her work. What then is the problem, and why must I use the word *ancillary* for the disciplines representing these areas? The critical answer for me is that organizing knowledge into the formal structure of a discipline involves the manipulation and refinement of ideas. It is ideas that are exciting in the evolution and explication of a discipline. For minds not driven to passion by the signals of the optic nerve, these exciting ideas are always the prime movers. For artists, however, even for artists who are energized by ideas, the pull of the eye and the play of the hand somehow take precedence.

I know that the information I derive from historical and critical studies would be so much less satisfying if I could not work myself. And because I do work, my view of art history is a participatory, proprioceptive one. In fact, it was as an artist teaching art history at Berkeley a few years back that I made some observations that, together with my own formative experiences, led me to the views that I would like to share with you.

In one particular seminar that I led at the university, I saw that art students might mistake the purpose of a work of art because of ignorance of iconography or chronology, but with some orienting exposure to the styles of specific artists, they rapidly became adept at differentiating between related styles and rarely hesitated to respond to special achievements in draftsmanship. And the works that these

alert studio-arts majors were asked to consider were no later than the eighteenth century, for they were participants in a seminar on Venetian eighteenth-century drawing. I should say that they were participants chosen at my pleasure, for the department of the history of art discouraged the inclusion of art students in a seminar on a relatively rarefied art historical topic. My argument on their behalf was that none of the art history majors was better prepared to take the seminar, for there had been no classes offered in Venetian or even, more generally, Italian eighteenth-century art in recent memory. Besides, I elaborated, the material was beautiful and I thought that students who are visually inquisitive and loved drawing would enjoy it.

It was decided to limit the seminar to twenty participants and I saw to it that somewhat less than half of those students were studio arts majors. I showed at least twenty-five unknown works at every session (slides and originals) as a kind of visual calisthenics, and as the course progressed, a number of the artists who were undoubtedly less articulate, or at least shy, compared to the historians, demonstrated that they were becoming excellent diagnosticians of style, rapidly differentiating the manner of Giovanni Battista Tiepolo from that of his son Domenico, the style of Francesco Guardi from that of his son Giacomo Guardi, and so on.

What the studio arts students did well was to identify and view the range of styles presented with a lack of prejudice (they

were not influenced by the orientation of the department to earlier and later art), to rapidly assess the potential of an artist's efforts, and to evaluate the success or failure of a particular work on the basis of how well it fulfilled that potential. In other words, these students manifested a talent for the range of judgments expected of connoisseurship. Theirs was an exercise in elementary connoisseurship nursed by an artist and sponsored within the precinct of art history. And I never used the term *connoisseurship*. A number of the art history graduates kept pressing me to spend more time on Tiepolo's iconography. One suggested that he really was not concerned with differentiating the styles of father and son. "A connoisseur can attend to that," he commented disdainfully. "What really interests me is the subject matter with which this father-son duo were concerned, how their iconographic programs were established, and how they related to earlier Venetian art."

Of course. What was occurring in my seminar was a confrontation best characterized by Lorenz Eitner in an address published in 1974 entitled "Art History and the Sense of Quality."[3] In that excellent evaluation of the critical differences between connoisseurship and what has become the role of the art historian, Eitner, clearly desirous of a rapprochement, persuasively argues that the shape of art history is ironically more influenced by the "quiet sifting and hoarding of the connoisseurs" than by the "theoretical ingenuity of historians."[4] He means that those whose

visual intelligence rather than historical leanings help to identify masters and masterpieces are those who elect the milestones and determine the resulting orientation of the study we call the history of art. Eitner reflected that

> *it did not occur to me [as a student] to question an education in art history that put a high premium on ingenuity, energy, and memory, but hardly tested my senses, and offered me little by way of an actual experience of art. I did not question, but I seem to remember that I was not very happy. What had attracted me to the study of art was the memory of the pleasure and stimulation I had received from museum visits as a child and adolescent, and from a precocious, if very modest collecting activity in the fields of Roman coins and sixteenth-century prints. These early impressions stayed in my memory, and proved strong, more persuasive than anything I encountered in my academic work.[5]*

Because of my earlier training as a physician, my particular prejudices were poised to support that often amorphous conglomerate of abilities defined as connoisseurship. In medicine, the parallel activity is called diagnosis, and its components and language are hardly amorphous. In fact, as many people appreciate, it is a highly evolved process that has come to depend heavily on the laboratory, as have many decisions relating to works of art. Also, the descriptive language of diagnosis

is exquisitely refined. Where human life is involved, one is taught to "mind the p's and q's." Though not dealing with matters of life and death, at least in the corporeal sense, it is peculiar that the fields of art history and criticism, so dependent on words, rarely use them precisely. How often have we bemoaned a presentation with certain exhausted descriptive adjectives, all perfectly good words, but shoes too loose to fit all the feet on which they continually and fashionably appear.

I have come to dwell on these points relating diagnosis and connoisseurship because as an artist with a background in the sciences, I am confident that it is a training not unlike that undertaken by the best connoisseur or diagnostician that would most amenably unite the individual purposes of the sister disciplines and give our children the best possible approach to art. I pushed connoisseurship in my seminar, and in all my art history classes, because I believe the correct attribution to be the essential fact on which histories are constructed. In art, histories woven with incorrect attributions are erroneous histories. Thus, the best art historian must also be a connoisseur or take a position based on dependable connoisseurship. As regards DBAE, however, I would encourage a curriculum approach that builds toward connoisseurship, obviously not because correct attribution is critical for the young student, but because of my artist's conviction that such an orientation will keep students close to the work of art and, at the same time, most compellingly focus and transmit the integrated knowledge of the contributing disciplines.

In my initial discomfort over the viability of DBAE as a student-influencing consortium—as a strengthened roadbed to replace the aesthetically deprived route of conventional curricula—I began to think of precedents for the program. Of course, I was initially unaware of relatively recent theoretical antecedents of DBAE as elaborated by Ralph Smith in this summer's issue of *Aesthetic Education*.[6] But what had come to mind when I first encountered the idea was a real, not theoretical, precedent. You see, DBAE was alive and well in England in the eighteenth century. True, it was usually functional only for a certain spectrum of society, the aristocracy, but where it functioned, it functioned well.[7] It is typical of the catholicity of learning in eighteenth-century England and of the artist's early role as spokesman for a broad-based view of the arts that Jonathan Richardson (1665–1745), a successful portrait painter, significant draftsman, and great collector of drawings, wrote essays dealing with the theory of painting (1715), the art of criticism (1719), and the science of a connoisseur (1719). He and most of his accomplished peers would have found it odd *not* to have held views on all these subjects. "It was never thought unworthy of a gentleman to be master of the Theory of Painting," he wrote, and elaborated that "to be an accomplished painter, a man must possess more than one liberal

art . . ." In concluding his thoughts on the matter, he wrote that connoisseurship was a pleasure that thinking men "know is one of the greatest and most excellent they can enjoy."[8]

I suggest that it is really connoisseurship in the best sense that one wishes to achieve by just that admixture of disciplines we are considering in DBAE. The logical question, then, is what specifically does the connoisseur do that should interest a proponent of DBAE as well as an artist? The connoisseur looks first and enjoys looking carefully. But his looking is not that of a hedonist, as too frequently has been the allegation rendered by those who sense a weak academic base to the activity. Nothing *should* be further from the truth, for what one observes must, at once, be filtered through a considerable fund of both visual and historical data to rank as connoisseurship. When what the connoisseur has seen is in some way related to this data, a connection is noted. When enough connections are established the connoisseur will propose them as a new piece of knowledge—an attribution, forgery, relationship, or chronology. This new knowledge will add to or alter art history, and it will be new matter for the aestheticians and critics as well.

In his aforementioned essay, Eitner recalled that "I was uneasily aware that my private enthusiasms [referring to his "almost physical appetite for the material object"] could be taken for symptoms of immaturity and naivete."[9] DBAE must never crush those private childhood enthu-

siasms. Rather, it should approach the student via those enthusiasms, for they are the yeast, the driving force behind connoisseurship.

Think of the possibilities. There are automobiles and aircraft of superb as well as poor design; animals and plants of an infinite variety of colors and shapes, displaying bilateral and radial symmetry; sports providing action, color, and form; and all these foci of childhood enthusiasm can be portals to the domains of those artists we call masters. There are so many ways of knowing art, and connoisseurship can be enriched by all: The old approach of copying masterpieces of nature and art can come into play here as can familiarity with the media, which can be fun as well as interesting (imagine making a small quantity of bistre from the ink of squid and showing children the kind of golden-brown wash that Tiepolo achieved using it). Looking at the variety of old papers and their watermarks and making paper gives even very young students insight into one of man's oldest and most essential tools. Visiting museum storage provides the opportunity to turn paintings around so that students can see what a three-hundred-year-old wooden panel looks like or whether Morris Louis's paints soaked through his canvases. Posing and answering questions that provide nonaesthetic, pragmatic means for the young student-artist to relate to the mechanics of achievement are important, such as, How long did it take Sargent to paint a portrait or

Whistler to paint a "nocturne"? How many watercolors did Turner paint, and did Degas copy or learn from his collection of Ingres and Delacroix?

It is good to note that connoisseurship is an activity bent on adventure, and like medical diagnosis, the adventure of connoisseurship can be geared, for teaching, to simple or complex ends. But whatever the level of the goal, my conclusion is that a kind of connoisseurship is vital to address the arts with any sort of conviction, and fortuitously, such connoisseurship depends on being grounded in the disciplines of DBAE. As we are dealing with acts of visual judgment that depend on both visual and nonvisual data and skills, it is not surprising that artists have had a predilection for rapidly adapting to the orientation of connoisseurship and that so many artists have come to be connoisseurs. But the skills that I have mentioned would be the greatest gift to the nonartist as well and could most enhance his or her life in relation to the visual world.

In conclusion, I would like to say that, given the comprehensive aims of DBAE, it is my belief that an artist's interests will be most equitably manifest in a curriculum inclined toward connoisseurship. As the root of the word connoisseur, *cognoscere* means "to become acquainted with," so this proposal is for a modest acquaintance with connoisseurship, but one that is pleasant, if not memorable, and encourages further looking and thinking. I suggest:

1 That teaching be heavily dependent on originals. If there is no local museum, draft local artists; if there are few or difficult local artists, employ the classroom's talent. An enormous amount can be learned by having students differentiate the styles of their classmates.

2 That teachers use inspiring examples. I am not referring only to subject matter derived from literary sources. Views that inspire thoughts of the sublime such as night compositions or dramatically lit interior scenes, viewpoints that are dramatic because of position or perspective, texture that is exaggerated and color that is sonorous and expresses mood: these features make works of art memorable. So as not to discourage ambition, it should be taught that ambitious themes and noble achievements can be small—that there is always the possibility of great accomplishment with the simplest tools and a hand-sized product. An illumination by the Limbourg brothers or a small van Eyck will illustrate the point. So will one of Miro's small *Constellation* series or one of Rembrandt's small etchings like *The Shell* or *Abraham and Isaac.*

3 That children meet artists. They meet physicians, policemen, politicians, schools principals, and bankers. Arrange for them to talk to artists. This reinforces that making things of beauty can be a profession.

4 That teachers stress doing before discourse and emphasize artistry as well as art history. Not everyone has to make things

successfully, revealing technical accomplishment and aesthetic refinement. But the hands don't forget trying, and art is a wonderful thing to try because it is an area of human endeavor where every failure may reveal a successful passage or two and where passages of little merit have been assembled into masterworks.

If it has become clear that by virtue of experience, I am prejudiced on behalf of artists and the centrality of the material work itself, I hope that it has also become apparent that my conviction is not meant to be polemical, for discipline-based art education *is* an ambitious idea, and I am certain that it could be a boon for some students and for some teachers, but I also know that the critical problems confronting a broadly effective program will be teacher preparation and curriculum pacing. Without resolving these issues, the program will at best produce students with but a veneer of preparation for dealing with art in its most powerful role: as a universal agent for human feelings. It will be possible to initiate early appreciation of the critical. As the eighteenth-century landscape gardener knew that a sequence of properly designed views or prospects could inspire dreams and a state of joy, we must also know that designing and executing curriculum in the arts is the crux of this discipline-based program, for there is more to lose than the lack of integration of the arts into the agenda of basic education.

References

1. C. P. Snow, *The Two Cultures and the Scientific Revolution* (Cambridge University Press, 1963).
2. Lewis Thomas, "On Matters of Doubt," in *Late Night Thoughts on Listening to Mahler's Ninth Symphony* (Viking: Penguin, 1981).
3. Lorenz Eitner, "Art History and the Sense of Quality," *Critiques III*, The Cooper Union School of Art and Architecture, New York, Fall 1974.
4. Eitner, "Sense of Quality," 36. Eitner also states (pp. 35-36) that "well articulated but constantly changing value judgments constitute the specific matter of art history, but cause it to be not so much a reflection of art as a reflector of historical circumstances. Unarticulated quality experience actually governs the system of inclusions and exclusions on which art history rests."
5. Eitner, "Sense of Quality," 20.
6. Ralph Smith, "The Changing Image of Art Education: Theoretical Antecedents of Discipline-Based Art Education," *The Journal of Aesthetic Education* 21 (Summer 1987).
7. Arthur Efland refers briefly to the eighteenth century in his overview of art in the history of education. See Arthur D. Efland, "Curriculum Antecedents of Discipline-based Art Education," *The Journal of Aesthetic Education* 21 (Summer 1987), 58. "Those exposed to the contributing disciplines of connoisseurship could and did succumb to foolish, shallow posing, valuing the fashion of the exposure rather than its substance, and words like amateur and dilettante, initially tributes to the breadth of one's interest, grew to have pejorative, unserious connotations."
8. *The Works of Jonathan Richardson* (Strawberry Hill, 1792), 15, 18, 252. This edition, published by Walpole, is the latest of which I am aware.
9. Eitner, "Sense of Quality," 20.

PANELIST
Franz Schulze
 Lake Forest College

The View from Art Criticism

We are all of us in the arts constantly changing our minds. Artists do it, to name the first and central group among us: almost invariably they shift ground in the course of a lifetime so that terms like early, middle, and late are customarily used to organize and elucidate the career output of a given painter or sculptor. Critics do it just as freely: they may adopt a formalist outlook during one decade and abandon it for a more iconographically oriented stance the next—and make no apologies for the switch. Art historians do it: not only do they exchange one favorite for another, frequently neglecting to acknowledge that they have favorites at all, but they rearrange the criteria they hold to be crucial to the reporting and assessing of the art and artists they study.

If there is one certainty left us in this intellectually most uncertain of centuries, it is that certainty itself is a dubious concept. We have learned this collectively the hard way, as reasonable people do individually in the course of growing up and growing old: once trusted absolutes lose their dominion, giving way to a more compli- cated, even relativistic understanding of a world that was formerly made of vivid con- trasts and is now gray, like our hair. For the twentieth century itself is an old century. It has barely a half-generation left to go

before we fold it away in the archives. Such famous early landmark pronouncements of modernism as the Futurist and Surrealist manifestos no longer stir our passions and forge our convictions the way they once did. Some of their passages even sound a little silly now, like the bylaws of a boys' club. We recall as well that talk of various notions of utopia, sincerely espoused, cir- culated throughout Europe in the years prior to and following World War I. Read- ing the millenarian programs of that time makes us wonder today in puzzlement how intelligent, well-educated adults could have seriously embraced the view that the arts would shortly and totally remake society— a society, mind you, that had just piled up four years of unprecedented horror in "the war to end all wars." (Even the nickname suggests a startling naivete.)

Actually, the absolutes in one form or another endured a pretty long time. In the 1950s the champions of abstract art often talked as if their way to creativity was the only valid one. As recently as the 1970s the idea that the avant-garde was by definition the most progressive phalanx in art, that is to say the best one, was alive enough to give conceptual art the special urgency that gained it the almost unanimous blessing of the establishment art world. Moreover, as late as the 1960s and 1970s many of us could assume confidently that nearly all the art- ists associated with academic and salon art of the nineteenth century were, on that very account, of a certifiably lower aesthetic order. Modernist opinion in architecture, again as recently as the turn of the 1970s,

commanded nearly total agreement that the revival of historical styles, especially when used for decorative effect, was something in the nature of a sin, a breach of artistic morality, no less, that we had long since lived down and recovered from. Surely no one but the most unregenerate among us would ever again have the bad taste to put an Ionic capital on a decorative column, or point an ogival arch in the late Gothic manner, or maybe use any kind of arch at all.

And now in the late 1980s, look around you. In painting not only did the art object make a striking comeback after being banished or cast into grave doubt by the conceptualist; so did painterly painting, figurative painting, narrative painting. We have lately taken seriously something we call neoexpressionism, deciding in the process that several national groups, like the Italians and the Germans, apparently do it better than we do. Even American superiority in the arts we can no longer take for granted. And the neoexpressionists themselves are now on the run, before they have had a chance to establish themselves comfortably in the bow of the international lead boat. In architecture the arch not only returned to favor; it has become the most overworked cliche of them all in the building of the past ten years. Decoration is not only permissible but resoundingly justified; indeed it is now called essential, since it confers "meaning," a factor that modernism is alleged to have dismissed in its totalitarian sponsorship or abstraction. Modernist builders spoke of "structural integrity." Postmodernist designers reject

that sort of thing as at worst sterile, at best passe. Historical allusion, we are told, is an enriching element in today's built forms, because it connects us with our past—the same past that modernists a half century ago were relieved to throw out like a bunch of dead flowers.

In this great sea change from modernist certainty to postmodernist laissez-faire pluralism, the critic has played just as forceful a role as the artist. One could even argue that writers and theorists urged the latest shifts on the artist or the architect before the latter even thought of them. Or if the verbalizers didn't think of them first, once they did, they often adopted the new message without blinking or missing a beat. As for the art historians, it may be enough to note that recent major retrospective exhibitions of artists like Lord Leighton, Edward Landseer, and Elihu Vedder testify to the extent of the revival of those old academicians we were once taught to despise. There is no longer a canonical art history; ask the Marxists, the feminists, or the homosexuals, all of whom will tell you they are trying to free the discipline from the old hammerlocks of capitalism, sexism, or what have you.

Then what is the educator to do? Which way do I go—I, who am nothing, let us say, but a teacher of the young, not necessarily an artist, a critic, or an art historian, but someone charged with a responsibility that is every bit as important to the preservation and transmission of culture as that of the more celebrated figures of our field. I have an answer to that, that suits me as a teacher

and that I commend to your attention even if you finally decide it is unworkable or even unattractive.

To begin with, while worrying about the apparent lack of gravity that our uncertain time leaves us with, why not enjoy the freedom of it? Forget about those critics who said a generation ago that only abstract painting would do, only American painting at that, in fact only New York painting. Do you like the French Academy? Walter Gropius? Liberace? Go ahead and like them. The people who tell you not to may within ten years be claiming to have rediscovered them and chiding you because you are not as prescient as they. On the other hand, if you cannot enjoy your independence but find it necessary to hang out in New York's East Village or Berlin's Kreutzberg or wherever the most "in" place for the moment is, go ahead and hang out there. You're free to. Don't be surprised, needless to add, if you wake up one morning and find all the galleries boarded up and the action moved to Detroit. And if it pleases you, move to Detroit yourself. And don't feel guilty about that either.

But I would like to propose something more and better than just personal self-indulgence. In fact there are some pretty strenuous responsibilities to assume as well, none more important than demand of proof. If some dealer or some critic or some collector or some university lecturer tells you that artist X is red hot or theory Y is incontrovertible, ask for lucidly persuasive evidence of it. If the evidence comes in the form of thick, convoluted writing

or speaking that defies or discourages understanding, put the burden of that on the critic, not yourself. If we have produced some awful art in our time, and we have, or some execrable buildings, and we have, we have also produced a form of art criticism that ranks among the worst corruptions of language that history can offer up.

A further suggestion: since we cannot function without believing in something, without preferring some form of X to some form of Y, reflect on what it is that you do care for, and do what you can to promote it, whether it is your own art if you are an artist, your own point of view if you are a critic, your own understanding of the facts if you are an historian. In other words, define your own personal absolute, but with this unabsolutist qualification, that you can pay close and constant attention to those who disagree with you. If you are a Marxist, give the capitalist his chance to answer you or at least to live independent of you. If you are a feminist, be willing to grant that a male chauvinist has a right to be heard and may even have something to teach you. And vice versa, in all cases.

Clearly, however, if we wish to reserve and exercise our right to demand proof, we must be able to recognize it, which means that we must know ourselves what we are doing or talking about. We must be professionals, not philistines, populists, or amateurs. This applies whether we are artists, critics, or historians, and whether we function at the level of the elementary or secondary schoolteacher or the university professor or the independent guru.

Primarily an artist is someone who makes things. Primarily a critic offers judgments about things made, separating the worthy from the unworthy and defending the separation. Primarily a historian amasses and traces the record of the past, seeking to find patterns of meaning in the data he uncovers. Each of these figures thus has his unique role, one more obviously "creative" than the others, another more evidently "judgmental" than the first, the third more "analytical," or some such. But the similarities among them count at least as much as the differences. The artist must judge and analyze as well as, shall we say, burst forth. The critic may be as insightful—that is, may be as moved by inspiration—as the artist. The historian in discerning currents and patterns in the past may be as creative as either of the other two. How can anyone read the criticism of George Steiner or the history of Edgar Wind without realizing that they made leaps of imagination every bit as breathtaking as the figural inventions of Picasso? And didn't Picasso himself collect, weigh, and edit the form of his early cubist abstractions every bit as judiciously as Steiner in his criticism and Wind in his history?

Moreover, if artist, critic, and historian are at least as alike as not, the junior high school teacher is the blood brother of the graduate school professor. What I have proposed here can be applied to young and old, to master and apprentice, to early phase and late, depending on and qualified by context and individual personalities.

That's really all there is to my suggested modus operandi. It is little more than an informed pluralism. And I may change my mind again, shifting to a more single-minded attitude later on, if that seems in order. If what I have said here was said earlier, better, and more simply by Voltaire—who did know what he was talking about—when he promised to defend to the death his adversary's right to disagree, well, Voltaire is a good man to emulate. Besides, if an informed pluralism ever really did become a widespread way of thought in the art world, it would be the first time within anybody's memory. That world, for all its now shaken dogmas, is still made up of more tyrants than democrats.

HISTORY OF THE UNIVERSITY CURRICULUM

SPEAKER

Lewis B. Mayhew
Stanford University

This paper is intended to be a selectively instrumental use of educational history. That is, from the vast amount of educational historical materials available, what are the most indicative and useful items to bring to bear on improving curricular understanding and policy-making? It will review the history of Western college and university curriculum, giving brief mention to medieval and early American developments but considerably more attention to the United States development from the end of the Civil War to the present. Although the focus will be on curricular matters, some organizational and structural elements that have curricular significance will be mentioned.

First, and in a sense the most significant development, was the medieval conception of the essential nature of a university as being a place in which, for any of varying periods of time, a life of study is followed through interactions between student and professor, student and student, and professor and professor. It deals with a kind of knowledge that can only be secured through constant interchange of ideas with other minds, thus generating a kind of enthusiasm impossible in isolation. It is this conception that determines the nature of the curriculum and of teaching.

That broad concept was refined by defining the curriculum as an organized body of knowledge (originally theology, the liberal arts, medicine, and law) and taught by trained individuals organized into faculties that over time gained control over whatever was taught in the university. The medieval university adopted the Greek idea of dividing the liberal arts into the quadrivium (arithmetic, geometry, astronomy, and music) and the higher-status trivium (logic, grammar, and rhetoric) that allowed access to the three philosophies of Aristotle (natural, moral, and mental).

The third medieval conception that was essential if the university were to achieve its purposes, and which is still an essential for colleges and universities, was the slowly won right of universities to govern themselves free from interference of either secular or religious authority. Who was to exercise that right did differ between the southern universities, in which students originally had power, and the northern institutions, in which the faculty was in control. Those differences gradually were erased, but the concept of institutional self-governance has remained and is responsible for progress of colleges and universities changing as times and conditions change.

There are of course hundreds of other contributions of medieval universities to how colleges and universities function in the 1980s. These would include the titles of most academic officers and the techniques of education, which included lectures, texts, examinations, and the ceremonies of graduation and receiving degrees. But the major debt owed to the medieval

universities is the idea of a life of study, a formal curriculum, a formal faculty, and freedom for these to function.

The colonial college was a transplant of English colleges, most notably those of Cambridge, which drew their body of knowledge rather directly from the medieval universities and had a system of governance that came originally from southern Europe as interpreted in Calvinistic churches in Switzerland and Holland. The lay board of trustees, which came to control the colonial colleges in much the same way as laymen controlled Calvinistic churches, produced a different kind of institution than would likely have evolved had faculty members governed the American colleges.

The early course of study adopted by colonial colleges reflected the medieval curriculum, with additions from Renaissance and Reformation England and was believed to be a suitable curriculum for training a governing class of gentlemen and men of action. It reflects a new concern for natural science, Greek, and ancient history, as well as the more traditional liberal arts, thus demonstrating curricular flexibility to accommodate new needs. It was a curriculum that would become preoccupied with training clergymen and educating a laity that could cope with the scholarly theology expressed by Puritan ministers. The first two years at Harvard in the seventeenth century required a review of Latin, a continuation of Greek, logic, Hebrew, and rhetoric. These were followed in subsequent years with natural, mental, and

moral philosophies, geography, and mathematics. Divinity was a study for each of all four years. Similar curricula were established in other colleges and in general remained stable for a century. However, as new knowledge reached the colonies from England and Europe, room was somehow found in one way or another to squeeze them in. This was a technique that continued throughout the history of American higher education. The old would be maintained with great drama and vigor, but the new would be reluctantly accepted and adopted. Thus the ideas of Copernicus, Descartes, and Newton were accepted as the new learning, and when that happened, change had to be made in mathematics and astronomy.

After the Revolutionary War, the college emerged with a reasonably clear idea as to what it was about. It offered its prescribed classical curriculum that relied on much translation back and forth from Hebrew to Greek to Latin. The philosophical parts of the curriculum were taught by the college president with drills in other subjects handled by quite young tutors, often graduates of the college in which they taught. The entire curriculum was strictly limited—the Yale catalogue for 1828 required but one page and was all prescribed, but had little in it that students believed relevant. In response to student protest, the state issued a report critical of the arid curriculum, which generated one of the most widely quoted faculty reports—*The Yale Report* of 1828. In it the strongest case possible was made in support of the traditional

prescribed curriculum, arguing that Yale should ignore enrollment drops because if Yale were true to its principles it held no fear for the future.

The report was widely read and its suggestions heeded as colleges across the country defended existing practices. However, *The Yale Report* was a last gasp for a concept of education already dead. Mathematics became well entrenched, laboratory science gained acceptance, professors of natural science were appointed, and gradually such requirements as the speaking of Latin disappeared and were replaced by greater stress on English. In fact from 1828 to 1862 the college curriculum on the surface appeared stable and of course classical. However, two things were happening that were to be repeated in another time. Students were staying away from college in large numbers because the curriculum had scant value for them. And elements were creeping into the collegiate experience—either in the curriculum or extracurriculum—out of which would come an entirely new curriculum. Student libraries became a major intellectual component of college life, professors were organized into departments, new subjects such as law, agriculture, and commerce were bootlegged in as evening lectures, and new styles of teaching were experimented with, such as Socratic discussions.

By the end of the Civil War conditions were ripe for an educational revolution. The entire continent had been occupied and required cultivation, the Civil War ended and released the needed resources to do that, and a new kind of learning, largely developed in Europe, especially in German universities, became available. In a brief period of forty years, between 1870 and 1910, a series of changes took place that created modern American higher education and that have never been reversed.

The free elective system replaced the prescribed curriculum and at once stimulated student demand for new courses and faculty experimentation with new subjects. The free elective system created a raging demand for the new learning that 10,000 American students brought back from their study in German universities, to which they had gone because of the lack of professional graduate programs at home. And science, which had been searching for a home, finally found one in the post-Civil War colleges and universities and at once began generating new knowledge, which in turn required new courses to promulgate those findings.

If the new knowledge were to be fully exploited, new institutions seemed essential. During these forty years, the various examples of what would come to be called the utilitarian university would be created. These were the land-grant colleges, created to provide higher education for the agricultural and industrial classes, which, in addition to advanced work in the arts and sciences, brought into the pale of higher education agriculture, engineering, home economics, education, and other applied programs. There were new institutions created to be exclusively graduate ones; there were to be new institutions intended to

combine graduate, undergraduate, and professional work. Old colleges evolved into full universities, and new institutions were created with the self-improved mission of offering education in whatever subjects students wanted or professors wanted to teach.

For two quite different reasons a new kind of institution was created called a junior college. On the one hand, at places such as Chicago and Stanford, it was seen as freeing universities from the bother of teaching undergraduates, while on the other it was seen as a democratic way of extending higher education to more students by adding two more years to the standard high school program.

As these and other new kinds of institutions emerged, so emerged the need for new kinds of teachers to serve them. So it was that among the several thousand new degrees created to staff the new academic specialties, there was adapted from a German model the Ph.D., which in time became the needed credential for college teaching and the standard for academic excellence in the United States. Its requirements then (1862) and now were in-depth study of a single subject, rigorous examinations, and completion of an original piece of research. Although criticized from its inception and despite attempts to replace it, the Ph.D. has persisted and remained the most respected academic degree in the country if not in the world.

As institutions offered new knowledge they found it necessary to develop new ways of teaching. Recitations were fine to parse Latin texts but not to present new scientific findings. It is perhaps symbolic that this creative educational period began with the adoption of the case method of teaching law in 1870 and ended with a new basic science approach to medical education. And in between, the lecture, laboratory, and seminar became the prevailing ways of college teaching.

In the midst of the explosive creation of new types of institutions, the expansion in size of many, and the increase in the sheer number of colleges and universities, especially in the absence of any federal and very little state regulations, some way of deciding what a college was, and what quality it must have, had to be devised. Lasting solutions to those problems came as a result of private voluntary effort.

The Carnegie Foundation for the Advancement of Teaching inadvertently helped the definition of the problem when it undertook to provide pensions for retired professors. In order to establish eligibility, the foundation had to answer the question of what constituted a college. First, state institutions and denominational colleges were eliminated from consideration, as were technical schools. Then, to be considered for the pensions, colleges had to require that students present fourteen units of high school credit, with a unit equaling five hours of class each week for a full year for each subject—the so-called Carnegie unit. It also must have at least six full-time professors, offer a four-year program in the liberal arts and sciences, and have an endowment of at least $200,000. Also, as a

by-product, regional associations came into existence to facilitate cooperation between colleges and high schools in offering work in liberal arts and sciences. These voluntary associations quickly developed the mechanisms to determine whether or not schools and colleges met minimal standards of quality. Thus was created voluntary accreditation in pretty much the form it still takes in 1987.

An important element in this qualitative concern was to determine students' ability to do college work. The earlier reliance on an applicant's interview with the president, which became impossible as enrollments increased, and the later reliance on high school grades, which proved unreliable in view of qualitative differences between high schools, had to be replaced by the use of admissions tests standardized by a national organization—the College Entrance Examination Board.

One of the more instructive developments of the period was the opening of Cornell University just at the beginning of these revolutionary four decades. It began offering a program for every student's needs and quickly became the largest American college, which within two years could begin selective admissions and by the next year enrolled more than any three New York institutions combined. As other institutions were subsequently created, they tried to ensure that what they offered would be attractive to students.

The list of innovations and reform could go on and on, but for now several more should be mentioned because of the power they exerted on the future. One was the expansion of academic departments into the controlling voice over curriculum and faculty selection. The second was the creation of the University of Chicago, which quickly became the model for all future research universities. And the third was the Flexnor Report, which ended proprietary medical education and established the curricular norm for medical education—two years of basic science followed by two years of clinical work.

Suddenly in 1910 a slowdown came. The number of new institutions created each year dropped and major experimentation and reform for the most part stopped. A chronology of curricular developments lists thirty-nine major innovations between 1862 and 1910, but only nineteen between 1910 and 1940. Of those educational developments that did take place, only three were destined to be influential in the future. The first was the creation of a variety of experimental colleges that elected a style different from the prevailing ones that dominated American higher education. Riesman has detailed what he calls telic reforms in higher education, which attempted to change the basic assumption as to how higher education should proceed. Two reforms, communal-expressive and political-expressive, were not really reflected in the prewar period. However, two subsequently were, and some influential colleges were created to express that point of view. One, called neoclassic, produced St. Johns College and clearly influenced the University of Chicago. The second, called

aesthetic-expressive, produced Sarah Lawrence College, Bennington College, and Stephens College in Missouri. These institutions stressed work in the fine and performing arts and established a level of respectability that would but gradually invade higher education. The creation of these new colleges provided the model that would influence the creation of cluster colleges in the 1960s and 1970s.

The second educational development was an attempt to recall the values of the prescribed curriculum of the nineteenth-century college through a new system of prescribed education called general education. First at Columbia and then at Chicago, there were serious attempts to create a new intellectual synthesis for a basic college education.

Lastly, as the United States attempted to dig itself out of the Great Depression, it created some federal programs that proved to be, with different names, federal aid to higher education.

And then came World War II, which itself generated some change in higher education, such as the advent of area studies, the stimulus of war-related research, and the various technical courses developed for the military. But it was after the war that the next great period of higher education expansion and innovation took place. It should be indicated that such an expansive period was not predicted. For example, when the Veterans Bill was passed, it was predicted that not more than 500,000 veterans would use the benefits—actually 2.5 million did so. The surprises that

affected higher education were the unexpectedly high postwar birth rates, the unexpected, sustained period of affluence, the unexpected stimulus to higher education that came from the successful war-related research, and the unexpected ability of higher education to respond to new needs.

The first major postwar curriculum development was the rise and then sudden fall of the general education movement. General education was an attempt to provide a common educational experience for all college students that would do for large numbers what the nineteenth-century prescribed curricula did for small numbers. Typically, programs offered prescribed courses in natural science, social science, humanities, and skills of communication, and during the immediate postwar years about two hundred institutions began formal programs each year until about 1955. However, almost as quickly as general education expanded, it declined, as newly trained professors refused to teach the courses, as new students refused to take them, and as faculties could no longer reach agreement as to what subjects should be required.

The second broad categories of change were new temporal and spatial arrangements. There was experimentation with the trimester system, the 3 x 3 x 3 system, the 4-1-4 system, and various sorts of module systems. And there were experiments with new groupings of students, such as team teaching, house plans, cluster colleges, and colleges for gifted students. The whole

purpose of both was to break the lock-step of regular nine-to-ten, Monday-Wednesday-Friday, fifty-minute courses with a presumed two hours of study for each hour in class, and to humanize the growing impersonal academic life on large campuses. For the most part, these did not succeed and quickly fell into disuse.

The third and somewhat more successful innovation was the increased use of off-campus experiences such as cooperative work-study, overseas campuses, and internships. These represented aserious effort to augment the academic preoccupation with courses with some real-life experiences. And especially in some professional schools such as medicine and law these efforts did seem to restore some humaneness into professional education.

Then there was the hope for a Fourth Revolution in education as technology became popular in such things as language laboratories, computer-based instruction, open- and closed-circuit television, and multimedia instruction. At considerable expense, colleges and universities developed large stockpiles of educational hardware but with little actual change in educational practice. It is true that the computer is widely used in higher education as a tool but not as an instrument of instruction.

A development that reached technical excellence but never reached its educational potential was the educational-measurement-and-evaluation movement based on the argument that if the outcomes of education could be answered accurately, improved education could then be continued. Over time some excellent tests were developed for limited but important uses. However, for financial and human reasons, except in a few places, the all-important outcome of courses continued to be measured in the traditional way of using unreliable and invalid instructor-created tests. The nation has developed some major testing resources, such as the Educational Testing Service, and has supported large numbers of evaluation studies, which still have not seemed to affect educational practice.

As a result, partly out of a presumed fiscal crisis caused by enrollment decline and higher faculty salaries, and partly because of the belief of some educators that colleges and universities should serve a greater variety of people, a new educational concept emerged called nontraditional education. If traditional education served the relatively young, relatively bright, relatively affluent, relatively high-achieving, and for the most part white, those having the apparent opposite traits were nontraditional students whose needs required different methods of education, which came to be called nontraditional. This concept seemed to claim that it would provide any kind of educational service that anyone wanted at whatever time or place the individual wished it. As it came to be practiced, nontraditional education made a great deal of use of part-time faculty, individual and self-study, convenient physical accommodations, and tended to assign academic credit for nonacademic life experiences.

How the two underlying factors interacted may be seen in one institution that began running an annual deficit of about a million dollars a year. The institution elected to contract with an independent agency to offer programs in educational and public administration to working people who could not attend regularly scheduled courses or programs. The program operated with one course meeting once a week for thirty weeks; the instructor was a part-time person. Each student presented a portfolio of past experiences having some educational significance, for which academic credit would be assigned. The typical student received three years of credit, which was then combined with the year of credit for the once-a-week course. This type of education spread rapidly during the 1970s, then experienced some decline in popularity although these non-traditional students are likely the reason that the expected college-enrollment declines for the 1980s did not materialize.

Two more recent curricular developments should be mentioned as relevant for the intent of this workshop. The first of these is the evolution in the 1960s and beyond of a group of professors who see themselves as curricular theorists and who believe that their theories can bring order to the undergraduate curriculum. These individuals, who include Paul L. Dressel, Ralph Tyler, Earl McGrath, Jerry Gaff, and, I suppose, your present speaker, have all written books in hopes that faculty members will use them as they ponder curriculum reform. Although some of this may

have taken place, one has the impression that the work of curriculum theorists is used by other curricular theorists and not by faculties in the professional schools and arts and sciences.

The second development is the outbreak of many different critiques of undergraduate curricula that have appeared over the past six or seven years. These all seem to take their orientation from the Carnegie Council on Policy Studies in Higher Education, with its contention that the undergraduate curriculum was a disaster area and that heroic measures would be required to restore it to health. The various critiques start with that premise and then proceed in one way or the other to suggest an undergraduate curriculum that really is a rosy version of the past. The report of the Association of American Colleges is typical of all the reports. It calls for new faculty concern with improvement of teaching, new faculty involvement in creating a grand curriculum design, and new faculty oversight of the entire educational effort of the institution. Then it suggests a list of objectives or goals that could be found in every report on educational reform published in the last sixty years. Students should develop skills of critical thinking, should learn to read and write and calculate numerical data, should develop historical consciousness, should be exposed to values, and should be exposed to art, international affairs, music, a major, and should study some broadening subjects. Then the report calls for all students taking a good dose of foreign language,

mathematics, and science. Above all the report urges that a great deal of evaluation should take place to provide a basis for still further curricular improvement. The problem with that and similar reports is that the ideals they urge cannot possibly be achieved in the contemporary college or university. For example, the vast majority of the seven hundred thousand professors do not have nor will they ever have the skills to carry on sophisticated evaluation, nor will they tolerate a skilled evaluator doing it for them. And it can be doubted that faculties will really adopt a curriculum that requires four years of formal language and four years of mathematics.

A review of the history of curriculum in higher education provides a basis for a number of assertions that might be of use when thinking about what is possible to do with respect to the curriculum.

The first assertion is that written plans, whether institutional or national, rarely result in specific curricular changes. At best they codify the prevailing curricula for actions and at worst they reflect wishful daydreaming. *The Yale Report* was influential largely because it simply reflected what was actual practice and did not urge change. The changes that did take place, and they were important, came as ad hoc solutions to problems that emerged out of the events and problems of the time.

Second, because many constituencies have an important stake in college curricula, curricular changes, to be effective, must be seen as satisfying some important needs of *each* of the relevant groups of students, fac-

ulty, administrators, parents, the labor market, and the larger society. Leave one out of consideration and the effort will fail in the long term and usually in the short.

The third assertion is that the curriculum cannot go beyond the abilities of faculty or the interests of students. Faculty members are trained by learning a subject and not by learning how to modify student behavior by other means. Even if it be true that there are hemispheric differences in the human brain that should be developed differently, few faculty members have, or ever will have, the ambition to do so.

Finally, while formal consideration does not usually produce formal and explicit results, still curricular discussion is good because it allows people to talk intensively about things important to them. It is out of those prolonged discussions that change gradually emerges and becomes real.

I am going to end with an observation that has pretty much become my standard notion, and that is that there are three highly important things that should take place on a college campus: number one is the preparation of the annual budget; number two is the making of a long-range plan; and number three is the formal curriculum. I think these are the most highly important things that can take place, and yet none of them will produce final products of any significance. With respect to the budget, put me on a college campus for two days and I will be able to write next year's budget, because it is so well established by increments and by traditions and the like—and yet it is good that people talk about this

very seriously. Secondly, long-range plans for the most part produce attractive sets of recommendations and some lovely architectural drawings, but once the recommendations are put in print, they are stillborn. And yet the planning is highly important, and so is the curriculum. So much emotion is expended every year as faculty members debate whether there should be the distribution requirement, the prescribed requirement, the free-elective system, or something else. My own notion is that whatever decision is reached, it is not going to make that much difference. But *talking* about the curriculum *is* going to make a difference. The curriculum, the budget, and planning offer opportunities for those of us who are men and women of good will working at something that we consider important—and that the society considers important—to bring to the surface our serious discussions. That's what I think you folks are doing here.

PROBLEMS AND ISSUES IN TEACHER CREDENTIALING

PANELIST
Thomas Ferreira
California State University, Long Beach

For three days now we have had the opportunity to attend a most enlightening series of plenary sessions that have addressed various issues related to the concept of discipline-based art education. The presentations were witty and thought-provoking and have provided us with an enlarged philosophical base on which we might continue to build a structure for implementing DBAE.

My role, as I see it in this seminar, is to address some of the more pragmatic issues that bear on our ability to put into practice the curricular reforms and innovations that have been suggested to us. In addressing you about these apparently mundane matters after you have attended sessions that have had more lofty concerns, I must admit that I feel a bit like a stonemason addressing a symposium on Gothic architecture. Nevertheless, the sublime achievements at Chartres could not be achieved unless people learned to stack stones up, one at a time, in a manner that they would not fall down.

All of us know from experience that higher education tends to be highly conservative and that, even in the best of circumstances, change is slowly effected. Each of us who has an idea for educational reform must answer to a number of agencies and constituencies: peers, adminis-trators, trustees, licensing boards, and accrediting agencies, to mention a few.

Driven by our own convictions, we may feel that these groups were created solely to frustrate progress, and it is true that sometimes that is how they behave. It is also true, however, that they frequently serve to ensure fiscal responsibility, the maintenance of academic standards, and adherence to legal mandates.

One such agency is the National Association of Schools of Art and Design (NASAD). It is worth discussing for several reasons: it is the only accrediting agency covering the entire field of art and design recognized by the Council on Postsecond-ary Accreditation and the United States Department of Education. NASAD shares its headquarters and permanent staff, including its executive directorship, with the National Association of Schools of Dance, the National Association of Schools of Music, and the National Association of Schools of Theater, each of which holds the same type of accrediting authority and recognition as NASAD.

It is worth knowing that each of these agencies places a major emphasis on the maintenance of standards in studio or performance instruction. NASAD, specifically, very jealously guards both the quality and *quantity* of studio instruction it considers appropriate in programs that lead to a degree in art, including art education. An awareness of NASAD standards is, therefore, obligatory for any of us who are proposing curricular reform in a

school that currently holds or aspires to NASAD accreditation.

Schools that neither hold nor aspire to NASAD accreditation would be, nevertheless, well served by becoming familiar with its standards for at least two reasons: first, its recognition as the sole accrediting agency for art and design vests it with power and influence beyond its member institutions, including federal agencies, foundations, and many state agencies; second, NASAD standards for the quality and *quantity* of studio instruction in art-degree programs very closely reflects the values of many, if not most, studio faculty. Since studio faculty almost invariably are the majority group with art departments, efforts to alter curricula that are not endorsed by studio faculty may be doomed to failure, especially if curricular alteration includes a reduction in studio instruction—even if the reduction would accommodate something as worthwhile as a DBAE component.

I have provided each of you with a copy of those pages of the *NASAD Handbook* that outline the standards for baccalaureate degree programs in art education and, with your indulgence, perhaps I might discuss them briefly. On page 61, there is a reference to two types of degrees. You will note that the degree described as "professional" recommends that at least 55 to 60 percent of the 120-credit-hour model should be in studio instruction. This translates to sixty-six to seventy-two credit hours or units. Even the "liberal arts" model requires forty-two to forty-eight hours. If we move to page 62 we notice that the first paragraph states that NASAD believes that art teachers who exhibit a high level of studio skills are generally more effective and commendsthe advantages of a BFA-type program.

Section B on that page states, "Competence in basic studio skills shall be emphasized in all art education degrees." Note, however, that the last sentence in section B indicates that optional subareas of concentration might include art history, aesthetics, and criticism. These themes are repeated again in section C on pages 62 and 63 under the listings of desired competencies that include not only a demand for rather high-level studio competencies but a specific reference to competencies in art history, aesthetics, and criticism.

The listings of personal qualities desired in prospective teachers, the teaching competencies, and the procedures for conducting an art education program are essentially consistent with those espoused by various art education organizations.

Before discussing what implications my comments thus far have for strategies that might be employed in proposing and seeking support for inclusion of DBAE components in the curriculum of art education, let me refer to another document. Several years ago, the visual art and performing arts associations I have mentioned today joined in a cooperative project with the International Council of Fine Arts Deans. This cooperative group is known as

the Working Group in the Arts in Higher Education. Its purpose is to formulate policy positions on critical issues, to publish those position statements, and to disseminate those statements to its own constituency, which includes more than one thousand postsecondary schools and departments that provide professional training and education to artists and teachers of the arts. In addition, its communications are distributed to selected agencies, elected or appointed officials, and others who hold important positions in the arts or are in positions where their actions could have a significant influence on one or more of the arts.

I have a copy of an early draft, which may be out in final form by now, of a position paper entitled, "Teacher Education in the Arts Disciplines" (Draft III, Nov. 1986). This position paper covers a number of areas including the arts in general education, but a major thrust is the position taken with regard to the formal education and competencies of arts teachers. Not surprisingly, the paper repeats many of the attitudes expressed in the NASAD standards. For example, in the section that refers to the formal education of specialist teachers: "Success in any profession requires talent, aptitude, and commitment. Specialist teachers must have talent for their art form, an aptitude for teaching, and commitment to pursue both as a career."

Now, what implications do these accrediting standards and position papers hold for us? A highly obvious one is that there is a large and well-organized constit-uency of studio artists and performing artists within the professoriate that passionately maintains that a very significant number of the formal education credits of students who plan to practice and/or teach the arts must be in studio or performance.

Because that is true, efforts to bring DBAE components into the curriculum have their best chance of success if they are endorsed by studio faculty. In view of the built-in conservatism of the higher-education curriculum-development process, those espousing DBAE hardly need to enlist their own colleagues from studio as opponents.

A second implication is that we must contend with overlapping and sometimes conflicting demands or standards established by accrediting agencies, on-campus policies and procedures, state agencies, and professional boards. My own institution is a good example of the kind of conflict that can occur between these different agencies and different constituencies to which we must answer. In the introduction, Marilynn Price pointed out that I was instrumental in developing the first BFA and MFA programs within the California State University system. To give you an idea of the speed of the process, I first proposed a BFA program in 1962, and in 1974 we were finally authorized to offer the first BFA and MFA degrees. It took our chancellor's office that period of time to determine that perhaps the world would not stop spinning on its axis if one or two institutions in California were authorized to offer professional degrees in the studio arts. Just prior to

approving our authorization, they determined that they would establish a set of standards so that not every one of the nineteen campuses in the California State University could offer the degree. Among the standards that they established was that the department seeking to offer the degree must become eligible for accreditation by NASAD. At the same time, they became preoccupied with the dangers that might occur with overprofessionalization of the curriculum. So they said that seventy semester units would be the maximum that could be included in the BFA program. Now, get this: they said that we had to be accredited by NASAD, and at the same time they said that there was a limit of seventy units on the professional degree. The problem is that if you look at these NASAD standards for a BFA, they indicate that somewhere between sixty-six and seventy-two semester credits must be in studio, and another twelve to fifteen ought to be in art history or related subjects. So at the point of implementation of our degree, we were put into conflict between our own centralized institutional standards and the accrediting institution.

I suspect that many of you out there have similar concerns. Many of you are probably at a point where the total number of credit hours or the particular mix of requirements in your curricula is right at the edge of meeting the standards of one or more of these agencies, and anything that you do now in order to implement new programs into those curricula is either going to bring you into conflict with your own faculty, with your own peers in your institution, with your own campus, or perhaps with one of these accrediting agencies.

I'm sure these concerns will be discussed by one or more of my fellow panelists in their presentations, and perhaps we can return to this topic in our discussion period.

PANELIST
Stephen Kaagan
Vermont Department of Education

―――――――――――

When I was at Pratt Institute, we used to refer to the accrediting agencies and the state education departments in their work as the visitation of the locusts. I'm sure that many of you have had that feeling on occasion. Now, along with some of the other members of this panel, I am one of the locusts.

What I want, eventually, is to talk a little bit about the politics, the competing forces, in this whole business of credentialing. I wouldn't refer to it as a mess—we can be more euphemistic and call it inchoate—but since my whole life is always a mess politically, I guess I've become used to a degree of uncertainty. I would refer to the business of credentialing as a very interesting water-polo match in which there are several different teams in the water all at once; I want to invite you to jump in with them and play.

First, however, I want to set out some assumptions—givens, handles, nonshibboleths, whatever one wants to call them. Credentialing in any field ought to be an outgrowth of the commitments inherent in a fiduciary responsibility—a fiduciary responsibility that we collectively have for children. Let me tell you what three of those commitments are for me. I think you might share some of them.

The first one—that art is central—may be obvious to you, but it is not so obvious to all of my colleagues who are chief state-school officers. Yet for me, the role of the arts in education is not an issue of "nice" but an issue of "necessary." It is even an issue of equity, in terms of the total development of a child or adolescent: without a variety of art experiences, the child is deeply short-changed. That's an important commitment, and it is part of our fiduciary responsibility.

Second, and what can be increasingly difficult, there are some rather compelling aspects to the student population that we collectively seek to serve. Let me read one short paragraph from a very disturbing piece on the American family written by Marian Wright Edeleman, whom some of you know as head of the Children's Defense Fund and who is referred to sometimes as "the one hundred first senator for children in this country." She writes:

In the next century we will need the contributions of every child in the U.S. today; yet we are far from meeting our national and community responsibilities to all children to make that possible. This is a perilous course, for the future is being shaped right now. The potential high-school graduate in the year 2000 is now a pre-schooler. One in four of today's pre-schoolers is poor. One in nine is living in a household with income less than half the poverty level. Only sixteen percent of these eligible poor children are enrolled in Head Start, and only half can expect to be given compensatory education when they go to elementary. One child in six lives in a female-headed

household, one in eight has no health insurance, and one in ten has not seen a doctor in the past year. One in two has a working mother, but only one in five has adequate day care. One in six lives in a family where no parent has a job, one in five is likely to become a teen parent, and one in seven is likely to drop out of school.

The composition of the student population that we will be dealing with in the next two decades is interesting, to say the least. About one-third of that student population, by the way, falls into the categories noted by Marian Edeleman.

The third assumption has to do with an adherence that all of us should have collectively in our work to the tenets of child and adolescent development.

I take you as an audience to be a proxy for the collection of people who could make discipline-based art education a reality. And I like the idea of discipline-based art education very much, because it's unapologetically a discipline; it's not namby-pamby; it doesn't go around the edges of the elementary or high school curriculum. It says, "We're disciplined. We want to be front and center in the curriculum." That goes back to my first tenet, about art being an issue of equity. It addresses weaknesses in both the content and pedagogy of art education. It does what we educators always talk about as being concerned with higher-order skills; it does that quite overtly. Finally, although I don't believe it has done this yet, it could

open up new avenues of communication for nonmainstream students, for those whom Marian Edeleman was writing about. In particular, discipline-based art education could focus the issues of fluency and context that are important to so-called at-risk students. You, as proxy for discipline-based art education, could be a core in your universities—if you are willing to work with those who have responsibility for child development, if you are willing to work aggressively with those who have responsibility for doing something about pedagogy, particularly in terms of effective practices for working with difficult students.

Taking you as that proxy, I begin to talk about some of the political issues. The three tenets, or principles, that I have enumerated are, for me, inviolate, but everything else is up for grabs these days. Three things in particular in the credentialing business are very much up for grabs, and this provides a great opportunity, I believe, for discipline-based art education.

First, almost every credentialing system for teachers and other people in education depends on a matrix, on groupings, on a categorization of different kinds of people who get different kinds of licenses—along three dimensions. The first dimension is that of generalist or specialist. The second is that of elementary, middle, or secondary school. Third is whether the candidate is teaching or nonteaching. Almost every state has to live with some form of this matrix as it tries to set out categories for licensure or certification, no matter who is

doing that work. I think the matrix is up for grabs because of the work that's being done—pressed forward by Holmes, by Carnegie, and by others. That forward motion is very important, because discipline-based art education is very ill-fitting in the present matrices, *very* ill-fitting. I struggled conceptually, and I couldn't figure out where in hell to put it. That's a very interesting position for a group of people concerned about art education to be in; it's both good and bad.

Second, in teacher education and credentialing, regardless of whom one wants to bait on the issue, there has been a delegation of primary responsibility for the essence of credentialing—certification—to universities, to you guys. You have been delegated the responsibility. One of Richard Kunkel's categories is program approval. Once a program has been approved, a student goes through that program and gets credentialed. I think that's up for grabs. Even in preservice education, it's up for grabs as to whether or not universities will play a primary role in the initial training and preparation of teachers.

Third, a key aspect of all of teacher credentialing that is very much up for grabs is assessment—the establishment of criteria and the way those criteria will be applied, the way in which people will be judged qualified. You know already about the work being done under the Carnegie Corporation, but the whole issue of assessment is very much up in the air, and what an opportunity that is for the arts! The arts have never been able to fit themselves into

the traditional assessment techniques. They've never been able to come up with a multiple-choice test that works for kids or teachers. Now there's an opportunity to think about portfolio assessment and performance in a way that it hasn't been gone about before. What a fantastic opportunity!

Politically, there are a number of actors on the scene, and you have to be concerned about all of them. You must be concerned about governors and legislatures, because in the last five years they have built an enormous tome of legislation and regulation with regard to teacher preparation and teacher credentials. As I talked informally with some of you yesterday, I was told that there is much more concern in this group about the Holmes Report than about Carnegie. But I can tell you categorically that, amid the governors and legislatures, there is more concern about Carnegie than about Holmes. That's very important in terms of communication. The states—including not just governors and legislatures but also the state education departments—are responsible for consumer protection. In the education departments, we're responsible for the equality of educational opportunity, and I take those responsibilities very seriously. Given the new laws and new regulations—and our responsibilities under them—state education departments are increasingly major actors.

In the area of accreditation, I think one of the most important things that has not been mentioned so far is what is, in essence, an increasing competition between

National Council for the Accreditation of Teacher Education, as an organization that wants to comprehend teacher education, and the Holmes Group. Although it is not a stated agenda of the Holmes Group, I think they want to be an accrediting organization, to be the fold into which all teacher preparation falls. That has to be talked about; it's very important.

In regard to the university itself, Derek Bok, president of Harvard University, in his study of graduate schools of education and in particular the Harvard Graduate School of Education, lamented the minimal participation of schools in the reform discussions of the last five to ten years. "How could it be that so much discussion has taken place about the nature of elementary and secondary education in this country," he said, "and the professional institutions responsible for that particular topic had very little to say, and exerted themselves in the discourse to such a small extent?" You, too, should be concerned about that.

Teacher organizations cannot be omitted as important actors on the scene. In a recent Sunday edition of *The New York Times*, Al Shanker—in his regular advertisement, which looks like an editorial—said that Mary Futrell of the National Education Association was essentially torpedoing the National Commission on Certification of Teachers because she was making it an issue of union predominance rather than professional predominance. In the next couple of years, that whole discussion will be very important, and it should not be left out of your current discussions.

What slant might you take, as the proxy for potential activists and substantive actors for discipline-based art education? As far as the matrix is concerned, I think you ought to boldly set out for yourself the role that you want to play in the training of art specialists, across the bounds of elementary, junior high, and secondary school—training people who understand the gamut of child and adolescent development but who are committed to a specific concept of art education, and can be credentialed in that way.

I think you ought to bet on Holmes. I think you ought to seriously consider postbaccalaureate options, or some variation thereof, for the preparation of the kind of person that I'm talking about, and I think that the work of the Holmes Group is the most important horse to ride at this point.

Finally, I think you ought to seek to make your graduates nationally certifiable. Discipline-based art education must insinuate itself into the new forms of assessment growing out of the Carnegie work, whether Lee Shulman is doing it at Stanford or not, because that's your only chance. You'll never make it with multiple-choice tests, but you do have a chance under new forms of assessment—portfolio assessment and assessment of performance. With support from some major authors, I think you have an important role to play there.

PANELIST
Richard C. Kunkel
 National Council for Accreditation of
 Teacher Education

———————————————

It is a pleasure to be here today and have the opportunity to interact with you participants of this national invitational seminar sponsored by the Getty Center for Education in the Arts. I'm not sure how familiar all of you are with the agency I represent; therefore, I would like to give you some background.

It is my intent to shape my role today here to help clarify the current practices of credentialing from an accreditation point of view and the opportunities and roles for professionals interested in art education and, in particular, discipline-based art education.

If I am at all successful, I would hope that at the end of the presentation you will understand the accreditation role in credentialing, you will know where you can learn more about national accreditation from an art education point of view, and you will have a better understanding of potential roles for art educators in impacting the quality of discipline-based art education in our country.

National Council for Accreditation of Teacher Education (NCATE) is the specialized accrediting agency recognized by the Council on Postsecondary Accreditation (COPA) and the Department of Education to accredit higher education institutions that prepare personnel to work

in schools. Currently we accredit 552 institutions all over the United States. We accredit bachelor, master's, and doctoral programs. Our mission, as established by the Council on Postsecondary Accreditation, which also establishes the mission in law, medicine, engineering, architecture, nursing, schools of art and music, and other professions, is to accredit those units that prepare people to work in schools, prekindergarten through twelve. We are not just an accrediting agency for colleges of education, but for school personnel preparation.

The Role of Accreditation Among Multiple Agencies
While the educational reform, reports, task forces, and position papers over the last four years have been clear and loud about all elements of excellence in our nation's schools, NCATE represents one very specific element of that quality assurance, and that is the national recognition of accredited institutions.

For many reasons, professional education has had a long and laborious task of building a solid, respected system of national accreditation comparable to most of the other professions. However, in recent years, ignited by the calls for reform and many significant changes in the standards, policies, and procedures of NCATE, teacher education has been responding to these calls for reform. But first of all, let's put accreditation in a perspective with other agencies and other quality control elements.

Let's look at four definitions that are

often confused (figure 1); I think they will lay a foundation for further discussion of this panel:

1 Accreditation: the process by which a teacher education program or other COPA-recognized area is nationally recognized by the profession as meeting standards for the content and operation of such programs;

2 Certification: the process by which a nongovernmental agency or association grants professional recognition to an individual who has met certain predetermined qualifications specified by that agency or association;

3 Licensure: the process by which an agency of state government grants permission to persons meeting predetermined state requirements to practice the education profession; and

4 Program Approval: the process by which a teacher education program is recognized by the state as meeting state standards for the content and operation of such programs.

Who Makes Up NCATE?
Figure 2 shows the organizations that make up NCATE. NCATE is divided into four major constituencies: teacher educators, teachers, state and local policy developers (i.e., chief state school officers, state departments of education, and local boards of education), and national organizations of professional specialty groups.

People interested in discipline-based art education clearly ought to be in that category. You will see by perusal of this list nearly all other subject areas are listed: math, science, English, social studies, industrial arts, and physical education. Art and music are not. By the way, I hope this panel leads into a discussion of the absence of your involvement from accreditation so that we can discuss future plans together.

The Responsibilities of Content Specialists in National Accreditation
As can be seen by the preceding chart, national specialty organizations are an integral and an important part of an NCATE review. Currently the process calls for national organizations to submit their standards to NCATE (figure 3), at which time these standards for the preparation of school personnel are then accepted by NCATE. When these standards are accepted, the following activities occur:

1 All institutions preparing for an on-site visit by NCATE must prepare a folio showing how their programs compare with the national standards;

2 The national specialty organization critiques the individual folio for every institution and comments on the congruity or lack of congruity;

3 The institution receives this advance critique and has an option of responding by correcting or countering the beliefs of a national organization;

4 The standards and weaknesses developed in this advance review are then carried by NCATE's Board of Examiners when they visit an institution.

Along with those procedural steps, content specialists also have the following governance roles with NCATE: (1) eligible to serve on all governance boards; (2) eligible to nominate and function as members of the Board of Examiners; and (3) opportunities to function in the specialty groups in developing of the national standards to be applied in the specialty areas.

Trends and Issues in the Future
Over the last three years, the National Council for Accreditation of Teacher Education has seriously and substantially changed its policies, practices, and standards. Most of this has been historically reported in the December 1986 issue of *Phi Delta Kappan*, in an article entitled "The Reform of National Accreditation,"[1] cowritten by Dr. Donna Gollnick, deputy executive director of NCATE, and me. As part of this, the reform of national accreditation, the new standards have begun to be applied since February 1987. We are currently piloting fourteen institutions over the next year and a half. The new system has extensive training for our site visitors; some of the best trainers and evaluators in the country have developed a sophisticated training and deployment model. People like you in this room are eligible to be in that pool.

The meshing of national accreditation in the profession, similar to the place of accreditation in other professions, is a vitally important linkage for our profession. Support and rigorous care of programs offered across this country are your responsibility as well as our responsibility. We can do that better together.

I hope that through this brief overview I have given you enough opportunity to know what NCATE does, how you can and should be a part of it, and some of the issues that we are facing.

References
1. Gollnick, Donna M., and Richard C. Kunkel. "The Reform of National Accreditation." *Phi Delta Kappan* 68 (December 1986): 310–314.

FIGURE 1. ASSURANCES OF QUALITY IN A PROFESSION

Accreditation (i.e., National Council for Accreditation of Eacher Education)
The process by which a teacher education program is nationally recognized by the profession as meeting standards for the content and operation of such programs

Certification (i.e., National Science Teachers Assocation and National Board for Professional Teaching Standards)
The process by which a nongovernmental agency or association grants professional recognition to an individual who has met certain predetermined qualifications specified by that agency or association

Licensure (i.e., each state)
The process by which an agency of state government grants permission to persons meeting predetermined state qualifications to practice the education profession

Program Approval (i.e., most states)
The process by which a teacher education program is recognized by the state as meeting state standards for the content and operation of such programs.

FIGURE 2. NCATE CONSTITUENTS*

Teacher Educators
American Association of Colleges for Teacher Education

Teachers
National Education Association

State and Local Policy-Makers
Council of Chief State School Officers
National Association of State Boards of Education
National School Boards Association

Specialty Organizations for Professional Preparation of Educators
American Alliance for Health, Physical Education, Recreation, and Dance
American Association for Counseling and Development
American Association of School Administrators
Association for Educational Communications and Technology
Association for Supervision and Curriculum Development
Association of Teacher Educators
Council for Exceptional Children
International Reading Association
National Association for the Education of Young Children
National Association of School Psychologists
National Council for the Social Studies
National Council of Teachers of Mathematics
National Science Teachers Association

continued on next page

continued from previous page

National Council of Teachers of English

International Technology Education
　　Association/Council for Technology
　　Teacher Education

Public Representatives

Student Representatives

*NCATE's executive board voted in October 1986 to expand its membership to include the American Federation of Teachers at AFT's request.

FIGURE 3. GOVERNANCE OF NCATE

PANELIST
Clyde McGeary
 Pennsylvania Department of Education

First, permit me to express the sense of
excitement and pleasure I feel as I join this
seminar to share information and opinions
about the challenges we face in shaping
and improving preservice experiences for
art teachers. This is indeed an opportunity
that should be seized, for it is one of the
very few times that those of us represent-
ing the disciplines that comprise art
education have come together to formalize
our concerns and possible plans for preser-
vice programs.

 Snowbird is a beautiful place to conduct
such work, and if I may be presumptuous, I
suggest that the model of this seminar
deserves to be replicated in every state.

 In preparing for my portion of this panel
presentation I have identified two major
items. The first is a review of the primary
agencies involved in awarding art teacher
certification credentials. Here, I wish to call
attention to the focused and necessary role
of each state's department of education.
Further, I want to suggest ways that might
dispel the ignorance so many of our col-
leagues have of agencies and procedures
involved in art teacher certification. The
second is an overview of recent efforts in
Pennsylvania that have brought about sig-
nificant changes in the Art Teacher
Standards for Program Approval and
Teacher Certification that embrace
discipline-based art education.

Primary Agencies
I read the text of Victor Rentel's presenta-
tion to this group on implications of the
educational reform reports—I believe he
spoke with you on Monday, August 10—
where he said, "Since both the Holmes and
Carnegie reports recommend substantial
changes that would weaken state-level
teacher certification, little support for
national certification standards or changes
in classroom teacher certificates can be
expected from state departments of educa-
tion. In fact, since states now totally control
the certification process, state education
bureaucracies will probably oppose
attempts to change certification." I refer to
Dr. Rentel's statement, for it calls attention
to a general level of ignorance about each
state's primary and constitutional, statutory
role in education, including teacher licens-
ing and certification. Furthermore, my
experience shows state bureaucracies to be
far more concerned and flexible than Dr.
Rentel implies.

 No doubt changes are in store for the
teacher certification process. However,
comparisons to other professions such as
medicine, law, and engineering, as they
might predict the future of education, are
of little value.

 Educational operations related to teacher
certification are intertwined, in complex
fashion, with the statutes of every state.
Until major and significant changes occur
that coordinate such functions, my strong
suggestions to this group, and to all you
represent, is to study and understand the

systems now in place. Then, changes can be set into motion.

To ease this seemingly difficult task, I urge administration and staff of preservice programs to obtain the manual[1] prepared for the National Association of State Directors of Teacher Education and Certification (NASDTEC). A copy should be on the shelf of every program office because it details and compares the licensing and certification procedures of every state. It is structured to align with NCATE programs and to help those who are responsible for issuing licenses. Whatever our critical thoughts are on the subject, licensing or certification of teachers is the government's way of assuring that those who serve students are competent. Simply put, it is a process designed to protect the public.

The complex process of licensing and certification oftentimes involves interstate agreements. This should be of concern to all of us because of the implications of the concept of reciprocity. For example, in California those who wish to accommodate teachers and aspiring teachers with some sense of mobility, allowing them to move to another state where their training and certification would be recognized, should take heed. Not that this issue needs to be one that occupies a "front burner," but teacher mobility should be a consideration. There are interstate certification contract administrators in each department of education to ease this process. Through it all, NCATE standards provide a foundation for comparison of programs and the

ultimate decision related to a person's records review.

Another growing concern is foreign credential reviews. A number of such reviews began when citizens fled Hungary during the uprising in that country. Many people claimed degrees or teaching credentials and verification was difficult, to say the least. As world travel, worldwide studies, and teacher exchanges become more popular, certification based on claims of such experience or competence are tested. Ignorance of foreign credentials and the experience or competency levels they stand for are often to blame for errors, on both sides of the ledger, in state license awards in the United States. Furthermore, United States students taking foreign-based courses or using foreign travel for preservice credits present a problem for certification officials.

Aside from the usual preservice programs in art education, certification for emergency situations is established, too. Emergency certifications are usually valid for one year. Such emergency programs also allow for the employment of teachers who do not have the special course requirements needed for full certification but do have highly specialized skills or knowledge. On a related front, there are a growing number of intern programs, in which people who wish to change careers or begin another career track can gain certification. These programs, accommodating preservice candidates by allowing employment and study at the

same time, are growing nationwide and deserve our full attention.

As state departments of education perform their certification work, concerns for the following appear, in my assessment:

- Teacher mobility. How can teacher mobility be accommodated within the changing climate of economic change, population growth, and individual needs?

- The uneven quality of preservice programs within a state or between states. Whose charge is it to assure quality?

- The reluctance of preservice programs to relate to community needs. Special problems of large city populations and rural populations are often ignored by preservice programs located within such settings! Further, problems of minority groups and influxes of foreign-speaking students are often "dealt out" of preservice training. How should the lead for such effort take form?

- Teacher assignments outside of their certification limits. Here, teachers are credentialed in one discipline area and used or assigned to teach in another. This is usually because of a teacher's special interest or experience. DBAE might invite such a mix of credentials or backgrounds among history, language study, philosophy, and studio art. The danger lies in illegal teacher assignments.

Recent Changes in Pennsylvania's Art Certification Standards

In 1983, my office in the Pennsylvania Department of Education, studied the needs for change in art-teacher-education preservice programs. The schedule for teacher standards review was considered together with opinions of art teachers, supervisors, and college/university leadership. Cooperation was sought and established with the Pennsylvania Art Education Association. Plans and budget were approved. A standards review and redraft committee was established, and such effort resulted in approved (by the State Board of Review and the State Board of Education) standards to be implemented beginning June 1987.

The standards include:

- requirements for studies in studio art, art history, aesthetics, and art criticism;

- balanced offerings among aesthetic experience, arts and humanities, heritage, human development, history of art education, vocational and avocational potentials of art, and purposes of the arts;

- studies of growth of learners;

- field experiences prior to student teaching;

- study of professional and ethical expectations;

- study and experience in instructional procedures, curriculum, classroom

management, safety/health hazards, proper use of tools and equipment.

Thus, in Pennsylvania, preservice standards are in place that relate clearly to discipline-based art education. Effort must now be applied to the task of helping colleges and universities to establish and maintain their programs according to such standards.

Since the approval of new Pennsylvania preservice art standards, coordinated efforts are under way for the following:

- the development of a renewed comprehensive plan for art education in Pennsylvania (an eighteen-step, articulated plan that embraces DBAE);

- the reconstitution of the Philadelphia Museum of Art's Institute for Teachers;

- the conduct of three symposia on DBAE at King's Gap, resulting in published reports that elaborate on each discipline's realm of concern, especially as preservice education and inservice education are concerned (King's Gap is a remote, state-owned conference center that is conducive to study and uninterrupted work);

- coordination with music educators to begin a discipline-based program in music;

- financial and staff support to the Kutztown and Allentown DBAE Institute for Teachers;

- Professional Art Educators Association

(PAEA) conferences and workshops on DBAE.

Efforts to address the issues raised by concern for quality preservice education in discipline-based art education must be considered in ways that appreciate their complex nature. All of us have much to learn about such a process. The job is possible and will be, no doubt, very exciting.

References

1. A copy of the NASDTEC manual can be obtained by writing Dr. Richard Mastain, NASDTEC MANUAL, California Department of Education, Commission of Teacher Preparation and Licensing, Room 222, 1020 O Street, Sacramento, CA 95814. Telephone (916) 445-0184. Approximate cost of the manual: $25.

THE INTERRELATIONSHIP BETWEEN PRESERVICE AND INSERVICE EDUCATION FOR ART TEACHERS AND SPECIALISTS

SPEAKER
Frances S. Bolin
Teachers College, Columbia University

I have one basic premise: teacher growth and development occur along a continuum of experience in the life of the teacher. I will argue that if there is to be an interrelationship between preservice and inservice art education, then it must account for this continuum. Because I am not an art educator, I take comfort in Gilbert Clark, Michael Day, and W. Dwaine Greer's recent comment that "Art is viewed as a subject with content that can be taught and learned in ways that resemble how other subjects are taught in schools" (1987, 131). My remarks will relate to pre- and inservice education of teachers and I will leave it to the educators of art teachers and specialists to draw the connecting threads.

The Continuum in Teacher Education
Webster's Unabridged Dictionary defines the word continuum as:

> *That which is absolutely continuous and selfsame; that of which no distinction of content can be affirmed except by reference to something else (as duration and extension, which are capable of support distinctions only by reference to numbers or to such relations as those of* now *to* then, *here* to *there, before* to *after); secondarily, that of which the only assessable variation is variation in time or space.*

John Dewey argued that, "The thing needful is improvement of education, not simply by turning out teachers who can do better the things that are now necessary to do, but rather by changing the conception of what constitutes education" ([1902] 1974, 338). If we were to reconceptualize teacher education as a continuum—an activity that is altogether in keeping with Dewey's idea, I believe—we would include at least three key strands in both pre- and inservice education. We would begin by focusing on what is continuous in the experience of the individual who is being educated to teach—that is autobiography. Next we would equip our students to be good observers of the complex, dynamic contexts in which they work. Finally, we would develop in our students a mind-set about teaching as a profession requiring continuous scholarship.

Preservice Teacher Education
1 *Focusing on autobiography.* That which is absolutely continuous and selfsame in the life of the individuals who present themselves to us in preservice programs is personal biography. When an individual makes the decision to teach and to begin a program of formal preparation, it is with reference to countless experiences with teachers. Some of these will have been positive and others negative. In any case, the individual who chooses to become a teacher has had at least twelve to sixteen years of direct, laboratory experience in schools where impressions have been formed about who teachers are and what

they do, or ought to be doing. These impressions are so powerful that they are likely to furnish the basic approach an individual takes in teaching and, more often than not, provide the model of teaching that is utilized once a teacher education program is completed. Sociologists such as Dan Lortie (1975) tell us that beginning teachers tend to set aside what they learn at colleges and universities in favor of generalized impressions and past experience that soon become entrenched ways of doing in the classroom. Dewey ([1902] 1974) referred to this phenomenon, describing it as the development of habits of work sanctioned by empirical rather than scientific evidence. Classroom practice is adjusted, not to principles of teaching, but to what succeeds or fails from moment to moment.

If this is the case, then what we do as preservice teacher educators is, more than likely, beside the point. It makes perfect sense for art educators to debate issues such as whether there should be more or less studio experience in preservice education. But unless art educators pay attention to sociological and psychological dynamics that influence the practice of teaching, these debates are academic.

A preservice program, however we might conceive it, must provide opportunity for the student to identify what is likely to be an unarticulated theory of education that guides interpretation of experience. Autobiography, classroom experiences remembered, remembrances that emerge as a result of fieldwork may help the student identify this theory.

Peter Berger (1963, 56–57) noted that as individuals we interpret and reinterpret our own experiences, reconstructing our past in accordance with present ideas of importance.

This means that in any situation, with its near-infinite number of things that could be noticed, we notice only those things that are important for our immediate purposes. The rest we ignore. But in the present these things that we have ignored may be thrust upon our consciousness by someone who points them out to us.

It is the preservice teacher educator's responsibility to thrust upon the consciousness of students his or her own philosophy of education and guiding theory. Admitting to a theory of education, searching for its sources, and exposing it to critique will enable the student to continuously reconstruct experience rather than a slave to experience. Then teacher education is not a new box full of experience stacked on top of a pile of boxes, but a repacking of all the boxes of the student's experience. It is not added on, but part of that experience.

Writing an autobiography and philosophy of education is a way to incorporate this strand into the preservice program, but there are countless other opportunities to draw on the student's lived experience. Dewey (1902, 323) pointed out that isolation of the preservice program from this experience is both unnecessary and harmful.

It is unnecessary, tending to futility, because it throws away or makes light of the greatest asset in the student's posses- sion—the greatest, moreover, that ever will be in his possession—his own direct and personal experience . . . But it is more than a serious mistake (violating the principle of proceeding from the known to the unknown) to fail to take account of this body of practical experience.

By beginning with the student's auto- biography and drawing on it to illustrate principles of teaching and learning, we are already facilitating the construction of personal meaning from the experience of teaching. Arthur Jersild (1955, 4) notes that:

The search for meaning is not a search for an abstract body of knowledge, or even for a concrete body of knowledge. It is a distinctly personal search. The one who makes it raises intimate personal questions: What really counts, for me? What values am I seeking? What in my existence as a person, in my relations with others, in my work as a teacher, is of real concern to me, perhaps of ultimate concern to me?

2 *Studying the complex, dynamic context of schools.* Students need to learn from the beginning of their programs that teacher education is applicable to the extent that they can figure out how to apply it. Then we need to give them the tools for doing so. Perhaps the most important tool we can

give them is an ethnographic approach to their work. At its core, ethnography is con- cerned with the meaning of actions and events to those we seek to understand (Spradley 1979). Prospective teachers will need to learn to be good observers, learn- ing how to study the school and classroom that are familiar as if they were strange. They must learn to ask themselves what the people who are actors in the school set- ting can teach them through overt behavior and language and implicit meanings that will enable them to be more effective.

Seymour Sarason ([1971] 1982) has reminded us that schools have their own culture where social relationships, rules, and standards have been developed over time. Despite their commonalities, each school has unique differences. Each has a profound influence on the teachers who enter the school for the first time and on those students who are in the school trying to make sense of it. Willard Waller (1932), in his classic *Sociology of Teaching*, pointed out that the school is a unity of interacting per- sonalities, a despotic organization that is always in a state of perilous equilibrium. While schools are organized on the princi- ple of authority, their authority is always being challenged by those who have a vested interest in their work. For the public, school outcomes are often more important than the details of education, and these outcomes are most often assessed in gross utilitarian terms (Stanley 1981). This has served to hide issues that ought to be held up to careful scrutiny—issues related to the quality of life that goes on inside the

school, to the development of dreams and imagination in students and teachers, to the fostering of personal meaning. Focus on utilitarian outcomes has served to hide the complexity of entering a particular school and being able to apply one's knowledge and skill in some kind of standard way. Neither children, schools, nor communities are standard, and they can confound those who attempt to institute widespread curriculum changes without regard to each school's uniqueness.

An ethnographic approach is crucial if we want our students to bring about change in the schools. It will enable them to take into account the strong beliefs that other people may have about the curriculum and make wise choices about how to proceed when there is conflict.

3 *Developing an experimental attitude.* In the final analysis, the way we enable our students to think about their work will probably have more impact on their future as teachers than any specific methods that we may teach. Perhaps this is why Dewey believed the laboratory experience to be superior to the apprenticeship in teacher education. Dewey argues that while specific methodology may render a more capable teacher for the first year or so, it will not render a more thoughtful teacher. Dewey's assumption is that teachers should promote learning in the broadest sense. A laboratory experience challenges the student to develop an experimental approach to teaching so that practice will be intelligent, rather than accidental and routine.

Activities such as less planning are ways of thinking about teaching. Evaluation is a way of thinking about the value students place on their experiences and the value that a community places on particular traditions and ideas. Disciplines of knowledge are ways of organizing thinking about the world or content to be taught. Skills are ways of gaining access to knowing and new ways of doing. Every method and practice that we teach should be, to use Dewey's words, developed under "the inspiration and constant criticism of intelligence" (1902, 320).

It is crucial that the teacher learn how to study context and draw from experience in order to make wise decisions about what to teach, because the real work of becoming a teacher is a difficult, complex, and lonely task. Teachers are not initiated into a world of meanings or a teacher craft and culture that they interpret with the help of mentors. And while there has been recent attention to development of mentoring and master teacher programs, most new teachers are on their own—expected to be skilled, knowledgeable, and understanding. The principal and board of education do not anticipate assisting them, over time, in acquiring the skill, knowledge, and understanding that are necessary to becoming a master teacher (Lortie 1975). Nor do parents want new teachers "learning" on their children. Admission of ignorance or uncertainty places the new teacher in a vulnerable position.

Teacher educators tend to want to look at the problem of induction into teaching as

a transfer-of-learning problem. We imagine that if we gave teachers better pedagogical tools, they would be better prepared to make the transition from pre- to inservice teaching. Sevigny (1987, 121), for example, suggests that the state of knowledge in discipline-based art education is such that "The foremost question for the immediate future is no longer *what* to teach, but rather *how* to teach." Undoubtedly art educators know a great deal more than ever before about what ought to be taught in the schools, but knowledge and context are dynamic. Even if we were able to identify the specific content that teachers need to know, hold it in a stable, suspended state, and discover *the* pedagogy that teachers most need and get them to perfect it in student teaching—even then, we could not be sure that this perfected practice would transfer into classroom practice during the first years of teaching. The process of learning to teach is too complex. Transfer of learning from the preservice program to practice requires experience, support, and time. The fact is, there are no generic schools or generic classrooms. Should our beginning teacher have the good fortune to complete an internship in the school where he or she begins to teach, the uniqueness of the various individuals who make up each classroom, the dynamic nature of the arts, and the complexities of teaching would make a direct transfer impossible— impossible, that is, unless we are willing to concede that teaching is telling and learning is receiving, without reference

to context, a concession I am unwilling to make.

Teaching, like learning, is experiential in nature. Once our teacher educators, entering students of teaching, and school people have a mind-set that sees preservice as a launching rather than a docking, a departure rather than an arrival, then we all can be more realistic in our approach to classroom improvement and continuing inservice education. Developing a continuum in teacher education requires more than some minor shifts in vocabulary. It requires the development of true laboratory settings at the college and university and it requires conscious attention to inservice teacher education.

Inservice Teacher Education
Unfortunately, the interrelationship between pre- and inservice teacher education as a whole is more problematic than positive. It is most often one of mutual suspicion and blame. We preservice educators recognize severe constraints on our time and resources. We are often angered by the difficulty we have finding appropriate field placements and lack of cooperation from the schools in preparing teachers. Sometimes we are angered by what we see happening to our graduates as they seem to be swallowed up into the schools and we are appalled at the bad habits they develop. We in inservice education are appalled at how little beginning teachers know and are frustrated over having to show them how to do every little thing—like how to keep

an attendance register! We are angered over the college's insistence that it call the shots in student teaching and see cooperation with the local university as having to buy into the university's research agenda, which is usually far removed from our concerns and needs.

I do not believe that this situation would exist if we were to reconceptualize teacher education in terms of the continuum. At the inservice level, the continuum would build on the same three strands that were begun in preservice: (1) autobiography, (2) study of context, and (3) continuous scholarship.

1 *Focusing on autobiography*. Maxine Greene (1973, 270) points out that teachers are often treated as if they were disembodied, not persons, but a role to be played. She writes:

> The numerous realities in which
> . . . [the teacher] exists as a living
> person are overlooked. His personal biog-
> raphy is overlooked; so are the many
> ways in which he expresses his private
> self in language, the horizons he per-
> ceives, the perspectives through which
> he looks on the world.

Strategies utilized in implementation of discipline-based art education must not deny teachers—whether these are art specialists or "ordinary classroom teachers" being asked to add DBAE to the curriculum—their own expertise and their vital role as curriculum decision makers. A great deal of what I read about curriculum reform in the arts sounds like what I read about curriculum reform in the 1960s and 1970s in other disciplines. It would be a serious mistake if art educators ignored the lessons learned from failed curriculum reform efforts of this period. It is apparent from studies of these curriculum implementation efforts that teachers will not follow through on implementation of a curriculum unless they have an investment in it (Bolin 1987). The investment has to be more than bringing them all into a workshop where they are told what they should do, how to do it, and what materials to utilize.

Here I find that I am in strong disagreement with those who advocate a teacher-proof DBAE where the objectives and strategies have all been settled. Michael Apple (1987, 68) has referred to this as the "separation of conception from execution." As teachers are handed material to implement, without thought to their own expertise either in the discipline or in pedagogy or in human growth and development, their skill in these areas begins to atrophy. As Apple points out, "lack of use leads to loss."

> Increasingly, teaching methods, texts,
> tests, and outcomes are being taken out of
> the hands of the people who must put
> them into practice. Instead, they are
> being legislated by state departments of
> education or in state legislatures, and are
> being either supported or stimulated by
> many of the national reports . . . which
> are often simplistic assessments of and
> responses to problems in education

. . . and which demonstrate the increasing power of conservative ideologies in our public policy discourse.

Clark, Day, and Greer (1987, 167) argue that a written curriculum is necessary in DBAE to ensure articulation and avoid repetition across grades, to utilize educational objectives that provide sequences of learning and encourage effective program evaluation, and to incorporate art curriculum into the mainstream: "If art is to be taught regularly in every classroom throughout an entire district, some means are required to ensure implementation. In art as in other subjects, such means include a written curriculum with plans that follow a scope and sequence for teachers in all grades." The concern expressed here is that we will expect too much of the ordinary classroom teacher if we ask that he or she become expert in art history, criticism, production, and aesthetics. My concern is that we will ask too little. As Apple points out (1987, 70), when curriculum becomes too centralized, focusing on competencies measured by standardized tests, the consequences are most often exactly the opposite of what has been intended. "Instead of professional teachers who care greatly about what they do and why they do it, we may have alienated executors of someone else's plans."

I have argued elsewhere that it is at the level of curriculum in use that curriculum thinkers have most often been frustrated over the past two decades (Bolin 1987, 96–97).

The link between intention and actuality in curriculum development is often a weak connection at best, and curriculum change is a tedious process. If one sees the curriculum as a document that outlines a set of objectives, implementation is not necessarily a curriculum problem but an instructional problem.

The teacher must be an active participant in curriculum development and implementation. Participation by the teacher begins when the teacher is intellectually engaged with subject itself. This is where the art specialist has a vital role to play with classroom teachers who do not have needed knowledge and skills in art, assisting them in making appropriate curriculum choices. The teacher examines a curriculum document, analyzing its substance (assisted by the art specialist if it is the classroom teacher who is working with a DBAE program), modifying and supplementing it in light of the realities of that teacher's own classroom and school situation. The teacher must be seen as one who utilizes a given curriculum as a basis for decision making—real decisions, not shallow choices about whether to use *suggested activity A* or *suggested activity B*.

2 *Studying the complex, dynamic context of schools.* Inservice teachers are often unaware of the complexities of their own setting and how these shape practice. Often the constraints of the workplace are accepted as personal failure—for example,

the teacher may believe that if she tried harder or had better skills students would be more responsive, when in reality, the school has failed to provide her with a reasonable class load, appropriate materials, or adequate supervisory support. The teacher who has learned to study the school context is less likely to confuse institutional constraint with personal failure.

Understanding the complexity and dynamic nature of schools is a key concept if one is interested in involving teachers in curriculum change. At the outset I noted that I take comfort in Clark, Day, and Greer's comment (1987, 131) that in programs of discipline-based art education, "Art is viewed as a subject with content that can be taught and learned in ways that resemble how other subjects can be taught in schools." I also find discomfort in that statement. There is a lot to concern us about how other subjects are taught in schools today. Mainstream thought on schooling is far less concerned about education for personal meaning, education of imagination and feeling—in short, education of the whole person—than it is concerned with development of those human capacities that are most easily verified by observation or measured by objective criteria. Though most educators may recognize the need for both analytical and imaginative thinking, and I know few teachers who are indifferent to personal meaning, they are under enormous pressure to teach a narrowly conceived, test-driven curriculum. If we attempt to place art education into the present school milieu

as another subject to be taught in ways similar to other subjects, we are in grave danger of allowing the arts to be treated as objective knowledge in the narrowest sense of that term. In the current political context of schooling, programs in creative and critical thinking, art, music, dance, and aesthetics—if they are present at all—are asked to follow rules of cognition for political purposes related to objective measurement as a means of accountability. The tragedy is not just a distortion of subject. The tragedy is that through the arts and their symbolic language many students have found a retreat from an oppressive, technical approach to learning that has been disinterested in their personal concerns. Too much that goes on in our schools has the consequence of rendering knowledge useless or meaningless to the student. Art education, or the disciplines of art education in their most rigorous sense, cannot be allowed to be one more set of subjects. Art educators can ill afford to accept schools as they are or feel that an advance has been made for art in education with acceptance of the arts in terms of mainstream education.

Teacher educators who are interested in implementing DBAE have often expressed concern over art teachers who favor studio art, supposing that this is the case because there is more studio art in preservice programs. While this is undoubtedly true for many art teachers, it is too simplistic an answer to teacher resistance to DBAE. Art teachers may tenaciously cling to studio classes because they recognize how little

opportunity students have for symbolic expression in the schools. To limit the studio in order to include history or aesthetics, if these are to be taught by mainstream rules, would be to sell students short. Many art teachers will need to be reassured that there will be alternatives to the narrow approaches to teaching and learning that they observe around them.

Inservice teachers who are convinced of the value of DBAE must learn how to carefully study the school context in order to develop thoughtful strategies for instruction. These teachers will be far more capable of dealing with the realities of mainstream education than will outside experts who do not understand the particular school milieu.

3 *Developing an experimental attitude*. The inservice teacher in a continuum should be thought of as a scholar teacher, one who is a continuing student of subject, pedagogy, and human growth. Research, inquiry, and writing are not the exclusive property of university scholars. Teachers, too, should be challenged to see themselves as scholars. Dewey (1929, 32) argued that it is not research that will be most helpful to teachers, but the research as it is critically examined and tested in light of their own understanding, experience, and particular circumstances: "The final reality of educational science is not found in books, nor in experimental laboratories, nor in the classrooms where it is taught, but in the minds of those engaged in directing educational activities."

Teacher scholarship needs to be supported, however. Becoming a teacher is a lifelong process. The very least that a teacher ought to be able to expect of the profession is that appropriate supervision be provided. Supervision is the right of teachers, though they are unlikely to ask for supervision as many presently experience it. Elliott Eisner (1981, 62) likened the supervisor to the critic in the arts: "The critic's function—and I would argue one of the major functions of the supervisor—is to help others appreciate what has transpired." Supervision should be directed toward enabling the teacher to be more thoughtful and reflective about practice. This perspective is not served by the supervisor who observes the teacher's performance in a few isolated instances, noting details such as writing the objective on the board, presence or absence of anticipatory set, increasing motivation through altering level of concern, or whether the teacher looks professional. As Dewey pointed out, "Such methods of criticism may be adapted to giving a training-teacher command of some of the knacks and tools of the trade, but are not calculated to develop a thoughtful and independent teacher" (1902, 335). When it is not possible to provide the specialist with a supervisor who is an experienced art teacher, the supervisor must at least be guided by an art educator. Although it is true that there are many generic skills in teaching, there is always need for specific, subject-centered feedback.

In a continuum, supervision is the right

of the teacher. Here we benefit again, by borrowing images from the arts. Think of the skilled pianist who continues to study with a teacher, moving beyond the teacher in skill and achievement, but returning for the discipline, practice, and critique. Teachers of art need to continue to study their craft—including subject matter, human learning, pedagogy, and studio work. Teacher scholarship may exist without supervisory support, but for it to flourish in the schools, we must not leave it to chance. Every teacher should be a scholar teacher.

Toward a Continuum in Teacher Education
I have argued that the interrelationship between preservice and inservice art education should be that of a continuum. I have suggested three strands that characterize a continuum in teacher education. The form that DBAE will actually take has not been addressed. There are many specific questions to be answered in any attempt to implement a wide-sweeping curriculum reform such as DBAE. Undoubtedly, the appropriate relationship between pre- and inservice education in discipline-based art will require certain agreements about who should do what and when. These are legitimate, pressing concerns that I have ignored. Art educators are far more equipped to work out specific details than I am.

I have presented some prior considerations that must be taken into account if DBAE is to find its way into the schools and stay. If preservice teacher education

makes little difference in teacher practice, then content of preservice teacher education is irrelevant. If inservice education does not contribute to improvement of the schools and lasting curriculum reform, then talk about content of inservice programs is idle talk. Questions of content and organization become important only as we are able to offer programs that are likely to make a difference in the way teachers do their work. I believe that the continuum does and will make a difference.

A continuum presupposes that education is concerned with construction of meaning through continuous reconstruction of experience in light of new information and experience. To be consistent with a continuum, all preservice and inservice instruction should give attention to autobiography of those who participate, study of the context of schooling, and continuous scholarship or developing an experimental attitude about teaching. These should be placed within a framework that will provide for (1) acquisition of knowledge, (2) analysis and reflection, (3) reconstruction and application, and (4) experimentation and critique.

Acquisition of knowledge is critical when new areas are being introduced. This may be presented in a variety of ways—lecture, briefing session, teacher (or student) study group, assigned readings. Too many preservice courses and staff development programs stop with direct input, however. *Analysis and reflection* time should be built in to any program that seeks to provide new

information. In a staff-development context, it often makes sense to present information to a large group. When this is the case, resource people should follow up with small group discussions, providing participants with the opportunity to question and consider the material. Allowing time for a few questions at the end of a lecture does not serve this purpose. Sometimes analysis and reflection can be promoted through writing reflective or dialogue journals that are read by appropriate supervisory personnel.

Once opportunity for analysis and reflection have been provided, *reconstruction and application* should be expected. When there is a specific innovation, such as DBAE, with concepts and organizing principles related to a strong philosophical base, there is always concern that contamination of the model will occur. The fact is, contamination occurs in every top-down model—contamination, resistance, and subversion. In a continuum, reconstruction of knowledge is not looked on as a necessary concession, but the best possible representation of the innovative idea—it is represented, transformed by the one who will receive it. If there are invariant guiding principles in DBAE, then these will survive the teacher's intellectual activity as they will survive the student's. As teachers are involved in thinking through and applying information in terms of their knowledge, expertise, and understanding of the school context, they will begin to apply it.

There is a place for carefully sequenced curriculum guides that are prepared with

teachers, but the key to their use is the word *guide* and the words *prepared with* teachers. Activity and sequence must always be subject to expert teacher judgment. It is far more likely that an innovation such as DBAE will become a part of the schools and recognizable ten years from now if this plan is followed.

Reconstruction and application are followed by *experimentation and critique.* Teachers need to modify, redesign, try out, experiment with ways to teach specific content to students. Their understanding of content needs to be assessed. They need supervisory support as they do this. The supervisor focuses on curriculum intentions—intentions outlined in the curriculum materials, teacher intentions, student intentions—and engages the teacher in dialogue about those intentions. In this way, the teacher will know when more information is necessary or that better application of principles of learning could be made, not because the supervisor has said so, but because the teacher's own critical skills are enlarged.

The strands of a continuum and framework for its development that I have outlined will provide broad guidelines for going beyond, exploring, and discovering how to better educate teachers in DBAE programs. A continuum will always be unfinished—there is always an overlapping horizon of what could yet be (to use Berger's words) when we are more likely to want some certain answers. In the past, teacher educators have been too ready to give answers to, rather than find answer

with, teachers. Answers, in a continuum, will always hinge on the uncertainty and unpredictability of pre- and inservice students with whom we work. The continuum is their continuum.

John Westerhoff (1987, 193) has remarked:

> *It is easy to forget that nothing—no media, film, field trip, teaching method, or educational resource—can replace a person. After everything has been said about methods, skills, knowledge, technique, or program, what finally surfaces as most important is the person who teaches.*

I suspect that if art educators bear this in mind, discussions and plans about discipline-based art education will not have to end up in the tradition of past curriculum reform movements that never got very far beyond the minds of the reformers.

References

Berger, P. L. 1963. *Invitation to sociology: A humanistic perspective*. Garden City, N.Y.: Anchor Books, Doubleday.

Bolin, F. S. 1987. The teacher as curriculum decision maker. In *Teacher renewal: Professional issues, personal choices*, ed. F. S. Bolin and J. Falk. New York: Teachers College Press.

Clark, G. A., M. D. Day, and W. D. Greer. 1987. Discipline-based art education: Becoming students of art. *The Journal of Aesthetic Education* 21(2):129-96.

Dewey, John. [1902] 1974. The relation of theory to practice in education. In *John Dewey on education*, ed. R. D. Archambault.

Dewey, John. 1929. *The sources of a science of education*. New York: Horace Liveright.

Eisner, E. W. 1982. An artistic approach to supervision. In *Supervision of teaching*, ed. T. J. Sergiovanni. Alexandria, Va.: Association for Supervision and Curriculum Development.

Greene, Maxine. 1973. *Teacher as stranger*. Belmont, Calif.: Wadsworth.

Huebner, Dwayne. 1987. The vocation of teaching. In *Teacher renewal: Professional issues, personal choices*, ed. F. S. Bolin and J. Falk. New York: Teachers College Press.

Jersild, Arthur T. 1955. *When teachers face themselves*. New York: Teachers College Press.

Lortie, Dan C. 1972. *Schoolteacher: A sociological study*. Chicago: University of Chicago Press.

Sevigny, Maurice J. 1987. Discipline-based art education and teacher education. *The Journal of Aesthetic Education* 21(2):95-126.

Spradley, J. P. 1979. *The ethnographic interview*. New York: Holt, Rinehart, and Winston.

Stanley, M. 1980. Education and public policy discourse. *Teachers College Record*, p. 81.

Waller, W. 1923. *The sociology of teaching*. New York: John Wiley and Sons.

Westerhoff, John. Teacher as pilgrim. In *Teacher renewal: Professional issues, personal choices*, ed. F. S. Bolin and J. Falk. New York: Teachers College Press.

RESPONDENT
Michael D. Day
Brigham Young University

First of all, by definition, preservice is usually considered to be the university-education and field-experiences part of our students' training prior to graduation and certification. The inservice part is their employment within school districts or other places as art educators.

Among the typical preservice experiences are instruction in the art disciplines (on which we have concentrated extensively in this symposium), courses and instruction in pedagogy, and the supervised practice-teaching experiences that our preservice students have. Inservice experiences often consist of such items as released-time faculty inservice meetings when teachers are paid for their time or are released from their regular duties, or seminars, institutes, and workshops. And then there is the college graduate-level course work that people do, which I think can also be considered as inservice work.

As we discuss preservice education, we must consider the inservice reality. In Dr. Bolin's paper, she says that "there are no generic schools or generic classrooms." I think that is an interesting observation and an important one for us to realize. I'd like to talk for a minute about the range of teaching experiences that our graduates coming out of the inservice programs can expect to find as they go out to look for jobs. Every

state is different. At Brigham Young University we have students from all fifty states, so we really have to consider this broad range. For example, you know that secondary art teachers coming out of a university program might find themselves in a high school or junior high school situation teaching foundations courses, drawing, painting, ceramics, printmaking, design courses, or crafts courses. They may be in charge of the yearbook. They may be doing photography. They may be helping with stage design and costume design. In other words there is a wide range of potential expectations. Our students can't be specialized in every one of the teaching areas.

Another reality that all teachers face—and some of these are generic to all teachers, and some are more specific to art teachers—is the fact that in the schools the students are mainstreamed. This means that we have multiethnic and multilingual student populations. We have in our classrooms students who are termed special students, gifted and talented students, students with behavior problems and learning disabilities—all in the same classroom with students that don't have any special, particular designation.

Another reality is the situation in the schools regarding counseling of students. Those of you who have taught art in the secondary schools, especially high school, realize that in some places the art courses are considered to be a dumping ground. And some of these realities do affect, they do influence the extent to which we can

implement a discipline-based art program. Are college-bound students counseled away from the art classes?

The reality of attitudes regarding the study of art in the classrooms must be considered. I'm talking about the attitudes of the students, the teachers, your colleagues, the superintendent and principal, and especially the counselors who talk to the students and help them decide what to take.

The inservice reality for art teachers includes all of the complexities of evaluation and grading, budgets for materials, and extracurricular expectations. Art teachers have to consider the art competitions and displays of artwork. Art teachers are usually engaged in some kind of advocacy because very often art is not as well ensconced in the curriculum as other areas. We have to run a studio not for just a few people but sometimes for hundreds of students. We have to order supplies, store them, take care of the equipment, get it repaired, and then consider the whole area of health hazards and safety standards, which are an increasing concern, not only for the students in the schools but for the teachers. In fact, I have had several colleagues and graduate students who have had health problems from teaching art in high schools. And finally we have the regular service and participation as a faculty member in a school situation.

What I've just reviewed briefly suggests the range of concerns that our students have to deal with as they go out into the schools. But I've only talked about the secondary level. At Brigham Young we have a K-12 certification with students going out certified or licensed to teach from kindergarten through the twelfth grade. That brings into play another whole realm, and that is the elementary situation. When I was at the Getty Institute in Los Angeles this summer, there were educators from all the eight regional planning grant sites around the country. I had an opportunity, in preparation for this particular responsibility that I have today, to survey the different kinds of teaching situations that are found around the country at the elementary level. I interviewed a number of people from several states and asked them to tell me what the situations were like that they knew of. From that I've come up with four that I want to mention quickly. These are four typical situations in elementary art education. You'll find some variations of these and many interpolations between these four situations around the country.

Situation #1. Here the teacher has an art room in a single elementary school. The teacher meets with three hundred to six hundred students in the art room on a weekly basis, regularly scheduled, and can expect follow-up and support from the classroom teachers. In this case art is a standard subject in the school curriculum. The art teacher evaluates progress of all students and completes grade reports— whatever kind of reports are given. That seems like a fairly good situation and one

in which we can probably do a good job of implementing the discipline-based approach.

Situation #2 is the same as the first situation, but in this case art is for the purpose of providing a preparation period for classroom teachers according to a union agreement with the district administration. Classroom teachers are not available for support and follow-up in this situation because they are having their break, and in this case very often art is not evaluated.

Situation #3. Here we have the itinerant art teacher—"art on a cart." You're all familiar with that. The art teacher visits two or three elementary schools, sometimes more, and teaches art in regular classrooms on a scheduled basis. This teacher services nine hundred to eighteen hundred or more children with visits every two to four weeks. In other words, sometimes once a month with eighteen hundred kids. A teacher from Nebraska told me that in one week he saw seventeen hundred kids. Now he couldn't attend that many classrooms, but that was obviously in some large group projects that he did. The art teacher in this case carries all the materials and supplies to each classroom and usually can expect little contact with classroom teachers, and certainly can never learn the names of the students. In this case art is not evaluated.

Situation #4. The art specialist in this case assists classroom teachers to implement a written curriculum adopted by the school

district. And by the way, you can find variations of these situations, with more detail, published in the "Seven Site Report" that Getty commissioned and Rand published. I think most of you know about that. If you don't, the reference is in the monograph article in the *Journal of Aesthetic Education,* which all of you were sent as a part of this conference. In any case, this art specialist services from three to six elementary schools, providing technical support for the teachers, ordering materials, demonstrating lessons on request, and providing general inservice support. This teacher assists the classroom teachers on a regularly scheduled basis. Art is taught regularly on a weekly basis and student progress is evaluated. An example of that model would be the Hopkins, Minnesota, site.

After reviewing the realities of inservice art education for which university art educators are preparing their students, I thought, "What does all of this suggest?" I came up with seven points.

1 Graduating art teachers face an extremely wide range of potential working situations. Frances Bolin says something about this in her paper: "Direct transfer is impossible." In other words, we cannot train our teachers in preservice for the specific situations that they will encounter. Even if we could, the situations would change.

2 Preservice education must take into account the inservice reality. We can't adequately prepare our students for all the contingencies in teaching that they will

encounter. Part of what we need to teach them is how to respond to new situations, how to find needed resources, and how to organize instructional units. Our speaker said, "We need to help them be experimental about their work, to try out ideas and figure out what works and what doesn't work."

3 Inservice education is obviously needed and is often much appreciated by the teachers. Since we know that the potential competency of each teacher is not fully developed the first year in the job, inservice becomes very important. This is just underlining the point made by Professor Bolin.

4 Many of the current corps of art teachers need and want inservice in the discipline-based approach and advanced work with disciplined art knowledge, especially in art criticism and aesthetics. And that comes from my experience and from the experience of many of you. I think it also is underlined by the kind of discussion that has gone on at this symposium.

5 Aestheticians, art critics, art historians, and artists who are familiar with the discipline-based approach, as well as art educators, are needed to provide inservice education for the current corps of art teachers. What I'm saying is that we can all get involved in this.

6 We need experienced art teachers in the schools who understand and practice the discipline-based approach so that we can

send our students out to work with them, so that the experienced art teacher can mentor our preservice student teachers. This has been mentioned earlier in some of our discussions. We try to develop a person who has a particular approach, who then goes out into a teaching situation where the opposite or different approach is being used, and it's not exactly reinforcing.

7 We need to consider the master's degree in art education as one form of inservice education. The M.A. can provide a balanced program of inquiry into the disciplines as well as advanced work in art education. The progress made by many teachers at this level, in my experience, can rival the type of progress that is made by preservice teachers who are going through student teaching. I've just recently had examples where teachers have come back to the university and have said, "You know, I was just about ready to quit teaching and have been revitalized by new ideas."

The reality is that, regardless of how successful we are at developing discipline-based art teacher education programs at the inservice level (which must be, I believe, our top priority), there is and will continue to be a serious need for sound inservice education for the approximately twenty thousand currently employed art teachers, not to mention the hundreds of thousands of classroom teachers who find themselves responsible for art instruction.

There is plenty for all of us to do.

RESPONDENT
Linda Peterson
Provo, Utah, School District

As W. Dwaine Greer states in his article "Approaching Art as a Subject of Study," there must be a stance that convinces the school board and administration that art is a serious area of study worthy of attention as part of general education. The art program must present art as a discipline with a regular sequence of instruction. Administrators and school boards must and will provide support when they know the art program will provide evidence of increasing sophistication of students.

Principals and teachers will accept DBAE when they see the possibility of sophistication in students with the resources they have available. Teachers need help with curriculum that is complete enough for them to use without undo effort. Districts must be willing to undertake professional development programs that will inspire and aid teachers in implementing a balanced DBAE curriculum.

Kathryn Bloom states, "As you have more art introduced into the school district, the district itself will see the need to add more skilled personnel. Money should be used as a carrot to encourage districts and state education departments to follow through."

In Provo School District, the Career Ladder Program has served as our carrot and given us the thrust for reform and inservice. Reform in Provo School District is not a luxury but a necessity. We are changing because we must! The Career Ladder Program has allowed reform through year-round schools, writing across the curriculum, reading in the content area, critical thinking, principles of effective teaching, effective schools research, clinical supervision, learning styles, study skills, and university partnership programs, among others. It is often said in jest, "If you want to go to reform school, go to Provo School District." Teachers have been gently coerced into a districtwide inservice program that suggests we be more professional. Inservice has been hard work. At its inception inservice appealed to us because of the additional money; now, we find it worthwhile because it has required us to be more professional in our teaching—and we receive more money. I believe that in this thrust for professionalism and reform DBAE has found its way as a natural partner. We are grateful to Dr. Michael Day and the Getty Center for Education in the Arts for their leadership and encouragement.

There is not enough time to elaborate on the details of the DBAE program we hope to implement in Provo's secondary schools, but I feel it hinges on the career-ladder model. This model allows us to provide and pay for the services of curriculum leaders and teacher specialists. Simply said, teachers are teaching teachers. We have found the success of inservice in our district to be tied to a few simple principles.

1 Understand the dynamics of change. Teachers are defensive and are not anxious to seek change. A book of interest might be *Taking Charge of Change*, by Hord, Rutherford, Austin, and Hall. Another is *Diffusion of Innovation*, by Everett M. Rogers.

2 Create a need for change in art. Resistance is to be expected. "We tried that." "I'm already doing it." "It doesn't apply to our kids." "We're moving too fast." Some teachers feel a different need, etc., which should be taken into consideration.

3 Create a vision. Goals that impact on art instruction; strategies that lead to improved instruction and learning; expansion of teacher repertoire; understanding of art's impact (whatever atmosphere is being encouraged) are all vital to the vision.

4 Provide quality art training. This has to be as well done for administrators as for teachers. The idea is to immerse people in the concept, to let them see the whole picture, and to give reinforcement. Teachers will have different rates of "enlightenment."

5 Practice. It is suggested that art strategies be practiced five times a month with no modification in the strategy. Remember: nothing works the way it is supposed to the first time.

6 Utilize problem-solving. Use variety, brainstorm, try different approaches, research, and experiment.

7 Encourage performance and coaching and involve the group in setting the timetable. Teachers teaching each other encourages the use of strategy, develops "ownership," gives a sense of "this is how it feels to be before this group."

8 Allow time. It probably takes about three years for new strategies and processes to become a part of one's art repertoire.

9 Provide constant reinforcement. Areas for support could include art meetings, demonstrations, newsletters, consultants, conferences, additional art inservice, etc.

10 Provide incentives. Compensate those involved with release time, money, position, advancement, recognition, and lane changes.

By the very nature of art inservice we enhance our teaching skills. We sharpen our intellectual perception, develop professional respect for one another while building a spirit of educational community and a bonding or connection to one another.

Inservice can help us in the process of becoming better art teachers by exposing us to literature and to greater knowledge of the subject matter in our field. Discussions provide us with the opportunity to communicate and become enthusiastic about what we teach.

Universities need to help at the preservice level by raising expectation levels for

art teachers going into the profession. University professors need to be more sensitive and perceptive; encourage students to work to the extent of their potential; help them participate in the larger world of the mind; ask questions; provide partnerships to schools; act as role models for the teaching profession; explore and research solutions for more effective teaching. As Frances Bolin has said: Help students reach self-understanding. Teachers should help them want to learn, have open minds, read, research, experience dialogue, and dare to risk.

Provo School District's greatest problem in inservicing has been resistance to change. Change is uncomfortable. Learning and applying new ideas is sometimes frightening. We worry about change. "Do I want to?" "What will others think?" "Will it require extra effort?" "Can I succeed?" Change needs to occur with care, support, and constant reinforcement.

Teaching is an isolated act. The teacher down the hall always seems to have the right answers, the better discipline, the more creative approach. We must realize as art teachers that there are no right answers: every teacher is unique, as is very student. Inservice can help us continue to learn, explore, change, and adopt throughout our teaching career. The interaction it provides will assist us in maintaining enthusiasm for sharing what we know and feel with those we teach.

RESPONDENT
Jerry Tollifson
　Ohio Department of Education

I'm a state education supervisor. You may not realize it, but you need me and my type if your dream of getting DBAE into every school is to become a reality. Perhaps my seventeen years experience in Ohio can be helpful to you. I have been conducting inservice education activities on our version of DBAE for that long. In that experience there are a few clues to answering the question we are asking here today: "What is the proper interrelationship between preservice and inservice in art education?" I believe the answer is somewhere to be found in the interrelationships that can be established between art supervisors and collegiate art educators. And mind you, it is absolutely essential that interrelationships be found and nurtured by preservice folks like you and inservice folks like me. In this, Frances Bolin and I are in complete agreement. Her belief that supervision is "the best place to create a continuum between pre- and inservice teacher education" is absolutely correct. Here's why I believe that, too.

Suppose the "millennium" comes soon and DBAE becomes established in your college or university art education program. Suppose further that your art education majors graduate and go confidently to their first teaching jobs. You prepared them well. They are ready. They know why and how

to teach art through the four major disciplines of DBAE—art production, art history, art criticism, and aesthetics. All seems right with the world. Your DBAE graduates are now ready to bring about the needed curriculum reform in the new schools. Right? Wrong! You're wrong if you hold this assumption, because it presumes that the world "out there" is a friendly one. It's not. It's a jungle out there, "a studio production jungle," a "creativity jungle." And it's very hostile both to the DBAE theory and DBAE practices.

What I am saying is that, although new teachers may be well prepared in DBAE, they will not find their ideas readily accepted by most of the other art teachers, by most principals, and by most students in their school districts. On the contrary, your DBAE graduate is more likely to be chewed up into little pieces by the existing system and spit back out as a back-sliding studio production believer within a year. Forgive my mixed metaphors, but they express what I've seen happen, unfortunately. The obstacles to DBAE are formidable.

To help your DBAE graduates overcome the obstacles to this curriculum reform, we need to do something to prepare the way for them. We need to make the districts into which they go more hospitable places for DBAE. This can be done by supervisors like myself working at the state level and other supervisors and administrators working in school districts. Through various inservice activities we can "fertilize the soil," so to speak, so your preservice DBAE

"seeds" will have a chance to take root and grow. This metaphor is one way to characterize the proper interrelationships between preservice and inservice education to promote DBAE.

Dr. Bolin declares in her paper that the focus of pre- and inservice experience should be on *existential* concerns—concerns such as "nourishing being," "self understanding," "finding personal meanings." She states that, "In reality, it may be self understanding that will most prepare the teacher in guiding students" (Bolin 2). These concerns may seem to be in direct opposition to the concerns of DBAE. After all, DBAE advocates stress the central importance of understanding the *subject—matter* in an art curriculum. By stressing subject matter over development of the self, DBAE proponents believe they have redressed the balance between these two long-term contenders for curriculum emphasis. Should one win out over the other in art curriculum? I think not. Should one win out over the other in the effort to find connections between preservice and inservice? Again, I think not. For the sake of preparing *great* art teachers, we need to prepare art teachers who have an understanding of art as a subject at the same time that they develop their individual selves in their search for personal meaning.

The clue to having it both ways is found in something that Dr. Bolin says in her paper: "As teachers, we are creators and bearers of meaning whose work is to empower students to find their own

personal meaning." And for added punch she quotes Jersild (1955) as follows:

The search for meaning is not a search for an abstract body of knowledge, or even for a concrete body of knowledge. It is a distinctly personal search. The one who makes it raises intimate personal questions: What really counts, for me? What values am I seeking? What in my existence as a person, in my relations with others, in my work as a teacher, is of real concern to me, perhaps of ultimate concern to me?

This statement expresses the essence of a concern for developing self-understanding. The essence of concern for understanding the subject matter of art is to be found in the DBAE statements of belief that works of art are humanistic inquiries, that they are embodiments of different life philosophies, human ideals, concepts of reality, or world views; and that these views are made comprehensible by students through their participation in the discipline of aesthetics, art criticism, art history, and art production. Barkan said it succinctly (Barkan 1966) when he said:

The professional scholar in art—the artists, the critics, the historians—would be the models for inquiry, because the kind of human meaning questions they ask about art and life, and their particular ways of conceiving and acting on these questions are the kinds of questions and

ways of acting that art instruction would be seeking to teach students to ask and act upon. The artist and critic would serve as models for questions that could be asked about contemporary life. The historian would serve as model for questions that might be asked about art and life in other times, other societies, and other cultures in order to illuminate the meaning of the past for better understanding of current pressing problems.

Thus, the search for meaning in works of art is what DBAE is all about. The search for self-understanding through discovering personal meaning is what Bolin is after. In my view, these are not incompatible views. The search for meaning in works of art can be turned to a search for personal meaning. As teachers learn the critical and historical inquiry processes, they can use them as means for understanding works of art as well as themselves. The study of works of art becomes the entree into questions of personal meaning. Thus, in my view, the study of works of art is the common ground for preservice and inservice education for teachers.

I don't have time today to develop this idea further, but I challenge you to consider it and make it the central concern of preservice teacher education. Those of us involved in inservice education, too, should make it the focus of our programs for teachers.

What might that inservice look like? I have several suggestions. They are based on an inservice education process we have

been developing for a number of years in Ohio. This inservice consists of a series of regional inservice curriculum education seminars on DBAE that the state Department of Education has conducted for art teachers and administrators. I have time to describe briefly eight features of the seminars.

1 First, we ask school districts to send districtwide teams to the seminars. On the teams are elementary and secondary art teachers and an administrator representing the district superintendent. Administrators are essential to ensuring follow-up after the seminars. Most districts do not have art supervisors so they send a curriculum coordinator, a generalist. They are the ones we try to educate to provide the "appropriate, supportive" supervision of art teachers that Bolin mentions.

2 At the seminars, the teams learn the goals and objectives for DBAE and how to translate them into units and activities that relate the four disciplines in the classroom. We try to strengthen the belief that verbalization about art and the creation of art can interact productively. For this we use our award-winning curriculum documents and television program.

3 Teams also learn about commercial resources for teaching DBAE and how to use them with students. We try to overcome the reluctance of teachers to use resources such as textbooks, once anathema to art teachers.

4 The seminars are held in eight of our major art museums, themselves a major resource teachers learn to use. This gives encouragement to teachers to use museums in teaching their DBAE units.

5 We involve teacher educators from our major universities as planners and presenters at the seminars. They help provide additional preservice/inservice connections.

6 After the seminars, teachers select exemplary state-designed units to teach to their students. They also design their own units based on the DBAE theory and teach them to their students.

7 Also after the seminars, the district teams design plans for infusing the DBAE approach throughout the district. This plan includes writing a K-12 course of study based on the DBAE model. Our inservice tries to overcome teachers' fears that a written curriculum will kill the creativity of teachers and students. This task is absolutely essential if we want more than a few hotshot individual teachers working to promote DBAE. While preservice experiences may adequately prepare teachers to plan a DBAE curriculum for one grade level (elementary or secondary), it is primarily through inservice experiences that teachers learn to develop a K-12 perspective.

8 A year later, the teams meet again at the museums to share their experiences in teaching and planning DBAE in their

districts. We hope this aids in the teachers' and administrators' "self-knowledge" with which to "reconstruct" their experiences (to use Bolin's terms).

As a result of these seminars, few teachers and administrators become experts on DBAE. For this, they recognize a need for additional in-depth inservice that they often acquire at local universities and colleges. From the seminars they gain a better understanding of DBAE—enough, at least, to be more receptive to the ideas brought to the schools by your DBAE graduates. The teachers and administrators who attend our seminars are less likely to put up obstacles to DBAE. Because of their openness to DBAE, they are more ready to learn from your graduates.

If this makes sense to you, I suggest you do three things.

First, I suggest that you incorporate into your teacher-preparation programs opportunities for prospective teachers to anticipate the obstacles to DBAE in schools and to prepare ways to surmount them.

Second, I suggest that the study of works of art to uncover personal meanings be a focus of preservice education.

Third, I suggest that you seek out ways to work closely with the state art supervisors and district supervisors in your states. Ask them to organize inservice education activities that will help lower or remove the obstacles to DBAE in the schools, to prepare the way for your DBAE graduates.

If both teacher-preparation institutions and state departments of education cooperatively address this issue, chances are much improved for making DBAE the important force in art education that it should be. DBAE is the common "turf" on which preservice and inservice can interrelate. There's no need for a "turf battle" on this ground.